REAL WORLD NIKON CAPTURE NX

BEN LONG

REAL WORLD NIKON CAPTURE NX

Ben Long

Peachpit Press 1249 Eighth Street Berkeley, CA 94710 510/524-2178 800/283-9444 510/524-2221 (fax)

Find us on the Web at www.peachpit.com To report errors, please send a note to errata@peachpit.com Peachpit Press is a division of Pearson Education

Copyright © 2007 by Ben Long

Project Editor: Alison Kelley

Development Editor: Anne Marie Walker

Production Editor: Kate Reber Copyeditor: Anne Marie Walker Tech Editor: Bill Durrence Proofreader: Liz Welch Compositor: WolfsonDesign Indexer: Valerie Perry

Interior design: Peachpit Press Cover design: Charlene Charles Will

Cover photos: Ben Long

Notice of Rights

All rights reserved. No part of this book may be reproduced or transmitted in any form by any means, electronic, mechanical, photocopying, recording, or otherwise, without the prior written permission of the publisher. For information on getting permission for reprints and excerpts, contact permissions@peachpit.com.

Notice of Liability

The information in this book is distributed on an "As Is" basis without warranty. While every precaution has been taken in the preparation of the book, neither the author nor Peachpit Press shall have any liability to any person or entity with respect to any loss or damage caused or alleged to be caused directly or indirectly by the instructions contained in this book or by the computer software and hardware products described in it.

Trademarks

Nikon is a registered trademark and Capture NX is a trademark of Nikon, Inc. Many of the designations used by manufacturers and sellers to distinguish their products are claimed as trademarks. Where those designations appear in this book, and Peachpit Press was aware of a trademark claim, the designations appear as requested by the owner of the trademark. All other product names and services identified throughout this book are used in editorial fashion only and for the benefit of such companies with no intention of infringement of the trademark. No such use, or the use of any trade name, is intended to convey endorsement or other affiliation with this book.

ISBN-13 978-0-321-48999-9 ISBN-10 0-321-48999-3

98765432

Printed and bound in the United States of America

ACKNOWLEDGMENTS

A very big thanks to the mob of talented people who made it possible for this book to be finished.

Michael Rubin at Nikon was very generous with his time and very helpful in answering all sorts of niggling little questions. This book would not be in your hands without his answers.

Bill Durrence, a long-time Nikon shooter and teacher at the Nikon School did the technical editing, and the book is much, much better because of it. Check out Bill's Web site at www.billdurrence.com to see some of his work. Bill leads excellent workshops and photo safaris, and you can learn about those at his site.

A big thanks to Pam Pfiffner for getting this book started and bringing me on board. And of course, much gratitude to the production team: Anne Marie Walker who greatly improved many hard-to-understandables, Owen Wolfson for the great layout, and Kate Reber and Alison Kelley for keeping it all going.

TABLE OF CONTENTS

Chapter One: Introduction	1
It's the Software, Stupid—and the Hardware	2
U Point—Unique Editing	
How This Book Is Organized.	
Chapter Two: Basic Theory	5
How Your Digital Camera Creates an Image	7
How a Digital Camera Sees	7
Mixing a Batch of Color	
Digital Image Composition	10
How Your Camera Makes a JPEG Image	11
Demosaicing	12
Colorimetric Interpretation	12
Color Space	12
White Balance	13
Gamma, Contrast, and Color Adjustments	14
Noise Reduction and Sharpening	15
8-bit Conversion	16
JPEG Compression	16
File Storage	17
How Your Camera Makes a Raw Image	18
Demosaicing	19
Colorimetric Interpretation	19
Color Space	19
White Balance	20
Gamma, Contrast, and Color Adjustments	20
Noise Reduction and Sharpening	20
8-bit Conversion	21
File Storage	21
Raw Concerns	22
Storage	22
Workflow	22
Shooting Performance	23

Image Editing Theory	23
Color Information Theory	24
Histogram 101	25
Contrasty Histograms	28
Understanding Nondestructive Editing	29
Chapter Three: Interface and Basic Workflow	33
Interface Overview	34
Defining a Workflow	37
Basic Workflows	37
Importing	39
Backing up your image master	41
Organizing your image files	44
Renaming your image files	49
Choosing selects—rating your images	49
Adding IPTC metadata	54
Editing and output	57
Archiving	57
Advanced Workflows	58
Using Capture NX with non-Nikon raw files	58
Adding Capture NX to a Photoshop workflow	59
Chapter Four: Preparing to Edit	61
Configuring Capture NX for Color Management	61
Color Management Basics	62
Color systems	63
Profiles	63
Not a magic bullet	64
Profiling Your Monitor	64
Software profiling on the Mac	65
Software profiling on Windows	66
Hardware profiling	67
Profiles and viewing conditions	68
Printer Profiling	69
Installing printer profiles on the Mac	70
Installing printer profiles on Windows	70
Color Spaces	
Color Management in Capture NX	72

Opening Images	73
Opening with the Browser	73
The Open Image Command	73
Open Recent	73
The Welcome Dialog Box	73
Opening from Your OS	74
Chapter Five: Basic Image Editing	
Image Editing Workflow	76
The Capture NX Edit List	
Base Adjustments: A Tale of Two Imaging Engines	
Editing Base Adjustments	82
Camera Adjustments and Raw Adjustments	
Adding an Edit Step	
Deleting an Edit Step	83
Altering an Edit Step	
The Edit List Context Menu	
Geometric Adjustments	84
Rotate	85
Straighten	86
Crop	87
Crop options	88
Flipping	88
Resizing	89
Changing the resolution of an image	90
Changing the number of pixels in an image	91
Resizing an image for print	92
Resizing an image for the Web or email	93
How much can you upsample?	94
Fit Photo	95
Distortion control	96
Correcting color aberrations	97
Adjusting Tone and Contrast	99
Auto Levels	99
Correcting color casts	102
Levels and Curves	
Adjusting Levels	
Reading the curve	
Adjusting individual channels	109

Levels and Curves eyedroppers	110
Adjusting curves	114
Contrast/Brightness	116
D-Lighting	120
LCH	123
Adjusting Color	125
LCH	125
Color Lightness controls	125
Chroma	127
Hue	128
Color Balance	128
Color Booster	130
Saturation/Warmth	130
Processing Raw Images	132
Camera Adjustments (for Nikon Raw Shooters Only)	
Applying camera adjustments from the browser	136
Raw Adjustments	136
Saving Files	139
Working on a JPEG or TIFF File	139
Working on a Raw File	139
NEF Options	140
JPEG Options	140
TIFF Options	140
at at 17 791	4.14
Chapter Six: Advanced Image Editing	
Knowing How Far to Push an Edit.	141
Changing Color Space	
Selection Brushes	
Brushing on an Effect	145
Lassoing a selection	149
Fill selections	149
Gradient selections	
Brush control and combining selections.	152
Combining effects	155
Feather	155
Seeing your selections	156

Control Points	158
Tonal Control Points	
Neutral Control Point	
White Control Point	
Black Control Point	
Color Control Point	167
Using multiple Color Control Points	
Advanced Color Control Points	177
Color Control Points and Selection Brushes	
Dodging and Burning	
Facial Retouching	
The Opacity Mixer	
Filters	
Photo Effects	184
Add Grain/Noise	
Contrast: Color Range	
Black and White Conversion	187
Additional Adjustments	
Gaussian Blur	
High Pass	
Noise Reduction	190
Unsharp Mask	191
Chantar Savan, Varsian Cantral and Batch Dragasing	102
Chapter Seven: Version Control and Batch Processing.	
Version Control	
Nondestructive Versions	
Creating a New Version	
Copying and Moving Settings	
Batch Processing	
Saving Settings	
Loading Settings	
Managing Settings	
Batch Processing	
Choosing a source	
Selecting settings to apply	
Renaming	
Format and destination	
Run the batch process	204
Watched Folder	

Applied Batch Processing	206
Preparing Images for the Web or Email	206
Quick Web Preview	207
Preparing for Print	207
Chapter Eight: Output	209
Outputting Electronic Files	209
Saving for the Web or Email	210
Saving for a Print Workflow	210
Saving for Use in Another Image Editor	210
Printing	211
Printing an Individual Image	211
Printing a Batch of Images	214
Printing a Contact Sheet	214
Color Managed Printing	215
Installing printer profiles.	216
Color management workflow	216
Activating onscreen proofing	217
Printing	219
Improving soft proofing accuracy	220
Printer-Controlled Color	220
Backup and Archiving.	221
Where to Go from Here	221
Index	223

CHAPTER ONE Introduction

If you had asked me a year ago if I would ever end up writing a book on Nikon Capture, I would have probably laughed and said, "Uh, I doubt *anyone* will ever write a book on Nikon Capture." Nikon Capture was never a *bad* program, but there have always been certain digital photography rules that you could live by fairly unquestioningly:

- 1. Digital zoom is never worth using.
- 2. It's always better to err on the side of lower ISO, if you can.
- **3.** Image editing programs made by camera vendors are always *far* inferior to standalone image editors.

Even though Nikon capture was a decent application, it was certainly no competition for programs like Adobe Photoshop. But then something changed: Nikon decided to turn its attention to the software end of things with the goal of producing a piece of bundled software that *could* compete with established, high-end editing systems.

To help with this, Nikon enlisted the aid of nik Multimedia, a well-respected software company best known for Photoshop plug-ins such as *nik Sharpener Pro* and *nik ColorEfex pro*. nik applied its interface and engineering prowess to Nikon's imaging understanding, and Capture NX was born.

IT'S THE SOFTWARE, STUPID— AND THE HARDWARE

Capture NX is *not* just for Nikon users. Because the program can work with JPEG and TIFF files, you can use it to edit images from any type of camera, or images that you've already processed with another image editor. If you have a Nikon camera that can shoot in raw format, you can use Capture NX to perform your raw conversion.

The development of Capture NX is intriguing because it's the first time that a camera maker has attempted to control both the hardware and software ends of the digital photography process. For years, Apple has shown that there can be a tremendous engineering advantage if one company controls both the hardware and software components of a product. The Macintosh and its associated operating system, for example, are extremely easy to configure because they compose a "closed loop" system. Because Apple controls the hardware and the software, both components can be engineered to work together smoothly. You'll find similar integration between the iPod and iTunes.

With Capture NX, Nikon has the potential to create a similar hardware/software relationship. If you're shooting with a Nikon camera, there's a good chance that Capture NX will be able to automatically perform some corrections to your image based on special information encoded in the files produced by your camera. For the shooter who needs to deliver a large volume of images very quickly, this can be a tremendous advantage.

U POINT—UNIQUE EDITING

While Nikon shooters will have access to some extra Capture NX features that aren't provided to users of other brands of cameras, digital photographers will find Capture NX to be an excellent postproduction tool for almost all of their image editing tasks.

In addition to all of the usual editing controls that you would expect to find in a highend image editor, Capture NX also provides unique image editing tools based on nik Multimedia's U Point technology.

Capture NX's U Point tools allow you to make extremely high-quality selective edits without ever having to build a mask or make a selection. With just a few simple clicks, you can create a localized edit that would require a lengthy masking or selection process if you were using a different image editor. These tools are great for users of all skill levels. They bring powerful editing capabilities to beginning shooters who aren't comfortable with the masking and selection features provided in other programs. Experienced pros will find that

NX's U Point tools let them make complex edits in far less time than it would take in a program like Adobe Photoshop.

In addition to its editing tools, Capture NX provides a high-quality raw converter (for users of Nikon cameras—if you're using a non-Nikon camera, you'll have to perform your raw conversions using a separate raw conversion application), an integrated image browser, and a fully color-managed workflow for high-quality printing and output.

I'll cover all of these areas in detail throughout this book.

HOW THIS BOOK IS ORGANIZED

This book takes you through all of Capture NX's features, providing you with explanations and examples that will help you get the most out of all corners of the program.

However, as with any full-featured image editor, to understand Capture NX, you'll be best served by learning a little theory. Chapter 2, "Basic Theory," begins with a theory lesson that explains the fundamentals of image capture, JPEG and raw files, and how to understand such essential tools as the histogram. This chapter also introduces you to some basic image editing concepts such as posterization and tone breaks, which will help you understand how much editing is *too* much editing. Additionally, you'll learn about the details of Capture NX's nondestructive editing architecture.

Coverage of the basics continues in Chapter 3, "Interface and Basic Workflow," where you'll learn the essentials of the Capture NX interface. Chapter 3 also helps you learn how to move your images in and out of Capture NX, and how to set up a workflow scenario that allows you to quickly and efficiently process an entire shoot's worth of images. Contriving an effective workflow can be especially tricky for raw shooters, and this chapter provides raw workflow examples for Nikon and non-Nikon shooters.

Chapter 4, "Preparing to Edit," shows you how to prepare your system for accurate color display and color management, as well as introduces you to the basics of getting images into the program.

If you do your job right when you're shooting, you won't have to do a tremendous amount of image editing later. Chapter 5, "Basic Image Editing," details the basic image edits that you'll need to make to the majority of your images. With most images, these edits will be all you'll need to perform. Chapter 5 also shows you how to use the Capture NX Edit List and how to process raw files.

4

Not every image can be finished with the global editing adjustments introduced in Chapter 5. In Chapter 6, "Advanced Image Editing," you'll learn how to use Capture NX's advanced editing tools, including the unique U Point editing tools mentioned earlier. These tools let you apply sophisticated localized edits to any part of your image, allowing you to emphasize contrast in one area or control the color in another.

Very often, you'll want to perform the same edits to entire batches of images. If you've shot a series of images in the same lighting setup, for example, the same Tone, Color, and White Balance adjustments will probably be relevant to all of the images. For this reason, Capture NX includes powerful batch processing capabilities that make short work out of applying edits to large groups of images. These features are all detailed in Chapter 7, "Version Control and Batch Processing."

When you're images are finished, you'll be ready to output them. While Capture NX is a completely nondestructive editing environment, you'll have no problem moving your finished images into other applications using any standard graphics file format. All of these details are covered in Chapter 8, "Output," along with an explanation of how to print your images using Capture NX's fully color-managed printing architecture.

No matter how much experience you have or how many image editing programs you already have in your digital photography toolbox, you'll find that Capture NX is an excellent resource for your digital postproduction.

CHAPTER TO Basic Theory

Ansel Adams's *Moonrise Over Hernandez* is one of the most famous photographs of the twentieth century. (If you're not familiar with the image, you can easily see a copy online by Googling "moonrise over Hernandez.") The image shows a wide New Mexico valley containing the small village of Hernandez. In the background a bright moon rises over a distant mountain range. One of the most striking features of the image is the heavy black sky that dominates the upper part of the frame.

Adams took the image on November 1, 1941 (analysis of the moon position reveals that he shot the image at 4:49:20 p.m. Mountain Standard Time, for those of you who are sticklers for accuracy), and for years he told an interesting story about its creation.

While driving through New Mexico with his son and a friend, Adams looked out the window and suddenly jerked the car off the road, so taken was he with the scene developing over Hernandez. Adams was shooting with a large 8 x 10 inch camera, which required a hefty tripod and a fair amount of preparation. He and his compatriots rushed to get the camera assembled, but Adams decided there wasn't enough time to find his light meter. However, Adams knew that the moon reflects 250 foot candles of light and so calculated an exposure based on that knowledge, and arrived at a shutter speed of 1/60th of a second at f/8. But because he was shooting with a Wratten G filter (to improve the contrast of his film), he adjusted his exposure to 1/20th at f/8. To increase the depth of field in his image he made an additional adjustment to his calculation and then settled on f/32 at 1 second.

After taking his one exposure, the light had faded, eliminating the option of any additional "safety" shots.

Once he was in his darkroom he decided that because of the white cloud and moon, and his understanding of the overall contrast ratio of the scene, he would need to use "extreme" development techniques to get the best results from the information he believed he had captured.

Although this story has been told many times by Adams and others, there is evidence that it is apocryphal: In some of his tellings, Adams related *having* a light meter.

In either case—whether he had a meter or not—he had only moments to make the shot, and only one chance to get it right, and he plainly succeeded. Even if you don't like the image, you can't fault its technical sophistication. Adams knew precisely how to expose his image to capture the tones he wanted, *and* he knew how to process the image to exploit that exposure.

Today, if you're shooting with a modern film or digital camera, you have far fewer decisions to make. Automatic focus and metering systems make short work of complex lighting situations, and state-of-the-art image processing technology makes it possible for beginning photographers to make corrections, adjustments, and retouchings that would require years of practice and study in a darkroom.

These technologies make it far easier for more people to take good pictures with less work. Point a fully automatic camera at a scene and most of the time you'll get a good shot that's well exposed with good color and detail.

However, although your camera is good at making a lot of necessary photographic decisions, it uses some baseline assumptions about what you might want. For more serious photographic work, these assumptions might not always be correct.

Moonrise Over Hernandez is a perfect example of a scene that would trip up an automatic camera. Adams's decision to render the scene with the dark black sky at the top is not one that the typical automatic camera would make. It was Adams's understanding of how his film and chemistry worked that allowed him to produce the image. And even though your camera can make a lot of decisions for you, for the most control and flexibility you'll be well served by a little technical understanding of your gear.

In this chapter, we'll look at some basic technical concepts related to your camera and to digital imaging in general. Some of these concepts include factors you'll want to think about while you're shooting, whereas others will become significant once you start editing in Capture NX.

HOW YOUR DIGITAL CAMERA CREATES AN IMAGE

Although a piece of film is a remarkably self-contained apparatus—it can both capture and store an image—your digital camera requires a large number of sophisticated technologies. Packed with everything from light-sensitive imaging chips to custom amplifiers to onboard computers and removable storage technologies, there's a lot going on in even the smallest digital camera.

Just as film photographers of old had an in-depth understanding of the imaging properties of their films and chemistries, digital photographers can benefit from a deeper knowledge of how their camera works.

How a Digital Camera Sees

From one perspective, there's very little difference between a digital camera and a film camera. They both use a lens to focus light through an aperture and a shutter onto a focal plane. The only detail that makes a camera a *digital* camera is that the focal plane holds a digital image sensor rather than a piece of film.

The quality of your final image is determined by many factors, from the sophistication of your lens to your (or your light meter's) decision as to which shutter speed and aperture size to use. One downside to digital photography is that the actual imaging technology is a static, unchangeable part of your camera. You can't change the image sensor if you don't like the quality of its output.

Just like a piece of film, an image sensor is light sensitive, be it a CCD (charge-coupled device) or CMOS (complementary metal oxide semiconductor) chip. The surface of the chip is divided into a grid of *photosites*, one for each pixel in the final image. Each photosite has a diode that is sensitive to light (a *photodiode*). The photodiode produces an electric charge proportional to the amount of light it receives during an exposure. To interpret the image captured by the sensor, the voltage of each photosite is measured and then converted to a digital value, thus producing a digital representation of the pattern of light that fell on the sensor's surface.

Measuring the varying amounts of light that were focused onto the surface of the sensor (a process called *sampling*) yields a big batch of numbers, which in turn can be processed into a final image.

However, knowing how *much* light there is in a particular photosite doesn't tell you anything about the *color* of the resulting pixel. Rather, all you have is a record of the varying brightness, or *luminance*, values that have struck the image sensor. This is fine if you're interested in black-and-white photography. If you want to shoot full color, though, things get a little more complex.

Mixing a Batch of Color

If you've ever bought paint at a hardware store or learned about the color wheel in grade school, you might already know that you can mix together a few primary colors of ink pigments to create every other color. Light works the same way: but the primary colors of ink are cyan, magenta, and yellow, whereas the primary colors of light are red, green, and blue. What's more, ink pigments mix together in a subtractive process. As you mix more ink colors, your result gets darker until it turns black. Light mixes together in an additive process; as you mix more light, it gets brighter until it ultimately turns white.

In 1869, James Clerk Maxwell and Thomas Sutton performed an experiment to test a theory about a way of creating color photographs. They shot three black-and-white photographs of a tartan ribbon. For each photo they fixed their camera with a separate colored filter: one red, one blue, and one green. Later, they projected the images using three separate projectors, each fitted with the appropriate red, green, or blue filter. When the projected images were superimposed over each other, they yielded a full-color picture.

Your digital camera uses a similar technique—and a lot of math—to calculate the correct color of each pixel. Every photosite on your camera's sensor is covered with a colored filter—red, green, or blue. Red and green filters alternate in one row, and blue and green alternate in the following row (**Figure 2.1**). There are twice as many green photosites because your eyes are much more sensitive to green than to any other color.

Figure 2.1 In a typical digital camera, each pixel on the image sensor is covered with a colored filter: red, green, or blue. Although your camera doesn't capture full color for each pixel, it can interpolate the correct color of any pixel by analyzing the color of the surrounding pixels. This array of colors is called a *Bayer pattern* after Dr. Bryce Bayer, the Kodak scientist who devised it in the early 1970s.

As you've probably already surmised, this scheme still doesn't produce a color image. For that, the filtered pixel data must be run through an interpolation algorithm, which calculates the correct color for each pixel by analyzing the color of its filtered neighbors.

Say that you want to determine the color of a particular pixel that has a green filter and a value of 100%. If you look at the surrounding pixels with their mix of red, blue, and green filters and find each of those pixels also has a value of 100%, it's a pretty safe bet that the correct color of the pixel in question is white, since 100% of red, green, and blue yields white (**Figure 2.2**).

100%	100%	100%
100%	100%	100%
100%	100%	100%

100% red + 100% green + 100% blue = white

Figure 2.2 To calculate the true color of the 100% red pixel in the middle of this grid, you examine the surrounding pixels. Because they're all 100%, it's a good chance that the target pixel is pure white, since 100% of red, green, and blue combines to produce white.

Of course, the pixel may be some other color—a single dot of color in a field of white. However, pixels are *extremely* tiny (in the case of a typical consumer digital camera, 26 million pixels could fit on a dime) so odds are small that the pixel is a color other than white. Nevertheless, there can be sudden changes of color in an image—as is the case, for example, in an object with a sharply defined edge. To help average out the colors from pixel to pixel and therefore improve the chances of an accurate calculation, digital cameras contain a special filter that blurs the image slightly, thus gently smearing the color. Although blurring an image may seem antithetical to good photography, the amount of blur introduced is not so great that it can't be corrected for later in software.

This process of interpolation is called *demosaicing*, a cumbersome word derived from the idea of breaking down the chip's mosaic of RGB-filtered pixels into a full-color image. There are many different demosaicing algorithms. Because the camera's ability to accurately demosaic has a tremendous bearing on the overall color quality and accuracy of the camera's images, demosaicing algorithms are closely guarded trade secrets.

The Bayer pattern is an example of a *color filter array (CFA)*. Not all cameras use an array of red, green, and blue filters. For example, some cameras use cyan, yellow, green, and magenta arrays. In the end, a vendor's choice of CFA doesn't really matter as long as the camera yields color that you like.

A final image from a digital camera consists of three separate *color channels*, one each for red, green, and blue information. Just as in Maxwell's and Sutton's experiment, when these three channels are combined, you get a full-color image (**Figure 2.3**).

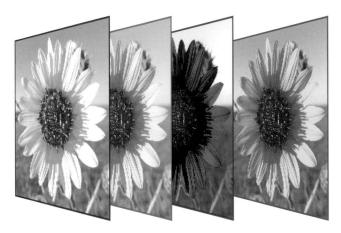

Figure 2.3 Your camera creates a full-color image by combining three separate red, green, and blue channels. If you're confused by the fact that an individual channel appears in grayscale, remember that each channel contains only one color component—so the red channel contains just the red information for the image; brighter tones represent more red, darker tones, less.

DIGITAL IMAGE COMPOSITION

A final image from your digital camera is composed of a grid of tiny pixels that correspond to the photosites on your camera's image sensor. The color of each pixel in an image is usually specified using three numbers: one for the red component, one for the blue, and one for the green. If your final image is an 8-bit image, then 8-bit numbers are used to represent each component. This means that any pixel in any individual channel can have a value between 0 and 255. When three 8-bit channels are combined, you have a composite 24-bit image that is capable of displaying any of approximately 16 million colors. Although this is a far greater number of colors than the eye can perceive, bear in mind that a lot of these colors are essentially redundant. RGB values of 1,0,0 (1 red, 0 green, 0 blue) and 1,1,0 are not significantly different. Therefore, the number of significant colors in that 16 million color assortment is actually much smaller.

In a 16-bit image, 16-bit numbers are used for each channel, resulting in an image that can have trillions of unique colors. Although the difference between 1,0,0 and 1,1,0, will be the same as in an 8-bit image, because each pixel of each channel can have a value between 0 and 32,768, 16-bit images have more significant colors—that is, more colors that your eyes are capable of seeing.

Color channels are an important concept to understand because some edits and corrections can be achieved only by manipulating the individual color channels of an image. What's more, some problems are easier to identify and solve if you are in the habit of thinking in terms of individual channels.

HOW YOUR CAMERA MAKES A JPEG IMAGE

By default, your camera probably shoots in JPEG mode. In fact, depending on your camera, JPEG images might be your only option. More advanced cameras will also offer a raw mode. When a camera is shooting JPEG images, a lot of things happen after the sensor makes its capture.

The camera first reads the data off of the sensor and then amplifies it. As you learned earlier, each pixel on your image sensor produces a voltage that is proportional to the amount of light that struck that site. When you increase the ISO setting on your camera, all you're doing is increasing the amount of amplification that is applied to the original data. Unfortunately, just as turning up the volume on your stereo produces more noise and hiss, turning up the amount of amplification in your camera increases the amount of noise in your image (**Figure 2.4**).

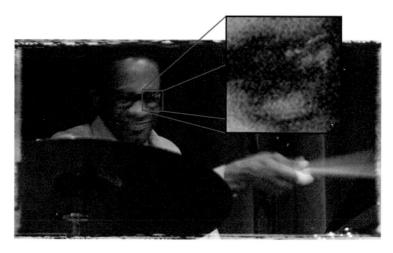

Figure 2.4 As you increase the ISO setting of your camera (often done when shooting in low light), you increase the amount of noise in your image.

After being amplified, the data is passed to your camera's onboard computer, where a number of important image processing steps occur.

Demosaicing

The raw image data is first passed through the camera's demosaicing algorithms to determine the actual color of each pixel. Although the computing power in your digital camera would make a desktop computer user of 15 years ago green with envy, demosaicing is so complicated that camera vendors sometimes have to take shortcuts with their demosaicing algorithms to keep the camera from getting bogged down with processing. After all, a computer can sit there and work for as long as it needs, but the camera has to be ready to shoot again in a fraction of a second. The ability to make the most of the camera's processing resources is one reason that some cameras are better at demosaicing than others.

Colorimetric Interpretation

Earlier it was noted that each photosite has a red, green, or blue filter over it, but it was never defined as to what "red," "green," and "blue" were. Your camera is programmed with colorimetric information about the exact color of these filters and so can adjust the overall color information of the image to compensate for the fact that its red filters, for example, may actually have a bit of yellow in them.

Color Space

After all this computation, your camera's computer will have a set of color values for each pixel in your image. For example, a particular pixel may have measured as 100% red, 0% green, and 0% blue, meaning it should be a bright red pixel. But what does 100% red mean—100% of what?

To ensure that different devices and pieces of software understand what "100% red" means, your image is mapped to a *color space*. Color spaces are simply specifications that define exactly what color a particular color value—such as 100% red—corresponds to.

Most cameras provide a choice of a couple of color spaces, usually sRGB and Adobe RGB. Your choice of color space can affect the appearance of your final image because the same color values might map to different actual colors in different spaces. For example, 100% red in the Adobe RGB color space is defined as a much brighter color than 100% red in the sRGB space.

All of these color spaces are smaller than the full range of colors that your eyes can see, and some of them may be smaller than the full range of colors that your camera can capture. If you tell your camera to use sRGB, but your camera is capable of capturing, say, brighter

blues than provided for in the sRGB color space, the blue tones in your image will be squeezed down to fit in the sRGB space. Your image may still look fine, but if you had shot in a larger color space, there's a chance that the image could have looked much better.

After demosaicing your image, the camera converts the resulting color values to the color space you've selected. (Most cameras default to sRGB.) Note that if you're shooting raw, you can change this color space later using Capture NX. You'll learn more about this in Chapter 6, "Advanced Image Editing."

White Balance

Different types of light shine at different intensities, measured as a temperature using the Kelvin (K) scale. To properly interpret the color in your image, your digital camera needs to know what type of light is illuminating your scene.

White balancing is the process of calibrating your camera to match the current lighting situation. Because white contains all colors, calibrating your camera to properly represent white automatically calibrates it for any color in your scene.

Your camera will likely provide many different white balance settings, from an Auto White Balance mode that tries to guess the proper white balance, to preset modes that let you specify the type of light you're shooting in, to manual modes that let you create custom white balance settings. These settings don't have any impact on the way the camera shoots or captures data. Instead, they affect how the camera processes the data after it's been demosaiced and mapped to a color space.

When you shoot in Auto White Balance mode, the camera employs special algorithms for identifying what the correct white balance setting should be. Although most auto white balance mechanisms these days are very sophisticated, even the best ones can confuse mixed lighting situations—for example, shooting in a tungsten-lit room with sunlight streaming through the windows, shooting into a building from outside, and so on.

If you're using a preset white balance or manual mode, the camera adjusts the color balance of the image according to those settings.

TIP: One of the great advantages of shooting in raw mode is that you can adjust the white balance of an image after you shoot. This makes it much easier to deal with tricky lighting situations.

Gamma, Contrast, and Color Adjustments

Suppose you expose a digital camera sensor to a light and it registers a brightness value of 50. If you expose the same camera to twice as much light, it will register a brightness value of 100. Although this makes perfect sense, it is, unfortunately, not the way your eyes work. Doubling the amount of light that hits your eyes does not result in a doubling of perceived brightness, because your eyes do not have a linear response to light.

Our eyes are much more sensitive to changes in illumination at very low levels and very high levels than they are to changes in moderate brightness. For this reason, we don't perceive changes in light in the same linear way that a digital camera does.

To compensate for this, a camera applies a mathematical curve to the image data to make the brightness levels in the image match what the eye would see. This *gamma correction* process redistributes the tones in an image so that there's more contrast at the extreme ends of the tonal spectrum. A gamma-corrected image has more subtle change in its darkest and lightest tones than does an uncorrected, linear image (**Figure 2.5**).

Figure 2.5 The left image shows what your camera captures—a linear image. The right image shows how your eyes perceive the same scene. Because your eyes have a nonlinear response to light, they perceive more contrast in the shadows and highlights.

Next, the camera adjusts the image's contrast and color. These alterations are usually fairly straightforward—an increase in contrast, perhaps a boost to the saturation of the image. Most cameras let you adjust these parameters using the built-in menuing system, and most cameras provide some variation on the options shown in **Figure 2.6**.

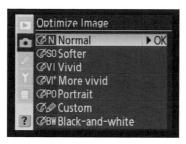

Figure 2.6 On most cameras, internal image processing can be controlled through a simple menu.

Noise Reduction and Sharpening

Many cameras employ some form of noise reduction. Some cameras also automatically switch on an additional, more aggressive noise reduction process when you shoot using a lengthy exposure.

All cameras also perform some sharpening of their images. How much varies from camera to camera, and the sharpening amount can usually be adjusted by the user. This sharpening is employed partly to compensate for the blurring that is applied to even out color variations during the demosaicing stage (**Figure 2.7**).

Figure 2.7 This figure shows the same image sharpened two different ways. The image on the left has been reasonably sharpened, but the one on the right has been aggressively oversharpened, resulting in a picture with harsher contrast.

8-bit Conversion

Your camera's image sensor attempts to determine a numeric value that represents the amount of light that strikes a particular pixel. Most cameras capture 10–12 bits of data for each pixel on the sensor. In the binary counting scheme that all computers use, 12 bits allow you to count from 0–4,095, which means that you can represent 4,096 different shades between the darkest and lightest tones that the sensor can capture.

The JPEG format allows only 8-bit images. With 8 bits, you can count from 0–255. Obviously, converting to 8 bits from 12 means throwing out some data, which manifests in your final image as a loss of fine color transitions and details. Although this loss may not be perceptible (particularly if you're outputting to a monitor or printer that's not good enough to display those extra colors anyway), it can have a big impact on how far you can push your color corrections and adjustments.

JPEG Compression

With your image data interpreted, corrected, and converted to 8-bit, it's ready to be compressed for storage on your camera's media card. JPEG compression exploits the fact that your eyes are more sensitive to changes in luminance than they are to changes in color.

With JPEG compression, your image will take up far less space, allowing you to fit more images onto your camera's storage card. However, JPEG is a lossy compressor which means your image loses image quality. How much depends on the level of JPEG compression that you choose to apply.

On most cameras, the best level of JPEG compression is indistinguishable from an uncompressed image. However, you must be very careful to not re-compress a JPEG image. JPEG compressing an image that has already been through a JPEG compression process can increase the image quality loss to a level that is perceptible (**Figure 2.8**). You must keep this in mind through your JPEG workflow.

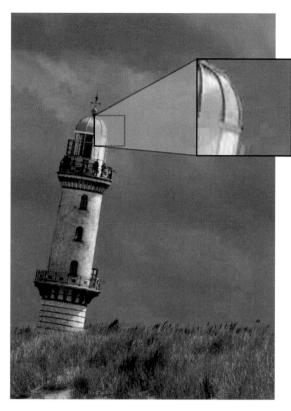

Figure 2.8 In this rather extreme example of JPEG compression, you can see the posterization effects that can occur from aggressive compression (or repeated recompression) as well as the blocky artifacts that JPEG compression can produce.

File Storage

Finally, the image is written to your camera's memory card. These days, many cameras include sophisticated memory buffers that let them process images in an onboard RAM cache while simultaneously writing out other images to the storage card. Good buffer and writing performance is what allows some cameras to achieve high frame rates when shooting in burst mode.

Your camera also stores important *EXIF* (exchangeable image file) information in the header of the JPEG file. The EXIF header contains, among other things, all of the relevant exposure information for your shot. Everything from camera make and model to shutter speed, aperture setting, ISO speed, white balance setting, exposure compensation setting, and much more is included in the file, and you can reference all of this information from within Capture NX (**Figure 2.9**).

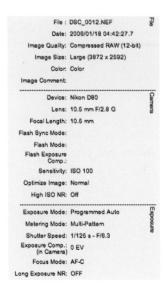

Figure 2.9 Capture NX allows you to look at the EXIF data of any image that you're browsing or editing.

HOW YOUR CAMERA MAKES A RAW IMAGE

It's much easier for your camera to make a raw file than a JPEG file for the simple reason that when shooting raw, your camera passes the hard work on to you. When shooting in raw mode, the camera does nothing more than collect the data from the image sensor, amplify it, and then write it to the storage card along with the usual EXIF information. In addition, certain camera settings such as white balance and any image processing settings are stored as well. It's your job to take that raw file and run it through software to turn it into a usable image.

A raw converter, such as the one included in Capture NX, is just a stand-alone variation of the same type of software that's built into your camera. With it, you move all of the computation that's normally done in your camera onto your desktop, where you have more control and a few more options.

Why should you do it yourself when you can get your camera to do it for you? Let's take a look at each image processing step to see why raw is a better way to go for many images.

Demosaicing

As mentioned earlier, the quality of a demosaicing algorithm often has a lot to do with the final image quality that you get from your camera. Demosaicing is a complex process, and a poorly demosaiced image can yield artifacts such as magenta or green fringes along high-contrast edges, blue halos around specular highlights, poor edge detail, or weird moiré patterns. Today, most cameras employ special circuits or digital signal processors designed specifically to handle the hundreds of calculations per pixel that are required to demosaic an image. Even though your camera may have a lot of processing power, it doesn't always have a lot of processing time. If you're shooting a burst of images at 5 frames per second, the camera can't devote much time to its image processing. Therefore, because time is often short and the custom chips used for demosaicing are often battery hogs, in-camera demosaicing algorithms will sometimes take shortcuts for the sake of speed and battery power.

Your desktop computer can afford to take more time to crunch numbers. Consequently, most raw conversion applications use a more sophisticated demosaicing algorithm than what's in your camera. This often results in better color and quality than your camera can provide when shooting in JPEG mode.

Colorimetric Interpretation

Just as your camera does when shooting in JPEG mode, stand-alone raw converters must adjust the image to compensate for the specific color of the filters on your camera's image sensor. This colorimetric information is usually contained in special camera profiles that are included with the raw software. If your software doesn't provide a profile for your camera, it can't process that camera's raw files.

Color Space

Just as your image data must be mapped to a color space when your camera shoots a JPEG file, your raw processor must map the colors in your image to a particular color space. Your raw converter lets you specify which color space you want to use. In addition to the sRGB and Adobe RGB color spaces that your camera probably offers, most raw converters provide choices such as ProPhoto RGB. You'll learn more about color space choice in Chapter 5, "Basic Image Editing."

White Balance

Good white balance is a tricky process, both objectively and subjectively. Objectively, calculating accurate white balance in a difficult lighting situation—say, sunlight streaming into a room lit with fluorescent light—can trip up even a quality camera. When working with raw files, you can adjust the white balance as you see fit, which can often mean the difference between a usable and an unusable image.

Subjectively, accurate white balance is not always the best white balance. Although you may have set the white balance accurately and achieved extremely precise color, an image that's a little warmer or cooler may actually be more pleasing. Altering the white balance of the image in your raw converter is often the best way to make such a change.

Even though your camera doesn't perform any white balance adjustments when shooting in raw mode, it does store the white balance setting in the image's EXIF information. Your raw converter, in turn, reads this setting and uses it as the initial white balance setting. You can start adjusting the white balance from there.

Gamma, Contrast, and Color Adjustments

As discussed earlier, when shooting JPEG, your camera performs a gamma adjustment to the image so that the brightness values are closer to what our eyes see when they look at a scene. When shooting JPEG, you can't control the amount of gamma correction that your camera applies, but when processing a raw image, you can easily adjust and tweak the gamma correction to have more control.

Similarly, although your camera may provide contrast, saturation, and brightness controls for JPEG shooting, these controls probably offer only three to five different settings. Raw converters provide controls with tremendous range and far more settings.

What's more, when working with raw files, Capture NX provides highlight recovery tools that allow you to perform corrections that simply aren't possible when you work with non-raw formats.

Noise Reduction and Sharpening

Just as your camera performs noise reduction and sharpening, your raw converter also includes these capabilities. However, like the gamma, contrast, and color adjustment controls, the noise reduction and sharpening controls of a raw converter provide much finer degrees of precision.

8-bit Conversion

Although your camera must convert its 12-bit color data to 8 bits before storing it in JPEG format (since the JPEG format doesn't support higher bit depths), raw files aren't as limited. With your raw converter, you can choose to compress the image down to 8 bits or to write it as a 16-bit file. Although 16 bits provides more number space than you need for a 12-bit file, the extra space means that you don't have to toss out any of your color information. The ability to output 16-bit files is one of the main quality advantages of shooting in raw. You'll learn more about why in Chapter 5.

File Storage

With a raw file, you can choose to save your final edited image in any of several formats. Obviously, you're free to save your image as an 8-bit JPEG file, just as if you had originally shot in JPEG mode, but most likely you'll want to save in a noncompressed format to preserve as much image quality as possible. And if you decide to work in 16-bit mode, you'll want to choose a format that can handle 16-bit images, such as TIFF.

One of the great advantages of shooting in raw mode is that you can process your original image in many different ways and save it in various formats. Thus, there might be times when you *do* want to save your raw files in JPEG format—as part of a Web production workflow, for instance. This doesn't mean that you've actually compromised any of your precious raw data, since you can always go back to your original raw file, process it again, and write it to a different format.

What's more, as raw conversion software improves, you can return to your original raw files, reprocess them, and possibly produce better results. Raw files truly represent the digital equivalent of a negative.

Why Not Shoot in TIFF Mode?

Before the development of raw, cameras worked around the problem of JPEG compression artifacts by offering an uncompressed TIFF mode. Many cameras still offer a TIFF option, but shooting in TIFF mode is a far cry from shooting in raw.

First, TIFF files don't offer the editing flexibility of raw files, and most cameras write 8-bit TIFF files, meaning that you don't get the high-bit advantage of raw. Second, TIFF files are typically much larger than raw files. Whereas a raw file stores only one 12-bit number for each pixel, TIFF files are demosaiced into a three-channel color image, meaning that they have to store three 8-bit numbers per pixel.

Third, the high-quality JPEG modes on most cameras are *very* good. In general, you probably won't be able to discern the difference between a well-compressed JPEG image and a TIFF image, so the storage space sacrifice will be of little value.

RAW CONCERNS

When compared side by side, it's easy to see that shooting raw offers a number of important advantages over shooting JPEG: editable white balance, 16-bit color support, and no compression artifacts. But as you've probably already suspected, there is a price to pay for this additional power.

Storage

Raw files are *big*. Whereas a fine-quality JPEG file from a 10-megapixel camera might weigh in at 3 MB, the same image shot in raw will devour 7–9 MB of storage space. Fortunately, this is not as grievous an issue as it used to be thanks to falling memory prices.

Workflow

One of the great advantages of digital photography is that it makes shooting lots of pictures very inexpensive. Thus, you can much more freely experiment, bracket your shots, and shoot photos of subjects that you normally might not want to risk a frame of film on. Consequently, it's very easy to quickly start drowning in images, all of which have unhelpful names like DSC0549.JPG.

Managing image glut is pretty easy with JPEG files since there are so many programs that can read them. In fact, both the Mac OS and Windows include JPEG readers.

With raw files, your workflow is a bit more complicated because a raw file doesn't contain any comprehensible image data until it has been processed: It's a little more difficult to quickly glance through a collection of raw images. Fortunately, both the Mac and Windows provide simple image viewers that let you look at raw files. These programs work by performing a simple automatic raw conversion, just like your camera does when shooting in JPEG mode.

However, because there's no set standard for the formatting of raw files, different vendors encode their raw data in various ways. Also, as you learned earlier, to perform a raw conversion, your raw conversion software has to determine certain things about the type of camera that was used to shoot the image, such as the colorimetric data about the colored filters on the camera's image sensor.

For these reasons, your raw conversion software must be outfitted with a special profile that describes the type of camera that produced the files that you want to convert. Unfortunately, these profiles have to be created by the software manufacturer. If your raw converter of choice doesn't support your specific camera model, you'll be unable to view and process raw files in that program.

Capture NX can process raw files from any Nikon camera that outputs NEF (Nikon Electronic Format) files. NEF files can contain raw camera data as well as non-raw data, just like a TIFF or JPEG file.

If you're shooting with a different type of camera, you won't be able to process your raw files in Capture NX. You'll need to process them using a different converter, save them as TIFF or JPEG files, and then bring the results into Capture NX when you want to edit them. We'll cover this process in more detail in the next chapter.

Shooting Performance

Because raw files are so big, the camera requires more time and memory to buffer and store them. Depending on the quality of your camera, choosing to shoot in raw mode may compromise your ability to capture bursts of images at a fast frame rate. In addition, your camera may take longer to recover from a burst of shooting, because its buffer will fill up quickly and take more time to flush.

If you want speedy burst shooting *and* the ability to shoot raw, you might have to consider upgrading to a camera with better burst performance.

IMAGE EDITING THEORY

Capture NX provides many powerful image editing features, and we'll explore them in detail in Chapter 3, "Interface and Basic Workflow" and Chapter 4, "Preparing to Edit." Although Capture NX provides innovative tools that make complex editing very easy, to get the most out of the program, you need to learn a few image editing basics.

The concepts this brief section discusses will help you more easily determine what edits and corrections your images need, and how to go about making them. What's more, these concepts—as well as the editing practices covered in the next two chapters—will greatly inform the way you shoot. Just as great film photographers know how to adjust their exposure decisions based on their understanding of their film and chemicals, as you learn more about the editing capabilities of Capture NX, you may want to alter the way you shoot. If you've used other image editing programs, you'll probably have already encountered much of the material in this section.

Color Information Theory

If you take this book into a windowless closet right now and close the door, you'll have a very difficult time reading this text. In a darkened closet, your eyes can't gather enough light to render a legible image. Similarly, if you take a walk in the park at night, although you may be able to navigate and see objects just fine, you probably won't experience a glorious display of color. Again, this is simply because your eyes are not able to gather enough light to render a color scene.

Your digital camera converts light into ones and zeros: data. Just as your eyes need a fair amount of light to be able to see an image and even more light to be able to see a color image, the amount of data that you collect with your camera determines the quality and nature of the image that your camera will produce.

A sculptor needs a good-quality piece of stone to create a good work, and as a digital photographer you need good data and preferably as much of it as you can possibly lay your hands on. Therefore, your goal when shooting is to gather as much image data as you can. An image with lots of data will not only look better straight out of the camera, but it will also afford you much more editing latitude. You'll be able to push and pull your colors further if your image is data rich.

It's essential to remember that the level of detail in an image is directly related to the amount of color information that you have. For example, **Figure 2.10** shows an image that was overexposed: The brighter areas such as the chrome highlights around the headlight were "blown out" to complete white. Because they're a mostly uniform color, those areas show very little detail. Contrast and varying colors and tones are needed to render contour and detail in an image. If your image lacks data, it lacks the varying shadows and highlights that are needed to render fine detail.

Figure 2.11 shows the same image properly exposed. Now if you look at the chrome highlights, you should see a fine gradation composed of lots of subtly varying gray tones. Similarly, the yellow fender should have a little more contour and shape to it. The correlation is very simple: where there's data, there's image detail; where there's no data, there's no image detail. (Underexposing an image can lead to the same problem, but instead of producing fields of white pixels, an underexposed image will have shadow areas that are composed entirely of black pixels.)

So how much is the right amount of color information? How do you keep track of it? How do you know if you've used it up? Fortunately, most image editors (and many cameras) provide a *histogram*, a simple tool that provides the answers to all of these questions. The histogram will quickly become your indispensable, irreplaceable, you-can-have-it-when-you-pry-it-from-my-cold-dead-fingers image editing tool.

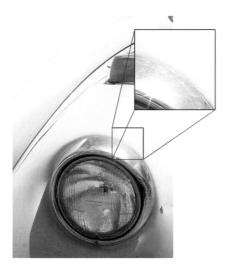

Figure 2.10 Because this image is overexposed, many of the bright highlights and brighter areas in the scene have "blown out" to white, resulting in a loss of detail.

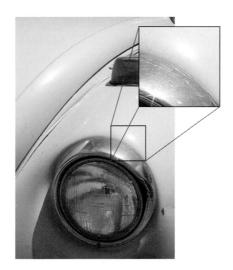

Figure 2.11 In a properly exposed image, the highlights are composed of varying shades of light tones rather than complete white.

Histogram 101

If you're not already familiar with an image editing histogram, read this section very closely. Although it may seem to veer dangerously close to something math-like, understanding a histogram is actually very simple.

A histogram is nothing more than a bar chart that graphs the distribution of tones in an image, with black at the left edge, white at the right, and one vertical bar for every tone in between. In other words, for every gray value in the image, from 0 gray at the left to 255 gray at the right, the histogram shows a bar representing the number of pixels with that value. For a very simple image like the one in **Figure 2.12**, the histogram contains only four lines: one at the extreme left edge, representing the black swatch; two in the middle for the two gray swatches; and one at the extreme right edge for the white swatch.

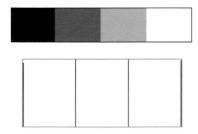

Figure 2.12 This simple four-tone image (top) yields a histogram (bottom) with four bars; one for each tone.

That's really all there is to a histogram. As an image becomes more complex, containing more tones, the histogram fills with more bars. **Figure 2.13** shows a simple grayscale ramp and its corresponding histogram.

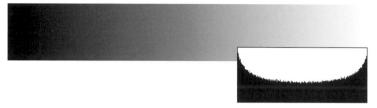

Figure 2.13 A histogram is simply a graph of the distribution of tones in an image. The histogram for this gray ramp shows a smooth distribution from black on the left of the histogram to white on the right.

Now consider some real-world examples. **Figure 2.14** shows a well-exposed image and its corresponding histogram. (The gray ramp beneath the histogram is provided to help you see that the histogram charts black to white.) The histogram shows that this image has a fairly complete range of tones from black to white. The vertical shape of the histogram is irrelevant—there's no "correct" shape that we're trying to achieve. Every image will have a uniquely shaped histogram because every image has a unique amount of varying colors. One of the important points we can learn from the histogram is that this image has a good range of contrast from complete black to complete white.

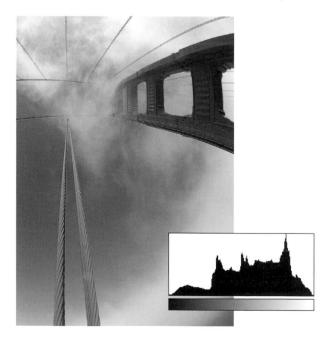

Figure 2.14 This figure is well exposed and so has a histogram that contains a lot of data ranging from black to white. However, neither end of the histogram is clipped at the edge. Instead, both the shadows and highlights make smooth transitions to complete black and white.

Figure 2.15 shows an overexposed image. On the left side of the histogram the data tapers off, dwindling to nothing by the time it reaches the leftmost, black end. On the other side, the image data slams into the right edge of the histogram, indicating overexposure, a situation referred to as *clipping*. Remember: Where there's pure white, there is no contrast and no information—no image data—and therefore no detail. Because the histogram shows a preponderance of pure white, it's safe to say that the image is overexposed and, therefore, has lost detail.

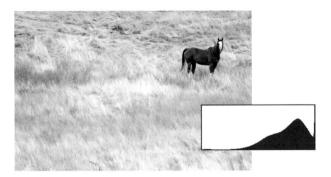

Figure 2.15 This image is plainly overexposed. Its histogram lacks data in the shadows and midtones, and the highlights are heavily clipped.

Figure 2.16 shows an underexposed image, and as you would expect, the results are pretty much the opposite of Figure 2.15. The histogram's data is piled up at the left side of the graph, indicating an undue number of pixels that have been reduced to featureless blobs of black. Although this image may not look so bad underexposed, there's no way to pull any detail back out of those solid-black shadow areas if you want to. Ideally, it's better to have a well-exposed image that you can darken later than to have a dark image (or an overly exposed bright image) with less editing flexibility.

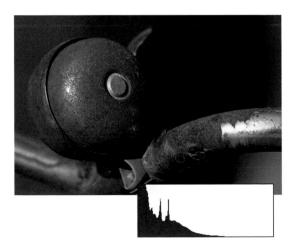

Figure 2.16 This underexposed image sports a histogram with the majority of its data crammed against the left, black side. Because the blacks are clipped, the shadows in this image are solid black, making it impossible to pull out any usable detail.

In addition to helping you spot overexposure and underexposure, your histogram can help you analyze other image troubles.

Contrasty Histograms

The human eye is much more sensitive to changes in luminance, or brightness, than it is to changes in color. Because of this, images that have more contrast are often more appealing (**Figure 2.17**).

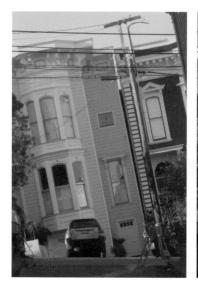

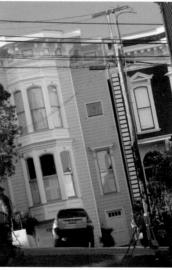

Figure 2.17
In general, images with greater contrast, such as the image on the right here, are more pleasing to the eye.

Because an image with greater contrast usually has more tones and gradations, it delivers better detail and subtlety. I say "usually" because an image *can* have great contrast between its darkest and lightest tones without having a lot of other tones in between (consider a black-and-white checkerboard). The histogram makes it simple to determine how much contrast your image has and how much data there is between your lightest and darkest tones.

If you look at the histogram for the low-contrast image in Figure 2.17, you see that the image data neither extends all the way down to black nor all the way up to white—it's collected in the middle. In other words, there's not a lot of contrast between the darkest and lightest tones (**Figure 2.18**).

Figure 2.18 Capture NX's histogram of the left image in Figure 2.17 shows that the image has no black or white tones. The distance from the darkest to the lightest tone is very short, showing low contrast.

By contrast (sorry!), **Figure 2.19** shows a well-exposed image. Its histogram shows data that extends all the way to both ends, yielding an image with a good range of detail from black to white.

Figure 2.19 This image was well exposed and has a good range of contrast. The histogram shows that the tonal range goes from black to white without clipping on either end.

Another way of thinking about the histogram is to describe it as showing how much information you've captured. The histogram in Figure 2.14 shows an image with a tremendous range of information (that is, gray levels), whereas the histogram in Figure 2.18 shows a much smaller quantity of information.

UNDERSTANDING NONDESTRUCTIVE EDITING

Unlike many image editing programs, Capture NX uses a *nondestructive* editing approach that provides an incredible amount of flexibility.

When you open an image in most image editing or painting programs, the image data is read into the computer's memory. The color of each pixel in the image is represented by a number, and when you edit any of the pixels in the image, their color values—and corresponding underlying numbers—are altered. When you save the image, the new numbers are written back to the original file. This type of editing is called *destructive editing* because the original pixel values are destroyed when you make editing changes (**Figure 2.20**). (Make sure you have saved a copy of your original file so that you can return to the original image if you need to.)

In a *nondestructive editing* process, your original image data is read into memory, but when you make an edit, the original pixel values are *not* altered. Instead, each edit is added to a

list of all of the edits that you have specified for that image. Any time the computer needs to display or output the image, the list of edits is applied to the original data. These edits are applied on the fly, whether you're displaying the images onscreen, printing to a printer, or saving to a file (**Figure 2.21**). Because your original pixel data is never altered, you can remove or alter any edit at any time and in any order.

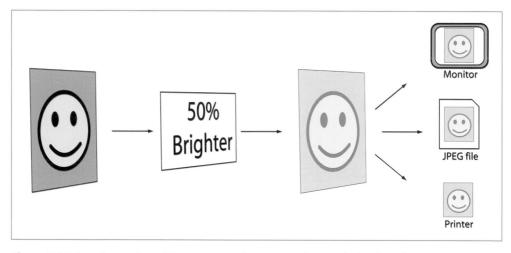

Figure 2.20 In a *destructive* editing process, when you make an edit (such as the brightening edit shown here), the pixels in your image are changed. When you output to a screen, printer, or file, those new, changed pixels are sent to the relevant device.

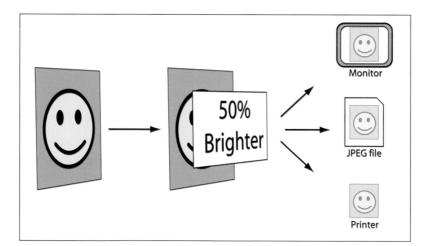

Figure 2.21 In a *nondestructive editing* process, any edit is simply added to a list of edits to be applied to the original image data. When you output to a screen, printer, or file, those edits are applied in real time as the image data is moved to the relevant device.

Some programs provide both destructive and nondestructive editing. Photoshop's Brush tool, for example, performs destructive changes to your image—it alters the original pixels; however, Photoshop's adjustment layers are completely nondestructive—their effects are applied in real time.

Capture NX, by contrast, provides only nondestructive editing tools. All of the edits that you make in Capture NX are stored in the Edit List palette (**Figure 2.22**). At any time, you can view and alter any of these edits by simply clicking on the reveal arrow to the left of the edit name. You can also completely remove an edit by unchecking the edit's check box. This edit list is applied on the fly to your image data as the image is written to the screen or printed.

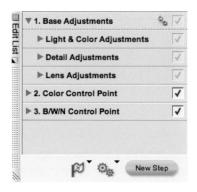

Figure 2.22 Capture NX's Edit List palette stores every edit that you make to your image. You can deactivate or alter any edit at any time, and if you save in NEF format, your edit list will still be there the next time you open the file. This is the advantage of nondestructive editing.

You have two options when you save your image. If you want to preserve your edit list (so that you can return to it later to refine or alter your edits), you'll need to save your image in NEF format. Although many people think that a NEF file means that the image is a raw file, the NEF format can actually hold far more than just raw data. NEF files can hold normal processed image data—just like you'd save in a TIFF file—along with the list of edits that you create in Capture NX. NEF is an all-purpose container that can hold all of the data that Capture NX needs to store, from raw information captured by your Nikon camera to edited images complete with alterable edit lists.

If you want to view your image in an application other than Capture NX, save it as a JPEG or TIFF file. These are standard raster file formats that are compatible with almost any image editing program. However, JPEG and TIFF files *cannot* preserve your edit list. If you save an image out of Capture NX as a JPEG or TIFF file, when you open the image again, your edit list will be empty. Consequently, you should save both NEF and JPEG or TIFF files of your image. You'll use the NEF file as your master, editable image, and your JPEG or TIFF file for distribution or for editing your image in another application.

You'll explore saving and editing in much more detail in Chapter 5.

CHAPTER THE Interface and Basic Workflow

When you learn a new editing technique in a chemical darkroom, you usually have to learn some new theories and concepts. But some techniques also require you to practice a lot of manual dexterity. With digital editing, your computer provides you with instant craftsmanship, so you don't have to spend a lot of time (and expensive materials) practicing particular types of exposure manipulations, retouchings, or difficult compositing tricks. Nevertheless, it still takes time to learn all of the ins and outs of a complex editing system.

Fortunately, Capture NX's interface is very streamlined and straightforward, and you should find that once you've learned a few basic concepts you can quickly get up to speed on all of the program's features.

Your postproduction consists of much more than simply making color corrections and image edits. Sorting through your images, organizing them, and finding the images that are worthy of further editing is also a huge part of your postproduction cycle. In this chapter, we'll take a quick look at Capture NX's interface, and then explore what makes a good postproduction workflow plan and how Capture NX facilitates that plan. Along the way, you'll learn how to use Capture NX to organize and rename your image files.

INTERFACE OVERVIEW

You've probably already spent a little time working with Capture NX and so should be familiar with its interface. Just to be sure that you understand the terms and interface concepts that we'll be working with, let's take a quick look at the program's basic interface structure.

Capture NX's interface is made up of a series of interlocking palettes (**Figure 3.1**) that can be easily opened and closed using the toggle button located in the upper corner of each palette (**Figure 3.2**).

You can also completely hide and show a palette by choosing its name from the Window menu.

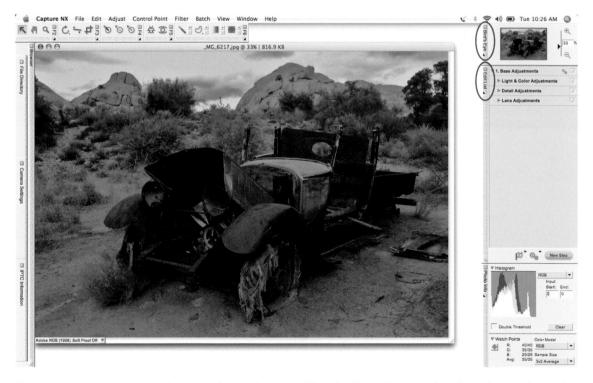

Figure 3.1 Capture NX's interface is made up of a series of interlocking palettes and toolbars that can be easily opened and closed or hidden entirely. You can also drag any palette to undock it and move it to a new location.

Figure 3.2 You can open and close any Capture NX palette by clicking the toggle in the upper corner of the palette, just above the palette name.

Tool palettes

Just below the menu bar is a row of small tool palettes, which you can toggle on and off by pressing the function key displayed on the right side of each palette. The palettes are "docked" together, but you can easily undock them by clicking the small arrow in the lower-right corner of each palette. When a palette is undocked, it turns into a movable, floating palette that you can reposition anywhere onscreen. Note that each tool palette contains a different category of tools. From left to right you'll find a palette of navigation tools—pointer, grabber hand, and magnifying glass; a palette of crop, straighten, and rotate tools; eyedropper tools; control point tools; and masking tools (**Figure 3.3**). Because the tools are grouped together, you can easily turn off any palette to free up more screen real estate, leaving visible only the palettes that are necessary for your chosen edits.

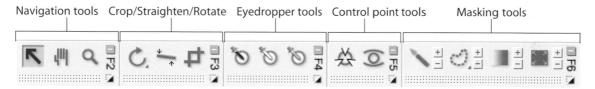

Figure 3.3 The Capture NX toolbar is divided into a series of smaller toolbars that you can hide, show, or reposition to customize the NX interface. Each subtoolbar contains a different category of tool.

Browser

On the left side of the screen are a group of related palettes and the Browser, as well as the File Directory, Camera Settings, and IPTC Information palettes.

The Browser palette displays the contents of the current directory, and the File Directory palette lets you choose the directory you want to look at. These palettes can be opened together or separately, as shown in **Figure 3.4**.

Figure 3.4 The Browser and File Directory palettes can be opened simultaneously. Use the File Directory palette to navigate to the folder you want to browse, and then view its contents in the Browser palette. Note that you can also resize the Browser palette using the resize box in the lower-right corner.

Because the File Directory and Browser palettes are independent, you can maximize your screen space by only opening the Browser palette when you need it. So you can use the File Directory palette to navigate to the folder you want to work with, and then close the File Directory palette and work with the folder in the Browser palette.

At any time, you can also open the Camera Settings palette to view the EXIF metadata of any file you select in the Browser, or open the IPTC Information palette to view the IPTC tags of the currently selected files (**Figure 3.5**).

Image editing

On the right side of the screen, you'll find another set of palettes that are used for image editing. You'll use the Bird's Eye palette for navigating your image, the Edit List for adding edits to your image, and the Photo Info palette to view various pieces of essential image data while editing.

Finally, there's the Color Picker palette, which by default is not visible (**Figure 3.6**).

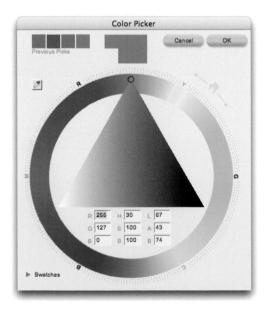

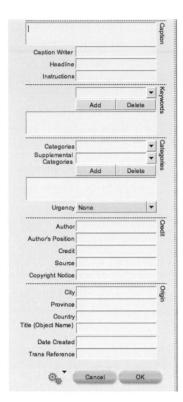

Figure 3.5 Capture NX's IPTC Information palette lets you view and edit the IPTC metadata of the selected image.

Figure 3.6 By default, Capture NX's Color Picker is not visible, but you can easily activate it from the Window menu any time you need it.

Many palettes have additional controls and functions, and Capture NX has a few more important interface elements—such as the Batch dialog box. We'll explore all of these details throughout the rest of the book. Let's begin by taking a look at the File Directory, Browser, and IPTC palettes, as we explore the concept of workflow.

DEFINING A WORKFLOW

These days, there are lots of programs that allow you to make very complex, sophisticated edits to your images. But image editing is a small part of your overall job as a photographer. Although you can use your image editor to correct technical flaws in your images, no amount of image editing can turn a poorly shot—or even just boring—image into a well-shot, exciting scene.

Deciding which images are the keepers and which of those keepers need editing can take time. What's more, you *don't* want to spend time editing images that ultimately won't make the cut into your final selection. Fortunately, with a little planning you can make your postproduction workflow easy, and Capture NX can help.

Basic Workflows

You can fairly easily break down the most complex post-production workflow into six simple steps (**Figure 3.7**):

- 1. Import your images.
- **2.** Add metadata to your imported images (ownership, copyright, and keywords).
- **3.** Cull the select images from your imported batch and rate them accordingly. (Some people call these the "pick" images or "hero" images.)
- **4.** Edit your selects as need be.
- 5. Output your images.
- **6.** Archive your images.

This workflow is very straightforward, and though we'll be looking at each step in more detail, you probably already have a pretty good idea of how to do each of these six steps. It's important to notice that in this workflow

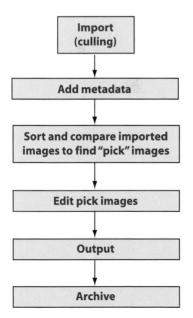

Figure 3.7 Most workflows can be broken down into these six steps.

you don't perform *any* image editing until you've culled your images down to your selects. Image editing can be time-consuming, so you don't want to bother with corrections unless you're confident that an image is a keeper.

However, the real world is often more complicated, and if you're like me, you might find yourself too impatient to perform *all* of your sorting before you start any editing, so you might do some steps out of order. Or, if you're on assignment, the final decision of which images are keepers may not be up to you. In these instances, your workflow might look more like this (**Figure 3.8**):

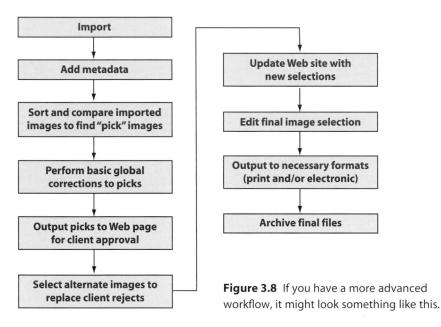

- 1. Import your images.
- 2. Add your copyright and ownership metadata.
- **3.** Cull your imported images to find your selects.
- **4.** Perform basic, global corrections to the selects that need some adjustment.
- **5.** Create a Web site or slide show of your roughly edited selects to show to your client for approval. If the client doesn't like some images, you'll need to remove them. If the client asks for alternatives, you'll need to go back to your original image batch and try to find alternate images. This "selection/presentation" cycle may occur several times.

- **6.** Edit your final batch of selects. These edits might be more involved.
- **7.** Output your images. You might have to output to several different media—perhaps a Web site for final client review followed by delivery of final electronic files or even prints.
- **8.** Archive your images.

Many tools and functions are available to help you through each of these steps, whether you're working through a basic workflow or a more involved process. In the following sections, you'll learn more about each of these high-level steps, so that you can rearrange these processes into an order that works well for your needs and preferred way of working.

Importing

You can import your images directly from your camera using a cable connection to your computer. However, if you've been out on a busy day of shooting, you probably have additional cards as well as the one in your camera. Also, importing from your camera uses up your camera's battery power, which can be an issue if you're on an extended shoot with no access to electricity. In addition, your camera may not provide especially speedy download throughput. For all of these reasons, it's usually best to import your images using a card reader.

Card readers come with either USB-1 or 2, or FireWire interfaces. USB-2 or FireWire is your fastest option. These days, you can get inexpensive card readers that can read several different media formats.

Capture NX does not provide any importing capabilities of its own. Instead, it expects you to depend on your operating system to perform your initial image transfer. Depending on your OS of choice, the details of importing will differ slightly, but you should find the procedure very easy no matter which OS you use.

Mac OS

If you use the Mac OS, your card reader will appear on your desktop just like any other type of drive or volume. However, depending on how your Mac is configured, it may automatically launch a specific application when it detects a card reader or camera. This behavior can be controlled from several different places.

The easiest way to configure how your Mac responds to a card reader is to use the Image Capture application stored in your Applications folder (**Figure 3.9**).

Figure 3.9 Mac users will find Image Capture, a standard part of every OS installation, stored in their Applications folder.

To change your card reader preferences:

- 1. Launch Image Capture.
- **2.** Select Image Capture > Preferences or press Command-, (comma).
- **3.** In the resulting dialog box (**Figure 3.10**), you can use the "When a camera is connected" option to select a specific application or No application.

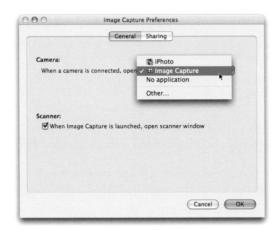

Figure 3.10 You can use Image Capture's preferences to specify what your Mac should do when you plug in a camera or card reader.

By default, your Mac is probably configured to launch Image Capture or iPhoto. If you select "No application," the card will appear on your desktop when you insert it. You can then begin manually copying images using the Finder, just as you would copy any other type of file.

This technique works fine and is often the speediest way to begin your workflow, because you can simply pull over all of the images from each of your cards and then sort through them later.

However, you might also want to consider using Image Capture, simply because it allows you to selectively import images from your media cards. If Image Capture is set as your application of choice, when you insert a media card or connect a camera, you'll see the dialog box shown in **Figure 3.11**.

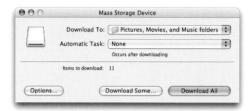

Figure 3.11 When you insert a card, Image Capture launches and displays this dialog box.

If you click the Download Some button, Image Capture presents you with a dialog box that allows you to select the images from the card that you want to import. You can select a range of images that you want to download by Shift-clicking multiple images (**Figure 3.12**). Note that you cannot Command-click images to select a noncontiguous range of images.

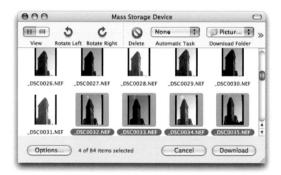

Figure 3.12 In Image Capture, you can select only the images that you want to transfer.

Being selective about which images you choose to import will serve as an initial sorting of your images. You can weed out any accidental shots (lens caps, your fingers, and so on) or other images that are blatantly unusable. By using the Thumbnail Size slider at the top of the window, you can elect to view fairly large thumbnails. However, since Image Capture doesn't provide Zoom tools or other features for making a refined, accurate assessment of an image, if you're at all uncertain about whether or not to import an image, it's usually best to elect to keep it. You can always delete it later.

Image Capture has some other handy features. The Download Folder pop-up menu lets you choose a download location, and the Options button lets you automatically delete the selected image after transferring, build a thumbnail of the image for the file's icon, add the image's EXIF data to the Finder's comment field, and embed a ColorSync profile (**Figure 3.13**).

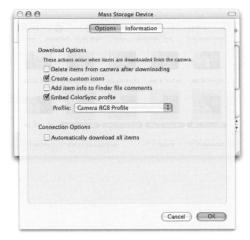

Figure 3.13 Image Capture provides a number of handy options that you can apply to your images during transfer.

Additionally, Image Capture allows you to perform a lossless rotation of your image and automatically crop or launch a script upon import. All of these features make for a powerful importing tool.

Using NX with iPhoto and Aperture

Apple's iPhoto and Aperture applications also have the ability to import images, and either one can be set to launch automatically when a card or camera is attached to your Mac. However, both programs maintain an internal library structure that they use as the basis of their own nondestructive image editing architectures. Working Capture NX into an iPhoto workflow is a little complicated, because you'll need to use iPhoto's export facility to export your images for use in Capture NX. If you're using Aperture, you can set Capture NX as an "external editor" and use Aperture's Open in External Editor command to automatically "round-trip" your images into Capture NX. See the Aperture Help facility for more information.

Windows

Windows treats a card reader just like any other type of external drive. Plug the reader into your PC and you'll be able to copy your images into any folder on your computer. When you plug in your card reader, Windows should automatically launch the Scanner and Camera Wizard, a simple app that helps you transfer your images (**Figure 3.14**).

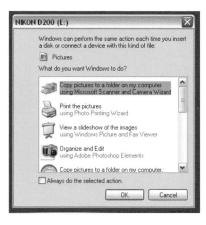

Figure 3.14 The Windows Scanner and Camera Wizard lets you easily transfer images from a card reader or directly from your camera.

Simply follow the instructions onscreen to select the images that you want to copy. The wizard asks you to define a destination directory and then copies the images for you (**Figure 3.15**). Because you can select only the images you want to copy, the Camera Wizard can serve as the first selection step in your workflow.

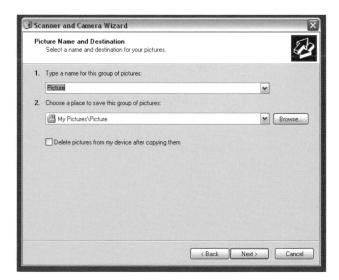

Figure 3.15 After you select the images you want to copy, you select a destination directory, and the Camera Wizard copies your images to that directory.

Using Lightroom for Mac and Windows

Adobe Photoshop Lightroom maintains an internal library structure, which it uses to facilitate its own non-destructive image editing architecture. Images can be imported into Lightroom's internal library, or imported as references, leaving the original files in their current location on your drive. However, once you've imported an image into Lightroom, you need to launch it into Capture NX from within Lightroom. If you try to work with the original file in Capture NX directly, the thumbnails that appear in Lightroom might end up incorrect and out of date.

Lightroom provides a special command for sending an image to another application. Select the image in Lightroom and then click the Develop button to move into Lightroom's Develop module. From the Photo menu, choose "Edit in Other Application" and then select the application that you want to use to edit the selected image.

You can also use Lightroom's Preferences dialog box to change the "Edit in Other Application" command to a specific "Edit in Capture NX" command. On the General tab of Lightroom's Preferences, change the Additional External Editor parameter to point to Capture NX (**Figure 3.16**).

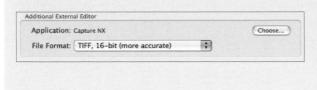

Figure 3.16 If you use Photoshop Lightroom, you might want to consider configuring Lightroom's Additional External Editor preference to point to Capture NX, which will provide you with an easy way to move images from Lightroom into NX for editing.

Backing up your image master

After you've copied your entire shoot's worth of images to your drive, it's a good idea to back up all of your original image files. Not only will this give you a backup set in the event of a hard drive crash, but it will also ensure that you have an original set of images in case you end up making changes or edits that you can't back out of. Some photographers find it useful to preserve the original camera-generated names, since these names are guaranteed to be in the order that the images were shot. By backing up your files, you'll have one set of images with your original camera-generated names, allowing you to freely rename the images on your drive as you please.

Organizing your image files

After copying the files to your drive, you may want to organize them into folders to ease your sorting and organizational chores. If you were *very* organized while shooting and kept separate cards for specific parts of your shoot (and you know which cards are which), you can simply import the images on these cards into specific folders. More often than not, you'll have to reorganize your images into subfolders after you've copied them to your drive.

For example, if you've just come back from shooting landscapes at the Grand Canyon and have copied all of your images from the shoot into a folder called "Grand Canyon, 2006," you might want to create subfolders for different parts of your expedition and for different subject matter. So, you might create folders for "North Rim," "South Rim," "Havasupai," "Sunsets," "Descent," "Ascent," and "Canyon Floor." Or, maybe it makes more sense for you to organize your images by day, so you could create folders for "Monday—April 12," "Tuesday—April 13," and so on.

Importing from Multiple Cards Simultaneously

If you're a very heavy shooter and routinely need to transfer images from large batches of cards, you might want to consider investing in a multislot card reader that allows for the simultaneous transfer of images from multiple cards. Lexar makes a Professional CompactFlash Reader that can be stacked, allowing you to plug multiple card readers into your computer simultaneously. If you come back from a shoot with lots of cards, using multiple card readers will be the fastest, most efficient way of transferring your images.

Whether you're a Mac or Windows user, Camera Bits' Photo Mechanic is an excellent tool for reading simultaneously from multiple card readers.

Browser organization

The Capture NX Browser simplifies file organization because it lets you see thumbnails of the images in a folder, and it lets you make subfolders and move files.

To reorganize a folder, begin by opening the folder you want to organize in the Capture NX Browser. Try the following:

- **1.** Open the File Directory palette by clicking the + button of the palette. If the File Directory palette is not visible, select it from the Window menu.
- **2.** In the File Directory palette, navigate to the folder you want to work on and click on it once to select it (**Figure 3.17**).

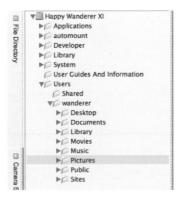

Figure 3.17 You use the File Directory palette to select the folder that you want to examine in the Browser.

3. Open the Browser palette by clicking the + button in its upper-right corner.

TIP: You can also open a folder in the Browser by choosing File > Open Folder in Browser, which lets you use the standard Open dialog box to navigate to the folder you want to open.

The Browser palette opens, allowing you to see the contents of the folder, including images with thumbnails and any existing subfolders. Note that the Browser does not display any documents that are unreadable by Nikon Capture NX. That includes incompatible image file formats, as well as text files, applications, or any other documents, providing you with a very uncluttered view of your folder. However, if you're shocked to find that some images that you thought you had copied over are not visible, don't panic. Most likely the images are simply in a format (such as a non-Nikon raw format or PSD files) that Capture NX doesn't recognize, so it hides the images.

By default, Capture NX displays your images by filename in alphabetical order. You can choose to sort in ascending or descending order by clicking the word "Alphabetical" in the status bar at the top of the Browser pane. The status bar also shows the number of images in the current folder and the path to the selected image. On the right side of the status bar, you'll find simple arrow controls for navigating forward and backward through the folders you've been using, much like the forward and back buttons in a Web browser (**Figure 3.18**).

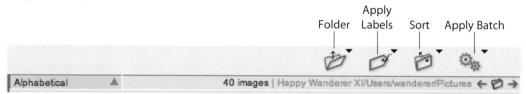

Figure 3.18 At the top of the Browser palette, you'll find navigation buttons for navigating up and down the file path that you've traversed. These work just like the forward and back buttons in a Web browser.

Browser views

The Browser toolbar provides two other ways to view the images in the folder. At the top of the Browser are four menus.

From the Folder menu you can select View > Light Table to view the current folder as a grid of thumbnails. At first glance, this doesn't look much different from the Rows view that Capture NX defaults to.

The advantage of Light Table view is that you can use the Bird's Eye palette to navigate the Light Table and to change thumbnail size (**Figure 3.19**).

Figure 3.19 When using the Browser palette in Light Table view, the Bird's Eye palette provides an easy way to navigate.

If you're working with an especially large folder of images, Light Table view can make navigation much simpler.

From the Folder menu you can select View > Details to see the contents of the folder displayed as a list with thumbnails, name, date, time, and size (**Figure 3.20**).

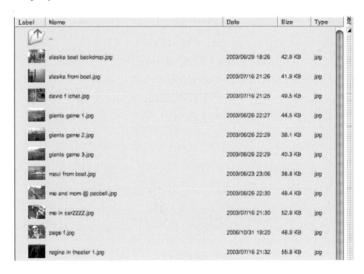

Figure 3.20 Details view provides you with a thumbnail, image name, date, and size data for each image in the current folder.

There's no right or wrong view to use when organizing your images, so you can freely switch between views as you work.

Zoom tool

To get a larger view of a thumbnail, click the Zoom tool in the Capture NX toolbar (it's the tool that looks like a magnifying glass) and hold it over any thumbnail. A larger preview image will appear superimposed over the Browser palette. Click in any gray part of the Browser palette to dismiss the preview image. You can then hover over another image to view it.

Moving files within the Browser

The Browser not only lets you view the images in a folder, it also lets you create new folders and move files around, making it a one-stop organizational tool.

Try moving some images into a subfolder.

- 1. From the Folder menu at the top of the Browser, select New Folder. Capture NX creates a new subfolder inside the folder you're browsing. Capture NX keeps all subfolders grouped together at the top of the Browser window, so you won't need to scroll through your images to find the new folder.
- **2.** In the Browser, click once on the folder's name to make the name editable. Enter a new name and press Return to rename the folder.
- **3.** Select the images that you want to move into the subfolder. Capture NX lets you select contiguous images by Shift-clicking and noncontiguous images by Command/Control-clicking.

TIP: You can change the size of the thumbnails displayed in the Browser by using Capture NX's Zoom in and Zoom out commands found on the View menu. Or you can use Command/Control+ to zoom in and Command/Control- to zoom out.

- **4.** Click on the images and drag them to the new subfolder. As you drag, small thumbnails appear superimposed over your cursor. Note that Capture NX does *not* highlight the destination folder when you mouse over it.
- **5.** Verify that your images moved by double-clicking the subfolder to open it.

Capture NX always displays a "navigate up one level" icon in the upper-left corner of the Browser (**Figure 3.21**).

Figure 3.21 The Browser palette always displays this icon in the upper-left corner. You can navigate up one folder level by double-clicking the icon.

You can double-click this icon to navigate up one level in your folder hierarchy or use the Next and Previous buttons on the right side of the status bar to navigate forward and backward through the folders you've been working with.

Using these tools, you can easily create all the subfolders that you need and rearrange your images accordingly.

Renaming your image files

Your camera generates fairly meaningless names. However, because Capture NX displays icons of your images, accurate filenames are not so critical, since you can always determine the content of an image by simply looking at its icon. Still, you might want more meaningful names if you intend to work with your files in other applications or move or manage them in your OS file browser.

To rename any image in Capture NX, simply click on the image in the Browser to select it, click once on its name, enter a new name, and then press Return.

Batch Renaming

A few programs provide batch renaming functions that let you rename entire folders full of images. These features usually allow you to automatically append your renamed images with sequential numbers. Adobe Bridge, which is bundled with Adobe Photoshop CS2 and the Adobe Creative Suite, provides a Batch Rename feature. Bridge is compatible with both Mac and Windows, and so is a good option for bulk renaming. Camera Bits' Photo Mechanic is another cross-platform application that provides powerful, speedy batch renaming operations.

If you're a Mac user, you can use my free Photo Renaming Actions for Automator, which lets you automatically batch rename. What's more, you can automatically include IPTC or EXIF data in your renamed files. You can download these actions from www.completedigitalphotography.com/?p=443.

For Windows users, Google's free Picasa browser provides batch renaming features in addition to organizing and management tools.

Choosing selects—rating your images

With your files imported, backed up, organized, and renamed, you're ready to start culling them to find the select images that you want to edit and output. In simplest terms, this process is fairly easy. You look at each image and decide which ones are the keepers. You tag them in some way, and then filter out those tagged images later. Capture NX provides a number of tools to help you with this process.

You'll perform most of your corrections in the Browser palette, using the image thumbnails that Capture NX displays. To make your selects, look through the images and find the ones that you want to mark as select, or pick, images.

TIP: Your camera should automatically add a rotate tag to any image that you shoot in Portrait orientation. Capture NX can read this tag and automatically rotate your images in the Browser. If a thumbnail is not showing a rotated image, use the Rotate tool on the toolbar to rotate the thumbnail. By default, the tool is set to rotate clockwise. If you want to rotate counterclockwise, click and hold the Rotate tool to open its menu. Select "Rotate 90 degrees CCW" to select the other Rotate tool.

Evaluating select images

What should you look for when searching for your select images? Good composition and subject matter will probably be the first characteristics that attract your attention. When you see an image that you like, you'll then want to assess:

- **The sharpness of the image.** Is it in focus? If it's soft, is the softness slight enough that the image can be sharpened with Capture NX's Sharpening feature?
- The exposure of the image. Is the image well exposed? Are the highlights blown out? Are the shadows too dark? Does the image have the detail, color, and tonal qualities that you want?
- Any problems with the image. Does the image suffer from noise problems?
- The data in the image. Does the image provide the data that you need for the types of edits that you want to perform? This is especially true when evaluating raw images. We'll discuss this topic in more detail in Chapter 5, "Basic Image Editing" and Chapter 6, "Advanced Image Editing."

Comparing images

Many of the preceding questions can't be answered from looking at a small thumbnail. Also, if you tend to bracket your shots a lot or shoot in bursts, you may find that you have to choose among several very similar images. To help with both of these issues, the Capture NX Browser lets you view selected images side by side.

- 1. Select at least two images in the Capture NX Browser.
- **2.** Choose View > Compare > Compare in Browser.

Capture NX superimposes larger versions of the images over the Browser window (**Figure 3.22**). The size of these images will vary depending on the number of images you've selected. You can't label or manipulate any of the previews, because they are only for comparing larger views of your selected images. When you've finished evaluating the images, choose View > Compare > Compare in Browser to return to the normal Browser view.

TIP: You can also access Compare mode by selecting two images and right-clicking on one of them. Select Compare Images from the pop-up menu that appears.

If you have only two images selected, you can select View > Compare > Compare in Editor to automatically open both images side by side in Capture NX (**Figure 3.23**). With the images open, you'll have access to all of Capture NX's tools, including the ability to zoom in and out. If the images are large, it may take a while to load them, so this is not a fix for getting a very quick view. But if you simply can't make your decision without seeing a very close-up view or a histogram, this command provides a quick way to open both images simultaneously.

TIP: Although Nikon has not supplied keyboard shortcuts for the Compare in Browser and Compare in Editor features, you can create them using any kind of macro program that works with your operating system. For example, on the Mac you can use Startley Technology's QuicKeys to create a keyboard shortcut for a menu item (the Mac's built-in keyboard shortcut creator won't work with Capture NX's submenus). On Windows you can use programs such as xStarter or MacroExpress.

Figure 3.22 Compare view superimposes the images you've selected over the Browser window, providing a better view for comparing image content.

Figure 3.23 The Compare in Editor command automatically opens two documents in Capture NX.

Rating your images

Capture NX lets you apply a rating of 1 to 9 to any of your images. To assign a rating, select the image you want to rate and then press any number from 1 to 9.

Depending on how you like to organize your images, you might not need such a "granular" degree of rating control. Many people simply want a binary rating system—either an image is a select or it's not—which you can easily achieve by simply using one rating for all of your selects.

You can also apply a rating of 1 to 3 by choose a rating from the Apply Labels menu at the top of the Browser pane (**Figure 3.24**).

Figure 3.24 You can apply a label to the currently selected images by selecting a label from the Apply Labels menu on the Browser toolbar.

As you can see, Nikon offers the suggestion of 1 for "Good," 2 for "Maybe," and 3 for "Bad." If you don't like these names, you can change them using the Customize Label Names command shown in Figure 3.25.

If you want to change a rating for an image, just apply a new rating. To remove a rating, press 0 or choose Remove Label from the Apply Labels menu. If multiple images are selected, the rating will be applied to all of the selected images.

Images that have ratings are shown with a colored border in the Browser. Good images have a red border, Maybe images have an orange border, and Bad images have a yellow border (**Figure 3.25**).

Figure 3.25 Labeled images have colored borders. In this case, red for Good, orange for Maybe, and yellow for Bad. The Customize Label Names command lets you alter the colors attached to each label.

Changing views

If you've renamed your files in such a way that an alphabetical view no longer displays related images next to each other, you might want to change to a date view, which lists the images in the order in which they were shot. In the Capture NX Browser, choose Date from the Sort menu at the top of the Browser window. Your images will be reordered into sequential order by date. You can then toggle the Date button in the upper-left corner of the toolbar to switch between ascending and descending order.

Now try this: Choose By Label from the Sort menu at the top of the Browser window. Capture NX changes the Browser display.

All of your unrated images will remain in the upper half of the display, whereas rated images will appear in their own section below. There is a separate section for each rating, allowing you to easily see all of the images that you have placed in each ratings category (**Figure 3.26**).

Figure 3.26 If you choose to view by label, Capture NX will show your labeled images in the bottom half of the Browser palette, separated by label type.

When viewing by label, you can continue to reassign ratings. Select the image whose rating you want to change and assign a new rating just like you did before.

TIP: You can also change the rating of an image by dragging and dropping it into a different rating section in the Browser.

As you can see, viewing by label gives you a quick way to browse your select images. You'll be using this view a lot once you start editing.

Adding IPTC metadata

In Chapter 2, "Basic Theory," you learned about EXIF metadata, the exposure and camera parameter details that your camera stores inside every image that it shoots. This data sits alongside the image data and can be read by any image editor that understands the EXIF metadata protocol. EXIF metadata cannot be edited.

However, another type of metadata, called IPTC metadata, was intended to be entered by the user and was designed to hold all of the author, copyright, keyword, and organizational information that a publisher or photographer might want to store with the image.

In Capture NX, you edit the IPTC metadata of an image through the IPTC Information palette (Figure 3.5).

Editing IPTC metadata is very straightforward:

- 1. Select the image whose IPTC metadata you want to edit.
- 2. Enter the metadata in the metadata fields in the IPTC Information palette.
- **3.** When you're finished, click the OK button to save the metadata in the image.

To avoid the repeated entry of keywords and categories, Capture NX lets you create a list of entries. For example, to enter a keyword:

- 1. Select the image or images that you want to add the keyword to.
- **2.** In the Keywords section of the IPTC Information palette, enter the keyword you want to add (**Figure 3.27**).

Figure 3.27 To add a keyword to an image, enter it in the Keyword field of the IPTC Information palette.

3. Click the Add button to add the keyword. It will appear in the Keywords list for that image.

In the future, you can select that keyword from the pop-up menu next to the Keyword field.

As you may have noticed, the Categories feature works the same way. As you enter more categories and keywords, you'll slowly build up a list of used categories and keywords, making it easy to ensure the use of consistent entries as you work on more images.

Defining metadata settings

You can add metadata to multiple images by selecting all of the images whose metadata you want to alter and then editing the metadata appropriately. However, you'll probably find that you routinely want to add the same metadata to an image—your credit and copyright information, for example. To ease your repeat metadata chores, Capture NX lets you define metadata settings, which can serve as templates that can be easily applied to other images.

To create metadata settings:

- 1. Select an image whose metadata you want to edit.
- **2.** Fill in the IPTC Information palette appropriately. Obviously, some fields are specific to an individual image, such as caption, headline, title, and date created. Leave these fields blank for now.
- **3.** From the Batch menu at the bottom of the IPTC Information palette, choose Save Settings (**Figure 3.28**).

Figure 3.28 You can save IPTC presets using the Save Settings command located in the Batch menu at the bottom of the IPTC Information palette.

- **4.** In the resulting dialog box, enter a name and click OK. Your metadata settings are stored.
- **5.** Click OK in the IPTC Information palette to apply the settings to the selected image. If you don't want to apply the metadata to this particular image, press Cancel.

Applying your metadata settings template to other images is very simple:

- **1.** Select the images you want to apply the template to.
- **2.** From the Batch menu at the bottom of the IPTC Information palette, choose Load Settings > Browse. The resulting dialog box should already be pointed to your Settings folder. Select the settings file that you saved earlier, and click OK. The metadata settings will be loaded, and the fields in the IPTC Information palette will be filled in accordingly.
- **3.** Click OK to save the metadata into the images.

TIP: Create a metadata setting for your copyright and credit information. For example, enter "Copyright © 2007 by <your name>" in the Copyright Notice field and your name in the Credit field. If you regularly shoot in particular locations or on particular types of jobs, create templates that contain those locations or categories. You can then easily apply your base metadata.

After applying a metadata template, you're free to go back and enter the image-specific metadata for each image.

Copying metadata

You can also use the commands in the Batch menu to copy metadata from one image to the other:

- 1. Select the image in the Browser that contains the metadata that you want to copy.
- **2.** From the Batch menu at the bottom of the IPTC Information palette, choose Copy Settings.
- 3. Select the images in the Browser that you want to apply the copied metadata to.
- **4.** From the Batch menu at the bottom of the IPTC Information palette, choose Paste Settings.
- **5.** Click OK in the IPTC Information palette to save the metadata.

It isn't always worth going to the trouble of making a template. Sometimes you just need to move some data from one entry to another. For these instances, copying and pasting is the fastest way to assign metadata to multiple images.

"Does IPTC Metadata Really Matter? Entering It Is So Tedious..."

I'm the first to admit that, on the list of to-dos that I really don't want to spend time on, entering metadata is right up there with doing the dishes. In addition to being tedious, it can be hard to see the advantage of metadata in relation to the workflow that we defined earlier.

When it comes to your short-term, project-based workflow, there's really only one reason to hassle with IPTC metadata and that's for ownership protection. With your copyright and credit information firmly ensconced in your image's metadata, you'll have reasonable proof of image ownership. For pictures that will be uploaded to the Web, this is especially important.

The big advantage of disciplined metadata entry occurs later when you need to search your entire image library for particular types of images. In other words, the advantages of metadata are not necessarily for the job you have now but for the jobs you may have later. For example, if you have an especially large library, finding all of your "exterior supermodel" shots can be difficult. But if you've applied good keywords and categories—in this case, category "supermodel" and an "external" keyword—you can easily find your images later using software that can search image metadata.

Many image cataloging programs let you search images by metadata. Your images need good metadata for these apps to produce good results, so you should be diligent about applying thorough metadata to your images.

Editing and output

After you've made your selects, you're ready to start editing, a topic that will be covered in detail in Chapters 4 through 7. With your images edited, you'll then be ready for output in the form of delivery of electronic files, creation of a Web page, or printing. Capture NX provides a full-color managed workflow with onscreen soft proofing. Output is covered in Chapter 8, "Output."

Archiving

Although you made an initial backup of your original camera files, you'll also want to back up or archive your edited images. This topic is covered in Chapter 8.

Advanced Workflows

The basic workflow outlined earlier is the process you'll follow with just about any image editing program. In some cases, you might even use several programs to achieve the basic workflow that was described. There will be times, though, when your workflow needs might be more complicated because of the type of camera you have or the types of edits you want to make, or because of existing workflow strategies that you've already employed. Here are some brief examples of how you can fit Capture NX into more complex workflows.

Using Capture NX with non-Nikon raw files

Raw files must be processed using special raw conversion software before they can be edited or output. Capture NX includes a built-in raw converter, but it only works with Nikon-created raw files. If you shoot with a non-Nikon, raw-capable camera (such as a Canon, Pentax, Sony, Olympus, Panasonic, or others), you'll need to include an additional step in your workflow.

You'll still begin by copying your images from your camera media cards to your hard drive. But you'll probably want to organize your images using a different app—one that is capable of showing thumbnails of your raw files. Assuming they support your particular camera, programs like Photo Mechanic, iPhoto, Aperture, and Adobe Bridge are well suited to this task.

You'll also want to use these applications to rate your images and make your initial selects. Since they also provide the ability to edit metadata, you can tackle that problem using these apps as well. After making your selects, perform your raw conversion using your raw converter of choice. You can then pass the converted, processed files on to Capture NX for further editing.

Many applications provide special commands for sending an image to an external application for additional editing, a process that is sometimes referred to as "round-tripping." Check your raw converter application's manual for details.

After editing you can continue with your workflow either in Capture NX or move your edited files out of NX and back into your existing workflow.

Adding Capture NX to a Photoshop workflow

If you're a Photoshop user, you may think it's a little strange to talk about adding an additional image editor to your workflow. However, as you'll see in the editing lessons in Chapter 6, many types of edits are much easier to perform in Capture NX than in Photoshop. Once you learn more about NX's editing capabilities, you'll have a better idea of which types of edits you want to perform in NX and which you want to perform in Photoshop.

If you're shooting non-raw images (JPEGs or TIFFs), your Photoshop/NX workflow will probably go something like this:

- 1. Find your pick images, organize them, and apply your metadata in Adobe Bridge.
- **2.** Perform all of the edits you want to make in Photoshop and save the results as TIFF files.
- 3. Open a TIFF file in Capture NX and perform your NX edits.
- **4.** Save the edited NX file in the native NX format (NEF), and then export a copy of the edited version as a TIFF file.
- **5.** Produce your output as desired.

If you're shooting raw files, your workflow will look more like this:

- 1. Find your images, organize them, and add metadata using the Capture NX Browser.
- **2.** Perform the edits that you want to perform in Capture NX.
- **3.** Save the edited NX files in the native NX format (NEF), and then export copies of the edited versions as TIFF files.
- **4.** Open a TIFF file in Photoshop for additional editing.

You'll learn much more about NX files, saving, and exporting images in Chapter 5. As you learn more about the types of edits that are possible in NX, you'll have a better idea of how to divide your image editing workload between the two programs.

CHAPTER FOLK Preparing to Edit

Just as a darkroom must be prepared before it can be used, you'll need to make a few preparations to Capture NX before you can start editing in earnest. Fortunately, working with Capture NX doesn't require any hazardous chemicals, and you don't have to worry about darkening your windows. You will, however, need to make some preference adjustments to help Capture NX better represent the colors in your image.

Getting predictable color from any image editing program is not easy, but Capture NX offers some simple color management tools that make color reproduction more predictable. In this chapter, we'll take a look at some of the basics of color management theory and how color management is handled in Capture NX, so you'll have more consistent color throughout your workflow.

CONFIGURING CAPTURE NX FOR COLOR MANAGEMENT

If you've ever printed any of your images, you already know that your printed output very rarely, if ever, matches the images that you see on your monitor. You might also have noticed that as you move an image from one computer to another and look at it on different displays, its color varies tremendously. To help make the color in your images more consistent from device to device and from your camera to your printer, Capture NX provides industry standard color management features. If you properly configure these features, you'll find that the color in your images is much more consistent from device to device.

Even if you never plan on printing, it's worth taking advantage of color management technology. As your computer monitor ages, its colors will shift, and it will likely become dimmer and less contrasty. Diligent use of color management technology can keep your images looking consistent as your monitor ages.

Color management can be a very "dense" topic if you choose to get into a lot of the underlying theory. Fortunately, for everyday use, you can get by with a few simple controls and a handful of guidelines. Keeping your system color accurate will take very little time.

Color Management Basics

A lot of factors make color consistency a difficult goal. For one, there's the simple fact that color is subjective; everyone sees color slightly differently. But there are also some hard and fast objective difficulties.

As you may have learned in grade school finger painting class, by mixing a few primary colors together, you can create other colors. Similarly, if you've ever set up an inkjet printer, you know that you put just a few ink cartridges in—usually cyan, magenta, yellow, and black—and yet your printer is able to spit out full-color images.

Your digital camera and your computer monitor work the same way. They combine the three primary colors of light—red, green, and blue—to create all of the other colors that they need (**Figure 4.1**). However, there's an important difference in the way your camera combines colors and the way that a printer combines colors.

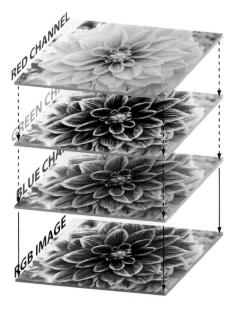

Figure 4.1 Your digital camera creates colors by combining the three primary colors of light: red, green, and blue.

Color systems

Your printer creates color by mixing different colored inks. The primary colors of ink—cyan, magenta, and yellow (CMY)—combine in a *subtractive* manner, meaning they get darker as you mix them together until they ultimately become a dark muddy brown. In theory, they should eventually turn black, but making perfectly pure inks is impossible, so very, very, dark brown is usually the best we can achieve. This is why black (the K in CMYK) is usually added to the printing process alongside the ink primary colors.

Like your eye, your camera's image sensor is sensitive to the primary colors of light—red, green, and blue—which combine in an *additive* manner. As you mix red, green, and blue, the result is a lighter color. Mix equal amounts of the three components and you get varying shades of gray or white, given sufficient intensity of the three.

As you might imagine, trying to translate one set of primary colors that mix together in an additive process into a different set of primary colors that mix together in a subtractive manner is a very complex process. Complicating it further is the fact that these two distinct methods of producing color have different *gamuts*. You can reproduce far more colors with an RGB mix of colors than you can with a CMYK mix of colors. So, the broad range of RGB colors that your camera can capture must somehow be squeezed down to fit into the more limited range of colors that can be represented with CMYK color.

As if this situation wasn't confusing enough, different types of paper yield dissimilar results, and various monitors display images very differently.

Profiles

A color management system (which consists of software and sometimes hardware) works in the background to adjust your colors as they pass from device to device to compensate for the changes in the color qualities of each device. The practical upshot is that you should see less shift as your images pass from device to device throughout your workflow.

Color management software works by examining special *profiles* that you specify for your monitor and your printer. A profile contains a description of certain color characteristics of each device. Your color management software uses this description to skew the colors as they pass through your workflow, so that your colors and tones appear more similar on each device.

Monitor profiles contain additional information, which allows your color management system to adjust special settings in your computer's video card, so that your display looks closer to an accepted standard. This process of *calibration* helps different monitors deliver a similar image.

Fortunately, there is a widely accepted standard for this profiling information. The International Color Consortium (ICC) has defined a specification for color profiles. Both the Mac and Windows operating systems provide OS-level support for these ICC profiles. Developing a working color management system begins with the process of building or acquiring good profiles for your system.

Not a magic bullet

Before we go on to profiling, it's important to understand one important fact: *The images that your printer outputs will never look exactly like what you see on your monitor!*

Your monitor is a self-illuminated transmissive color device with a huge gamut of colors at its disposal. A printed page is a reflected color device with a narrow gamut of colors and a very different contrast range. As such, your colors and tones are *always* going to look different from the monitor to the printed page. So, if you're expecting that you'll be able to configure your color management system and from then on know *exactly* what will come out of your printer, you're going to be disappointed.

However, a well-implemented color management system *can* greatly reduce the number of experiments and test prints that you need to make. I usually find that, on difficult images, working with a color managed system decreases the number of test prints I need from 6 or 7 to just 2 or 3. This is better than I was ever able to do in a chemical darkroom!

Profiling Your Monitor

Configuring your color management system begins with the creation of a monitor profile. The underlying color management software uses the monitor profile to adjust the colors in your image as they pass to your screen, as explained earlier.

You can create a monitor profile in two ways: using a software calibrator or using a hardware calibrator. The Mac OS has a built-in software calibrator and Photoshop ships with one for Windows. Both solutions work fine, but you can now buy a hardware calibrator for under \$200, and a hardware calibrator does a *much* better job than a software calibrator. So much so, that the amount of money you'll save in paper and ink will probably pay for the calibrator fairly quickly.

For getting started with color management, using a software-generated profile will at least let you see how the system works.

Software profiling on the Mac

Mac OS X includes a built-in software monitor profiler that builds a monitor profile based on your answers to some simple questions.

To use the Apple Display Calibrator Assistant:

- 1. Open System Preferences and click Displays. A dialog box appears with a generic monitor name such as "Color LCD." If you have multiple monitors attached to your Mac, a separate dialog box appears for each monitor. For now, pick a monitor that you want to display and move the appropriate dialog box to that screen.
- **2.** Click the Color tab to bring up the color controls for your monitor (**Figure 4.2**).

Figure 4.2 Mac OS X has a built-in software monitor calibration system that you can activate from the Displays section of the System Preferences.

- 3. Click the Calibrate button to launch the Display Calibrator Assistant.
- **4.** In the Display Calibrator Assistant, click the Expert Mode check box (**Figure 4.3**).

Figure 4.3 The Display Calibrator Assistant walks you through building a monitor profile for your display.

- 5. Press the Continue button and work your way through each of the screens that the Calibrator Assistant displays. Follow the instructions and answer each question. On some screens, the Calibrator Assistant will ask you to choose among several different patterns. You'll find this process much easier if you squint to defocus your eyes.
- **6.** When you're finished, the Calibrator Assistant will ask you to name your new profile. You can name it whatever you want, but it's usually best to include a date in the profile name. As I'll discuss later, keeping up-to-date profiles is very important.

Software profiling on Windows

If you have Adobe Photoshop version 7 or later, or Photoshop Elements installed, you can use the Adobe Gamma control panel that installs with the software to create a monitor profile.

- 1. Choose Start > Settings > Control Panel.
- 2. Double-click Adobe Gamma.
- **3.** Select Step By Step (Wizard) and click Next (**Figure 4.4**).

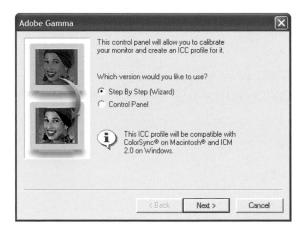

Figure 4.4 The Adobe Gamma control panel lets you create ICC profiles for your Windows computer.

4. Follow the instructions onscreen to create and save a profile.

Under Windows XP, profiles are stored in the Color directory (Windows\System32\Spool\ Drivers\Color directory).

Hardware profiling

For more accurate profiles—and therefore, a more effective color management system—you'll want to use a hardware profiler. A hardware profiler is actually a combination of a *colorimeter*, a small device that you place in front of your monitor, and a piece of included software that uses the colorimeter to analyze your monitor to create a profile (**Figure 4.5**).

Figure 4.5 A hardware monitor calibrator generates a far more accurate profile than you can make by eye using a software calibration scheme.

Because a hardware profile can perform a more accurate analysis of your monitor's characteristics, hardware-generated profiles are usually much more effective than profiles that you create by eye using a software profiler.

Many different hardware profilers are available at a range of prices. The Pantone Huey sells for \$80, whereas the ColorVision Spyder product line ranges from \$79 to \$280 depending on the options you select. At the higher end, products by X Rite and Gretag Macbeth deliver high-end quality at higher prices. All of these devices will give you better results than what you'll get with a software calibrator, but you definitely get better profiles if you buy a more expensive calibrator.

Using a hardware profiler is very simple. After installing the included software, you simply follow the onscreen instructions. At some point, you'll be prompted to mount the device on, or in front of, your display (**Figure 4.6**).

Figure 4.6 A monitor calibrator hangs in front of your monitor. Special software drives the calibrator and builds a profile for you.

Unlike with software calibration, you won't be asked to evaluate any test patterns or image swatches—that's the colorimeter's job. Profiling times will vary from device to device, but you can usually expect to have a profile within 10 minutes.

Although it may be frustrating to have to spend even *more* money, you may find that the improved accuracy of a hardware-profiled display will pay for itself fairly quickly, since you'll most likely be using less printer media on test prints.

How Often Should I Profile My Monitor?

The good news is that a monitor profile can greatly improve the quality of your displayed image, but the bad news is that it won't last. Whether you use a CRT or LCD monitor, the image on your display will shift in hue and brightness over time. The older the monitor, the faster the shift. If you're working with a fairly new display, you probably only need to profile your monitor once every month or so. After about 18 months, though, you'll want to step up your rate of profiling. If your monitor is a couple of years old, you should build a new profile once a week.

The software that ships with most hardware profilers automatically reminds you every week that it's time to build a new profile. You don't need to keep the old profiles, so don't worry, you won't soon be drowning in profiles.

Also, don't think that you can just wait until you notice a difference. Your eye can adapt very well to your monitor's subtle shifts, and you may not notice how much your image has washed out, lost saturation, and shifted colors. Trust your color management system and profile regularly.

Profiles and viewing conditions

The ambient light in the room where you view your monitor has a huge impact on your perception of the colors onscreen. Ideally, you want to work in a room where you have full control over the lighting—that is, a room with no windows and no mixed light sources.

When you build a monitor profile, your profiling software will ask you the temperature of the ambient light in the room. You'll usually want to pick an option that matches the dominant light source in your room. If you work in a windowed office, this will probably be sunlight.

In a windowed office, the ambient lighting will change throughout the day. So, you might have heavy sunlight for part of the day and mixed lighting or no sunlight at other times of the day. If you're serious about color management, you should build separate profiles for each of these ambient lighting situations and change from profile to profile as the day progresses.

Some CRTs allow you to create different configurations of monitor settings. This allows you to store different brightness and contrast settings for different ambient lighting

situations. You can build separate profiles for each of these monitor settings, and then change the monitor setting and your profile as the day progresses.

Where Is This Color Management Software?

Throughout this section I've been talking about the color management software that utilizes your profiles to correct the color on your screen and printer. This software is part of your operating system and runs in the background. You will never interact with it directly, other than to install profiles in the appropriate places. However, you will alter settings in Capture NX, which in turn will handle all necessary communication with the color management software.

Printer Profiling

Just as your color management software needs good monitor profiles to be effective, it also needs quality printer profiles to accurately adjust your images for output. However, although you only need one monitor profile (unless you're creating multiple profiles for different ambient lighting situations), you typically need many different printer profiles installed, at least one for each type of paper and ink combination that you intend to print on.

Printer profiles are built using special hardware that measures printer output on a specific type of media, using specific printer settings. To be used effectively, you use that profile with that same type of paper and same combination of printer settings. If you don't have a profile for a specific type of paper, you'll have a more difficult time running a color calibrated workflow.

Fortunately, these days most decent photo printers ship with a collection of profiles for all of the paper types that the printer vendor sells for that printer. These profiles are usually installed when you install the printer driver. In some cases, only a basic set of profiles is installed with more available from the printer vendor's Web site.

Nowadays, many independent paper companies such as Hahnemuhle provide free profiles for using their papers on specific printers.

Unfortunately, profile quality can vary from vendor to vendor and printer to printer. Some printer makers provide excellent profiles for all of their printers; some provide very good profiles for their high-end printers and marginal profiles for their lower-end models; and others don't provide profiles at all.

Further complicating the printer profiling situation is the fact that not every printer that rolls off the same assembly line is identical. As such, a "stock" profile may be more effective on one unit than another depending on how well each unit conforms to the ideal baseline.

If you aren't getting good results from the profiles included with your printer, or if you want to print on paper for which you don't have a profile (maybe you want to use handmade paper, paper from an art supply store, or paper from a different printer vendor), you might want to consider getting a custom profile.

Several online services will make a custom profile for you for anywhere from \$15–\$40. To use these services, you download a few simple test pages, print them out, and mail them to the service. The service then returns an ICC profile that you can install.

For the ultimate control, you can invest in your own paper profiling hardware: but be warned, this gear isn't cheap. Starting at around \$1000, products like the XRite Pulse ColorElite provide everything you need to create custom paper profiles. The process is very simple, and you can usually create a profile in about five minutes, depending on the speed of your printer.

Installing printer profiles on the Mac

Under Mac OS X, printer profiles are stored in the Profiles folder (Library > ColorSync > Profiles). They can be loose in the folder or kept in a subfolder, allowing you to keep profiles for specific printers grouped together. Simply copy your printer profiles into this folder and restart Capture NX.

Installing printer profiles on Windows

Under Windows XP, printer profiles are stored in the Color folder (Windows\System32\ Spool\Drivers\Color folder). Simply copy your printer profiles into this folder and restart Capture NX.

Why Don't I Need to Profile My Camera?

Since I'm making such a big deal out of having accurate profiles for your monitor and printer, you might wonder why you don't also use a profile for your camera. As you've already seen with printer and monitor profiles, color profiles are very specific to particular situations. For example, a monitor profile is specific to a particular ambient light level, whereas a printer profile is specific to a particular kind of paper. Because your lighting situation constantly changes when you shoot, there's no way to create a usable camera profile.

However, if you're a studio photographer who works only in very controlled lighting situations, it is possible to profile your camera. Camera profiling involves a complex process involving shooting expensive test charts and is way beyond the scope of this book. Lack of camera profiles, though, won't prevent you from running a color managed system.

Color Spaces

In Chapter 2, "Basic Theory," you learned about color spaces—mathematical specifications that define the boundaries of the color range in an image. The color space that you choose is simply stored as a tag in the image metadata. When displaying your image, your image editor looks at this tag to find out which color space you want to use for the image, and then maps the color values in the image accordingly.

Many color space specifications are available, but the two most popular are sRGB and Adobe RGB. Of the two, sRGB is smaller; the range of colors that it specifies is not as large as Adobe RGB. Probably the most noticeable difference is in the reds. An image mapped into sRGB has more muted reds than an image mapped into Adobe RGB (**Figure 4.7**).

Figure 4.7 The upper image has been mapped into sRGB, whereas the lower image has been mapped into the larger Adobe RGB, resulting in some colors being slightly more saturated.

Many digital cameras offer a menu option that lets you select sRGB or Adobe RGB (**Figure 4.8**). sRGB was designed with the hope that it would become the standard color space used on the Web. As you've probably already discovered if you've posted any images on the Web, Web pages don't look the same from one monitor to the next. However,

because of its smaller color space, if you tag your images as sRGB, there's a better chance that they'll look good on a greater number of monitors. The smaller color palette of sRGB means you'll stand less chance of pushing older or less advanced monitors beyond their capabilities.

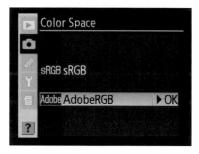

Figure 4.8 Your camera probably includes a menu option for selecting a color space, usually sRGB or Adobe RGB.

Most quality desktop photo printers have a gamut that's larger than sRGB. So, if you are shooting with the intent of printing or if you plan on doing a lot of image editing, tagging your images with the larger Adobe RGB color space is a better option. If you're shooting raw, your camera setting is not as critical, because you can always select a different color space later. But even though you can always re-tag your images later, having them come out of the camera properly tagged will save you a step during your postproduction phase.

Color Management in Capture NX

Once you've acquired and installed the requisite monitor and printer profiles, you might want to make a few preference changes in Capture NX.

- 1. Open Capture NX's Preferences and click the Color Management tab.
- 2. Change the Default RGB color space pop-up menu to the color space that you'd like to use for your images. As discussed in the sidebar "A Close Look at Color Spaces," you'll probably want to set this to sRGB or Adobe RGB, or keep it at its default of Nikon Adobe RGB. This is the same as the Adobe RGB color space and is provided for those users who don't have an Adobe RGB profile already installed on their system.

If you want, you can change the Printer Profile pop-up menu to a specific printer profile, but you'll also have the opportunity to set a printer profile when you print. I'll discuss printing and the color management issues related to printing in detail in Chapter 8, "Output."

OPENING IMAGES

You can open your images in Capture NX in many ways, and which one is right for you is largely a matter of personal preference. (I'm assuming you've already transferred your images to your computer, a topic covered in detail in Chapter 3, Interface and Basic Workflow.")

Capture NX can open TIFF files, JPEG files, or Nikon NEF files. I'll have much more to say about NEF files in Chapter 5, Basic Image Editing."

Opening with the Browser

As you saw in the previous chapter, Capture NX's Browser palette lets you see thumbnail views of all of the images in a folder. In addition, you can add ratings to your images to easily sort out the ones that you want to edit. Once you find an image in the Browser that you'd like to begin editing, simply double-click on it or drag it into the NX window to open it in Capture NX.

The Open Image Command

The Open Image command (File > Open Image) works just like the Open commands in any other application. Choose it, and you'll be presented with your operating system's standard Open dialog box, which lets you navigate to the file that you want to open. Select the file and click the Open button to open it in Capture NX.

Open Recent

Under the File menu you'll also find an Open Recent command, which lists the last nine documents that you've opened. You can simply select one of these items to reopen the document.

The Welcome Dialog Box

When you launch Capture NX, the program displays a dialog box that lists the last ten images that you've opened. Click one of these images and Capture NX opens it. The Open Recent Browser section of the dialog box shows the last ten folders that you've viewed in the Browser palette. You can click one of these folders to automatically browse that folder (**Figure 4.9**).

Figure 4.9 Capture NX's welcome screen provides single-click shortcuts to recently opened documents and folders. You can deactivate this screen by checking the Don't Show Again check box and reopen it later by choosing Help > Show Welcome Screen.

In the New section, you'll find options for invoking the program's Open dialog box and Open Folder in Browser dialog box. You can also drag an image from your desktop into the "Drag an image here to open it" portion of the dialog box to open it immediately.

If you'd rather not be presented with the Welcome dialog box, click the "Don't show again" check box.

Opening from Your OS

Of course, you can also open images in Capture NX using all of the normal mechanisms provided by your operating system.

Opening Raw Files

Capture NX can open the raw files that are produced by almost any raw-capable Nikon camera. It *can-not* open raw files produced by non-Nikon cameras. If you're working with non-Nikon raw files, you'll need to perform your initial raw conversion using a different program and save the resulting images as TIFF files. You can then bring those TIFF images into Capture NX. (See Chapter 3 for more on these types of workflow concerns.)

Some raw-capable image editors require you to first perform a raw conversion step before passing the results on to the rest of your image editing process. In Capture NX, there is no separate raw conversion step. Simply open a Nikon raw file just as you would a TIFF or JPEG and start editing. All of your image editing controls will look the same no matter what type of image you're editing, although you may find some extra functionality in some controls when working with raw files. I'll cover all of these differences throughout the next two chapters

CHAPTER FIXE Basic Image Editing

You decide to edit your images for different reasons. Sometimes, you employ an image editor to fix mistakes, such as exposure or color problems, or to remove sensor dust or optical artifacts. At other times, you edit your images because it's not possible to achieve the tone and color that you want in-camera. Because your camera has a limited dynamic range, tone and color adjustments are often required to achieve the image that you had in mind while shooting. You might also choose to edit your images because the result you're trying to create requires "special effects."

Image editing can occur at many different places within your workflow. In Chapter 3, "Interface and Basic Workflow," we outlined a plan for how to take your images through post-production, and we placed the image editing step after your sorting and selecting stage to ensure that you don't waste time editing and correcting images that you don't ultimately want to use. However, you might have your own workflow, and on a very small shoot—perhaps you spied a beautiful sunset out the window and quickly ran out to shoot half a dozen images—you might simply transfer all of the images you shot and run each one through your image editor.

Capture NX can facilitate all of the edits and corrections that you'll need to make the most of your images. Tone and color corrections can be applied globally or locally, providing you with a tremendous amount of editing power.

In this chapter, you'll learn how to use all of NX's global tone and color correction controls (by "global" I mean the tools that affect your entire image rather than just one part). You'll also learn how to fix optical problems in your images, as well as how to resize and sharpen. In addition, I'll discuss how to save your images. Saving is a simple process, but because Capture NX is a nondestructive editing system, it's important to understand how it stores edits and images.

IMAGE EDITING WORKFLOW

Once you've opened your image, you're ready to start editing. However, before diving into the editing controls, it's a good idea to make a plan of attack; that is, to assess your image and determine which edits you think it might need. Certain edits are best performed in a specific order, so developing an editing plan can help you work more efficiently and prevent you from having to backtrack later.

In general, you should proceed through your edits in the following order:

Make geometric corrections. You can't always frame your image precisely as you want it in the camera. Sometimes, the proper framing isn't possible (maybe you want a very skinny image, for example), and sometimes you'll simply discover later that a crop allows you to recompose your image to bring better focus to your subject (**Figure 5.1**).

Figure 5.1 For this image, the editing workflow began by straightening and cropping the image.

Similarly, if you didn't shoot your image straight, you may want to straighten it. If your image suffers from extreme distortion problems, you might want to employ some kind of distortion correction.

All of these edits can result in cropping your image. Because you don't want to waste time correcting part of an image that will ultimately be cropped away, it's best to perform these

edits before you perform any additional edits. This will make the Capture NX histogram more accurate (since it won't be including irrelevant data in its reading) and will help you make color and tonal decisions that are correct for your final image composition.

Remove color casts. If you did your camera work right, you won't need to worry about this step. Sometimes, especially in low-light situations, there's no way to shoot without acquiring a color cast. It's best to correct color casts first, because doing so might "use up" some of your editing latitude. With the cast corrected, you'll know how much image data you have left for your other edits (**Figure 5.2**).

Figure 5.2 Because the image had a slightly cool cast, it was corrected to a more neutral color tone.

At this stage you should also correct any *chromatic aberrations*, color fringes around high-contrast details that can occur in certain types of image.

Adjust tone and contrast. Next, you'll attack any basic tone and contrast problems. If the image is overexposed or underexposed, or has too little or too much contrast, you should fix those problems in this step. Altering tone and contrast usually has an impact on the color in your image as well, and often, tone and contrast adjustments will also correct certain color issues (**Figure 5.3**).

Figure 5.3 Adjusting the image's contrast and tone restored some of the blacks and improved the overall contrast.

Perform color correction. Any additional global color corrections that weren't repaired by your tone and contrast adjustments can be applied now. These might include hue adjustments and shifts or saturation changes (**Figure 5.4**).

Figure 5.4 A saturation adjustment was applied to give the colors more punch.

Make final tweaks. Color corrections might affect your previous tone and contrast adjustments, so you might need to make minor corrections to those adjustments. Those, in turn, might mess up your color. Usually, you'll go back and forth between adjusting tone and contrast, and making color corrections until your image is complete.

Sharpen and output the image. With your image corrected, you're ready to apply sharpening, and then to output your final result, either as a print or an electronic file (**Figure 5.5**).

Figure 5.5 For the final image, an Unsharp Mask adjustment was applied to sharpen the image for output.

You won't need to perform all of the preceding steps on every image, and some images might require a very different workflow. For example, an image shot in extremely low light might need an initial brightening before you can see it well enough to crop it or make any other edits. Fortunately, thanks to Capture NX's nondestructive editing architecture, it's very easy to adjust your workflow on the fly.

I'll discuss the details of each category of edit later in this chapter.

THE CAPTURE NX EDIT LIST

As discussed in Chapter 2, "Basic Theory," when you're editing, Capture NX never alters any of the pixels in your original image file. Instead, it simply keeps a list of the edits that you want to make. These edits are applied to your original image file in real time, and the results are written to the screen (or to a file if you're exporting, or to a printer if you're printing). The practical upshot of this process is that you can change or remove any edit at any time. The change simply alters the list, and a new image is rerendered from the original master file.

By default, the Edit List is visible on the right side of your display. You can toggle it on and off by choosing Window > Edit List. You'll use the Edit List to manage and alter all of the edits you make to your image.

Base Adjustments: A Tale of Two Imaging Engines

The Capture NX Edit List always includes a default *Base Adjustment* entry. A Base Adjustment is actually a collection of adjustments that you can make to your image. If you're working with a Nikon raw file, Base Adjustments include special Camera Adjustments and Raw Adjustments categories, which allow you to adjust the raw conversion parameters for your image (**Figure 5.6**).

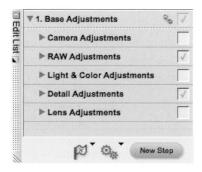

Figure 5.6 All images include a set of Base Adjustments in their Edit List. For raw images, a Base Adjustment includes extra Camera Adjustments and Raw Adjustments categories.

Whether you're working with a raw or non-raw file, Base Adjustments also contain Light and Color Adjustments, and Detail Adjustments. These edits can also be applied using another kind of adjustment called an Edit Step. You select Edit Steps from the Adjust menu. Each Edit Step is added to the bottom of the Edit List (**Figure 5.7**). To understand the difference between Base Adjustments and Edit Steps, you need to know a little something about Capture NX's inner workings.

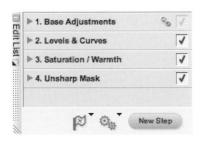

Figure 5.7 As you add edits to an image, they are appended to the bottom of the Edit List.

Capture NX is the latest in a series of Nikon Capture applications that have been around since Nikon first included raw capability in the Nikon D1, circa 2000. Nikon Capture version 4 was the most recent version of the program before Nikon decided on developing the more powerful image editing program that became Nikon Capture NX.

Previous versions of Nikon Capture did not include any of the selective editing features that you'll see in the next chapter, such as the new masking and Control Point features. Capture version 4 did, however, include the full selection of global adjustments that Nikon Capture NX provides in its Base Adjustments collection. To ease your transition from Capture 4 to Capture NX, Nikon made NX backward compatible with Capture 4 files. Any NEF files that you were working on in Capture 4 can be opened in Capture NX. All of your existing edits will appear in the Base Adjustments section of the Edit List.

With Capture NX, Nikon has included an entirely new image processing engine, which is used any time you apply an Edit Step. While many edits can be applied either from Base Adjustments or as Edit Steps, applying an edit as an Edit Step offers the following advantages:

Edit Steps deliver better performance than Base Adjustment edits. When you
apply an edit using Base Adjustments, the older Capture 4 editing engine is used.
When you apply adjustments using Edit Steps, the newer, faster Capture NX
engine is used.

- Edits that you make using Edit Steps can be selectively applied to your image through the use of special brushes.
- Edit Steps provide additional editing functions not found in Base Adjustments, including Nikon Capture's unique Control Point edits. (Control Points are discussed in Chapter 6, "Advanced Image Editing.")
- You can control the order of Edit Steps. Sometimes you might find that you want to apply edits in a particular order. The most obvious example of this is sharpening, which you usually want to apply after all of your other edits.

The following Base Adjustment edits can also be applied as Edit Steps:

Light and Color Adjustments	Detail Adjustments
Color Balance	Noise Reduction
D-Lighting	Unsharp Mask
LCH Editor	Auto Red-eye
Levels/Curves	
Photo Effects	

Image quality-wise, it doesn't really matter whether you apply these effects as Base Adjustments or Edit Steps. However, for the reasons listed earlier, you'll have much more editing flexibility if you apply these functions as Edit Steps. Because of the advantages of Edit Step operations, you'll probably find it's best to leave the *Light and Color Adjustments* and *Detail Adjustments* sections of Base Adjustments alone. You can apply these edits using Edit Step adjustments.

If you absolutely need backward compatibility with Nikon Capture 4, apply those effects using Base Adjustments.

You will use Base Adjustments, specifically the Camera Adjustments and Raw Adjustments controls, any time you work with raw files (remember, Capture NX only supports Nikon raw files).

Editing Base Adjustments

You can alter any Base Adjustment by simply clicking the reveal arrow next to its name in the Edit List (**Figure 5.8**). A Settings palette opens to reveal the controls for that edit. After you've adjusted the settings, click OK to close the Settings palette.

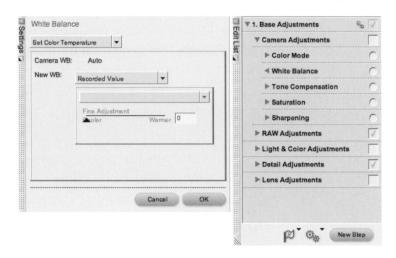

Figure 5.8 To edit a Base Adjustment parameter, click its reveal arrow to open its Settings palette.

After editing a Base Adjustment, a checkmark appears next to its name in the Edit List. You can toggle the adjustment on and off by clicking the checkmark. This allows you to easily see before and after views of your image. Note that you can also toggle the effect of entire categories of Base Adjustments by clicking the checkmark next to the category names in the Base Adjustments palette.

You can alter the settings for any Base Adjustment by reopening its Settings palette and altering its parameters.

Camera Adjustments and Raw Adjustments

As mentioned earlier, unless you need to ensure backward compatibility with Nikon Capture 4, the only Base Adjustments parameters you'll need to adjust are those in the Camera Adjustments and Raw Adjustments groups. I'll discuss the specifics of these controls in the "Processing Raw Images" section at the end of this chapter. If you're a raw shooter, feel free to skip ahead and read that section now.

Adding an Edit Step

While your Edit List will always contain Base Adjustments, additional Edit Steps will be added as you select them. Edit Steps are added in two ways.

- When you select an adjustment from the Adjust menu, an Edit Step is added for that specific adjustment.
- Many of Capture NX's tools—Crop, Straighten, Rotate, Control Points, and the Red Eye tool—also add Edit Steps (Figure 5.9).

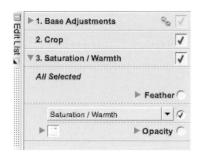

Figure 5.9 Edit List entries are also added edits that you make using Capture NX's tools, such as cropping, straightening, or rotating.

No matter what type of edit an entry contains, all Edit List entries have the properties shown in Figure 5.9. All entries have a check box that enables you to activate and deactivate the effect. Most also have a reveal arrow that opens a Settings palette, which contains the parameter controls for that effect. Many also have Feather and Opacity controls.

When you first add any type of Edit Step (except for Crop, which offers no editable parameters), Capture NX displays a Settings palette that contains the editable parameters that are specific to that type of adjustment. After configuring the parameters, click OK to close the Settings palette.

NOTE Edit Steps are always added after the currently selected edit. So, you can insert an edit anywhere you want within the Edit List.

Deleting an Edit Step

You can delete any edit in the Edit List (except for Base Adjustments) by clicking the edit's title bar to select it, and then pressing the Delete key. You can delete multiple Edit Steps at once by clicking to select the first one, and then Shift-clicking to select additional sequential edits. If you want to select noncontiguous edits, click to select the first one, and then Command/Control-click additional edits to add them to the selection.

Altering an Edit Step

You can alter the parameters of any adjustment in the Edit List by clicking the adjustment's reveal arrow to open its Settings panel. Change the parameters to taste, and then click OK to accept the changes and close the Settings palette.

The Edit List Context Menu

If you right-click an edit in the Edit List (or Control-click if you're using a Mac with a one-button mouse), the Edit List context menu appears (**Figure 5.10**). From here you can Delete edits or Select all edits. You can also choose to Expand all or Collapse all edits, which opens and closes every edit in the list.

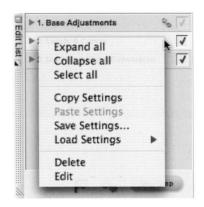

Figure 5.10 If you right-click an edit in the Edit List, you'll have additional options for managing your edits.

You'll learn about the other options (Copy, Paste, and Load Settings) in Chapter 7, "Version Control and Batch Processing."

GEOMETRIC ADJUSTMENTS

For those times when you can't frame your image the way you want, or for those times when you didn't have your camera quite level, Capture NX provides several tools for performing geometric corrections to your images. Some are available from the toolbar, and others are implemented as menu commands.

TIP If you can't see the Crop, Straighten, and Rotate tools on the toolbar, press F3.

Rotate

Most digital cameras these days include a rotation sensor that lets them determine if you are shooting in vertical or horizontal orientation (sometimes referred to as *portrait* or *land-scape*). When the camera saves an image, it stores a flag in the image metadata that indicates the orientation of the image.

Capture NX, like many other image editors, can read this orientation flag and automatically display your image appropriately. There will be times, though, when the flag won't get set or will get set incorrectly. Sometimes, you will be working with scans or with a camera that lacks an orientation sensor. For all of these instances, Capture NX provides a Rotate tool that rotates your image in 90° increments.

To rotate an image 90° clockwise:

1. Click the Rotate 90° Clockwise tool on the toolbar (**Figure 5.11**) once.

Figure 5.11 The Rotate tool on Capture NX's toolbar lets you rotate your images in 90° increments.

2. Note that a Rotate Edit Step is added to your Edit List.

To rotate an image 90° counterclockwise:

- 1. Click and hold the Rotate 90° Clockwise tool.
- **2.** From the resulting pop-up menu (**Figure 5.12**), select the Rotate 90° CCW tool. Your image will be rotated accordingly.

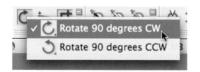

Figure 5.12 If you click and hold the Rotate button, a pop-up menu appears and allows you to select between clockwise and counterclockwise rotation.

3. Note that a Rotate Edit Step is added to your Edit List.

As you continue to click the Rotate tools, additional Rotate Edits are added to your list. So, for example, if you click twice to rotate an image 180°, you'll see two Rotate Edits in your Edit List.

Straighten

You can use Capture NX's Straighten tool to level out those images that might have been shot a little off-kilter. Be aware, however, that straightening an image also results in your image being cropped. When you rotate an image to straighten it, it goes "out of true" with the rectangular canvas that contains it (**Figure 5.13**). Capture NX automatically crops the image to eliminate this extra space.

Figure 5.13 When you rotate an image to straighten it, it goes out of true with its original rectangular canvas and requires cropping to restore it to a rectangular shape. Capture NX's Straighten tool rotates and crops at the same time.

To straighten an image:

- 1. Click the Straighten tool on the Capture NX toolbar, or select Edit > Rotate > Straighten. A Straighten edit is added to your Edit List, and the Straighten settings automatically open.
- 2. Click in your image at one end of something that should be straightened, drag to the other end of the object, and release the mouse (**Figure 5.14**). Capture NX automatically calculates the amount of image rotation required to render the line you drew horizontal. That value is automatically entered in the Straighten Settings palette, and your image is rotated and cropped.

TIP If it's easier to spot a line in your image that should be vertical, you can use the same technique on a vertical line rather than a horizontal line.

3. If the straightening looks correct, click OK in the Straighten Settings palette to accept the straightening and close the palette.

If the straightening isn't quite right, click Cancel and then define a new horizontal line. Repeat the process until you straighten the image to your liking.

TIP If you'd rather not let Capture NX automatically crop your image after straightening, check the "Include Areas without image data" check box in the Straighten Settings palette.

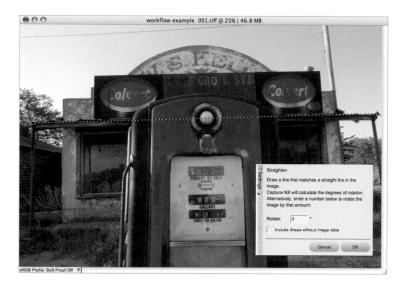

Figure 5.14
To straighten an image, use the Straighten tool to drag a line across something in your image that should be horizontal. Capture NX automatically calculates the necessary amount of rotation to straighten your image.

Crop

The Capture NX Crop tool lets you crop your image by simply dragging a rectangle to define the crop that you want.

To crop an image:

- 1. Click the Crop tool on the toolbar, or press C.
- **2.** Drag in your image to define the cropping rectangle that you want (**Figure 5.15**).

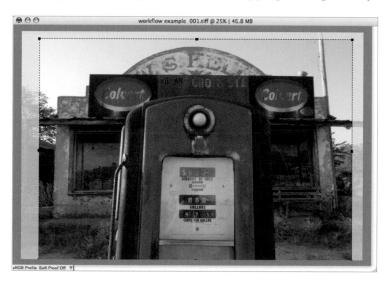

Figure 5.15 You can use the Crop tool to drag a cropping rectangle around your image. Adjust the crop by dragging on the crop handles. Accept the crop by pressing Return or double-clicking within the crop area.

- **3.** If your crop needs any adjustment, click and drag on the control handles on the border of the crop rectangle.
- **4.** When your crop is adjusted to your liking, double-click within the crop rectangle or press Return.

Like all other edits, cropping in Capture NX is nondestructive. If you later decide that you don't like the crop, click the Crop entry in the Edit List, and press Delete to remove the crop.

TIP If you hold down the Alt or Option key with the Crop tool selected, Capture NX superimposes a grid of horizontal and vertical guidelines over your image.

Crop options

If you double-click the Crop tool, the Capture NX Crop Options dialog box appears. With Crop Options, you can constrain your crops to a specific aspect ratio. Change the Free Crop menu to Fixed Aspect Ratio, and then enter the aspect ratio that you want in the text fields (**Figure 5.16**).

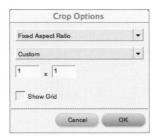

Figure 5.16 In the Crop Options dialog box, you can specify a fixed aspect ratio that you want to crop to.

Flipping

You can flip your image vertically or horizontally (or both) by using the Flip commands (Edit > Flip). A Flip edit will be added to your Edit List. The Flip adjustment provides no additional parameters.

The Grid Some geometric corrections will be easier to make if you activate Capture NX's grid. Choose View > Show Grid to superimpose a reference grid over your image (Figure 5.17). The grid provides a reference for true horizontal and vertical. You can change the color of the grid lines as well as their frequency and number of subdivisions using the Levels & Grid options (Preferences > Levels & Grid). To deactivate the grid, choose View > Show Grid again. Preferences Color Management Levels & Grid Cache Settings G 0 Set black point R 255 G 255 Set white point: R 128 G 128 B 128 Set neutral point:

0.5

0.5 % 3x3 Average

1

Inches

Subdivisions per line

Black auto-contrast clip: White auto-contrast clip:

Dropper sample size

Grid Color

Display

Gridline every

Figur
Prefer
of the
NX ca

Figure 5.17 Use the Levels & Grid Preferences to spec out the details of the reference grid that Capture NX can display over your images.

Resizing

A digital image is a grid composed of pixels, one for each pixel on your camera's image sensor. For example, if you have an eight megapixel camera, the images produced by your camera will have dimensions of roughly 3500 pixels by 2300 pixels. Your camera also tags your image with a resolution setting, which specifies how closely these pixels will by spaced (in pixels per inch) when they're output on a printer. The higher the output resolution, the closer the pixels will be to each other. Obviously, a higher output resolution means a smaller print size.

Capture NX provides you with two different ways of resizing an image: You can change the output resolution setting, which doesn't change the number of pixels in your image but simply tags the image as having a different number of pixels per inch; or you can choose to change the size of the image by adding or removing pixels.

NOTE Capture NX uses the term "dots per inch" in its Size/Resolution dialog box. Technically, this is an inaccurate use of the term. "Dots per inch" is usually a measure of the number of printer dots that an inkjet printer lays down. "Pixels per inch" is the correct term for the pixels in an image.

Changing the resolution of an image

To change the output resolution of an image:

- 1. Open the image.
- **2.** Select Edit > Size/Resolution. The Size/Resolution dialog box appears (**Figure 5.18**).

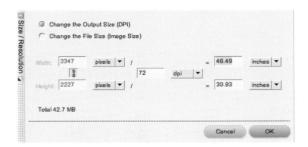

Figure 5.18 The Size/Resolution dialog box lets you change the resolution of your image as well as the number of pixels in your image.

- **3.** Click Change the Output Size (DPI).
- **4.** Enter a new size in the dpi field. (You can change the dpi [dots per inch] measure to dpcm [dots per centimeter; **Figure 5.19**]). Note that the output size fields are automatically updated to reflect the new print size that results from your resolution change. As you increase resolution, your print size will get smaller.

Figure 5.19 If you prefer to work with metric measurements, you can change dots per inch to dots per centimeter.

Note that the *Total* readout, which indicates the total size of your image, remains the same. You haven't changed the number of pixels, only their density.

5. Click OK to accept the changes.

You won't see any change in your image because you haven't altered any of the actual pixels. Instead, you've merely changed the output resolution setting in the document.

TIP For printing photos on most desktop inkjet printers, use a resolution of 240 pixels per inch. In some instances, you can get away with less resolution. The only penalties for higher pixel density (PPI) is larger file sizes and possibly longer print times.

Changing the number of pixels in an image

The Size/Resolution dialog box also lets you change the number of pixels in an image, a process called resampling. When you lower the pixel count in an image, Capture NX throws away as many pixels as necessary to achieve your desired target size. When you increase the number of pixels in an image, Capture NX concocts new pixels to boost the pixel count of your image to your desired size.

NOTE Capture NX uses a bicubic interpolation for its resampling. This is a high-quality algorithm that is well suited to almost any photographic resizing task.

To change the number of pixels (altering the native or original resolution) in an image (resizing by resampling):

- 1. Open the image.
- **2.** Select Edit > Size/Resolution. The Size/Resolution dialog box appears.
- **3.** Click Change the File Size (Image size).
- **4.** Enter new pixel dimensions in the Width and Height fields. Alternatively, you can change the pixels' pop-up menus to % to enlarge or reduce your image to a percentage of its original size.

By default, the Size/Resolution dialog box resizes your image proportionally: The lock icon between the Width and Height fields (**Figure 5.20**) indicates that the two values are proportionally related. You can click the lock to deselect it, which allows you to change each axis independently but results in image distortion.

Figure 5.20 The lock icon between the Width and Height fields lets you choose whether or not you want to preserve the aspect ratio of the original image.

Note that the *Total* readout changes. If you increase the image size, the total count goes up. If you decrease the size, the total count goes down.

5. Click OK to accept your changes. A Size/Resolution edit is added to your Edit List.

You can also change the resolution and resize at the same time.

- 1. Select Edit > Size/Resolution to open the Size/Resolution dialog box.
- 2. Click Change Output Size (DPI).
- **3.** Enter a new resolution in the dpi field. As before, your print size will change, but the Total value will remain the same.
- **4.** Now enter new values in the output size fields. These fields are always proportionally locked, so if you change one, the other changes to preserve your image's aspect ratio. Note that the Total field changes.

Resizing an image for print

Your camera usually tags images with a resolution of 72 pixels per inch, which means they'll have an unreasonably large print size—30 inches wide or more on an eight megapixel camera. (Obviously, if you crop an image, you'll have fewer pixels.)

Consider the image shown in Figure 5.21.

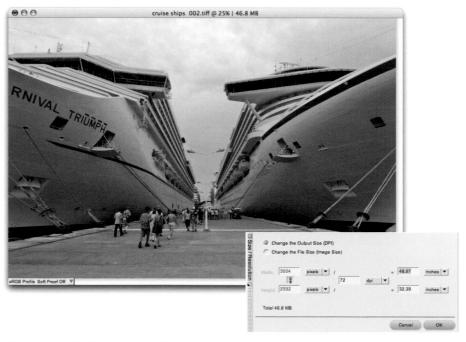

Figure 5.21 We'll use the Size/Resolution dialog box to resize this image for print on a desktop inkjet printer.

The Size/Resolution settings show that the image has pixel dimensions of 3504 x 2332 pixels at 72 pixels per inch, yielding a print size of roughly 48 x 32 inches.

Let's say that you know that the printer works fine with images that have a resolution of 240 dots per inch, so you can change the dpi field to **240**. The print size changes to 14.6 x 9.72 (the print size gets smaller because the pixels are closer together). You want to print an 8 x 10 image, so this is still larger than you want. So, you enter a width of **10**. Capture NX automatically *reduces* the total size of the image to yield a final image at the size and resolution that you want (**Figure 5.22**). Note that the total size and pixel dimensions have decreased.

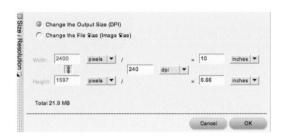

Figure 5.22 With the Size/ Resolution dialog box you can resize your image to the precise size and resolution settings that you want.

Resizing an image for the Web or email

Resizing for the Web or email is usually easier than resizing for print. First, output resolution is irrelevant for images that will only be viewed onscreen. The resolution of your monitor is fixed to a certain number of pixels per inch. When an image is displayed onscreen, its pixels are simply lined up, and the resulting number of pixels per inch depends on how close together the pixels on your screen are.

Second, images for screen display usually need to be made small. If you're shooting with a high-resolution camera, you'll need a fairly significant reduction.

In general, it's safe to assume that most users are capable of displaying an 800×600 pixel image on their screen with plenty of room for their OS interface. If you know your intended viewer has a larger screen, you might consider increasing the size to $1,024 \times 768$. If you want to play it very safe, stick with a small size such as 640×480 .

How much can you upsample?

Be careful with upsizing. Too much upsampling introduces noticeable artifacts into your image—jagged lines and an overall softening. That said, Capture NX does a very good job of upsampling, and you'll probably be surprised to find that you can enlarge your images quite a bit before they become noticeably degraded. This allows you to create very large prints.

Bear in mind, too, that larger prints are usually viewed from far away. You don't handle and examine a large print the way you do a 4×6 " or 8×10 " print. As such, you can usually get away with a little softness in a larger print.

If you need to upsample by more than 10 percent, you'll probably find that you get better results using multiple 10 percent resizings rather than one big resizing. You can easily stack multiple resize Edit Steps in your Edit List.

Nondestructive Resizing or "How I Learned to Stop Worrying and Love My Edit List"

In a normal, destructive image editor, if you resample an image—either up or down—you permanently alter the pixel count in the image. If you downsample, the pixels that are thrown away are permanently lost, whereas if you upsample, you end up permanently degrading your image with interpolated pixels. For this reason, you usually need to save multiple versions of your image at different sizes when working with a destructive editor.

In Capture NX you don't have to worry about resizing issues. Resizing is simply one more edit in your list of edits. Like the other edits, resizing is applied on the fly. So, if you want to return your image to its original pixel dimensions or resolution setting, you can simply delete the resize edits.

Because Edit Steps can be deactivated, you can even keep multiple resizings within one document. For example, you can have one resize step that resizes your image to 4×6 ", and another that resizes to 8×10 ", and yet another for email delivery. When you want to print a 4×6 ", you simply activate the 4×6 " step and deactivate the 8×10 " step. Then do the opposite for an 8×10 " step or email output.

Fit Photo

A landscape-oriented image has a longer width than a portrait-oriented image, and a portrait-oriented image has a taller height than a landscape-oriented image. You can use the Fit Photo command to automatically resize an image to fit into a given size regardless of its orientation.

For example, you can use Fit Photo to prepare an image for email:

- **1.** Open the image.
- **2.** Select Edit > Fit Photo.
- **3.** Change the pop-up menus to pixels.
- **4.** Enter a width of **800** and a height of **600** (**Figure 5.23**).

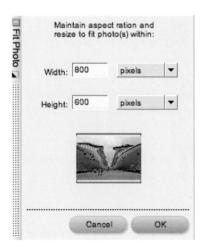

Figure 5.23 Fit Photo automatically resizes an image to fit into given pixel dimensions regardless of the image's orientation.

5. Click OK.

A Fit Photo edit is added to your Edit List, and your image is automatically resized so that it fits proportionally and is as large as possible inside the dimensions you specified.

Of course, you can do the same task manually by using the Size/Resolution dialog box. However, as you'll see later, Fit Photo becomes very handy when you start batch processing large groups of images.

Distortion control

If you're shooting with a wide-angle lens (or a really low-quality lens of any focal length), you might notice distortion in the corners of your image. That is, straight lines begin to curve as they near the edge of the frame. You can correct for this distortion using Capture NX's Distortion Control.

To correct distortion in an image:

1. Open the image (Figure 5.24).

Figure 5.24 Because this image was shot with a wide-angle lens, it has distortion problems. The horizontal lines bow near the edges of the frame.

- **2.** Select Adjust > Correct > Distortion Control. A Distortion Control edit is added to your Edit List, and the Distortion Control Settings palette opens.
- **3.** Slide the Correction slider back and forth to correct the corner distortion of your image. As you can see, the Distortion Control works by applying a spherical distortion to your image. The corners of your image bow in and out, allowing you to correct for the bowing introduced by your lens (**Figure 5.25**).
- **4.** Click OK to accept the correction.

Note that if your image has been cropped, you might have to apply a fairly high amount of distortion before you start to see the correction in the cropped portion of your image.

In an uncropped image, the corner correction results in empty space being left on the edges and corners of your image—it's as if the picture has been peeled back off the canvas, revealing the white material beneath. The Distortion Control Settings palette lets you pick a color for the revealed, underlying pixels.

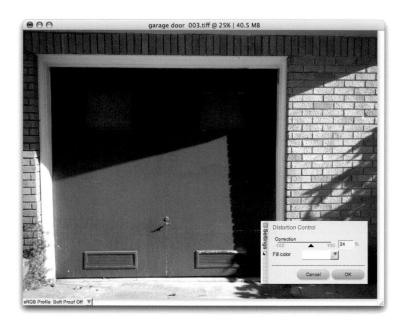

Figure 5.25 Using the Distortion Control adjustment, you can easily correct the bowed distortion at the edges of the frame.

Correcting color aberrations

When you take a picture, your camera's lens focuses the light that bounces off your scene onto the sensor in your camera. However, some lenses—especially wide-angle lenses—sometimes have trouble focusing all wavelengths of light onto the exact same point on your sensor. The result can be weird color fringes. Very often these fringes occur around high-contrast areas in your image.

At other times, especially when shooting very bright scenes, the individual pixels on your camera's image sensor can "overflow" with photons. When this happens, excess photons can spill over into adjacent pixels, creating a phenomenon called *sensor blooming*. Sensor blooming also manifests in your image as colored fringes.

Capture NX provides a Color Aberration Correction edit that can make short work of removing color fringing problems.

In the image crop shown in **Figure 5.26**, you can see both green and purple fringing around the columns. This is an extreme magnification of the image, and whether or not this problem would show up in print depends on the quality of your printer and the size at which you choose to print. Nevertheless, it's best to play it safe and remove the fringe.

Figure 5.26 This image has trouble with green and purple fringing along the edge of the columns. Capture NX easily removes color fringes.

To remove color fringing:

- 1. Select Adjust > Correct > Color Aberration Control. A Color Aberration Control edit is added to your Edit List, and the Color Aberration Settings palette appears.
- **2.** If the fringe you're trying to remove is red or purple, drag the Red-Cyan slider to the left. The fringe should disappear (**Figure 5.27**). If the fringe is blue or yellowish, use the Blue-Yellow slider.

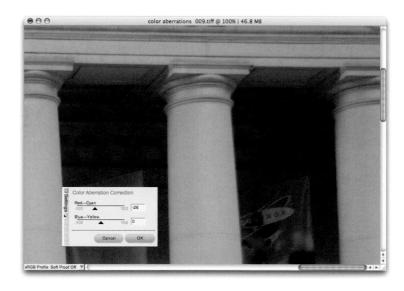

Figure 5.27
The Color Aberration
Correction edit lets
you use a simple
slider interface to
remove color fringing.

If you push a correction too far, a different colored fringe might appear. Fortunately, it's easy enough to redo your adjustment if you need to. While this is, technically, a color correction, removing color fringing is often something you do at the beginning of your workflow so you can assess whether the image is useful. If you can't completely remove the color fringing, you may decide not to use the image.

ADJUSTING TONE AND CONTRAST

There's no right or wrong order in which to make tone, contrast, and color adjustments, and all three affect each other. However, you'll usually want to adjust tone and contrast first, because these adjustments often resolve some of the color issues in your image. In addition, if you've been shooting in low light, you'll need to adjust tone and contrast simply to get the image up to a brightness level that lets you see the details and specifics of your picture. In this section, we'll look at each of Capture NX's tone and contrast adjustments.

NOTE For the rest of this chapter, I assume that you have an understanding of how to read a histogram, as well as the terms black point, white point, and midpoint. If such concepts are a mystery to you, check out "Histogram 101" in Chapter 2.

Auto Levels

A good place to start with your tone and contrast adjustments is with the Auto Levels adjustment, which often does a good job of setting your image's white point and black point.

Consider the low-contrast image in Figure 5.28.

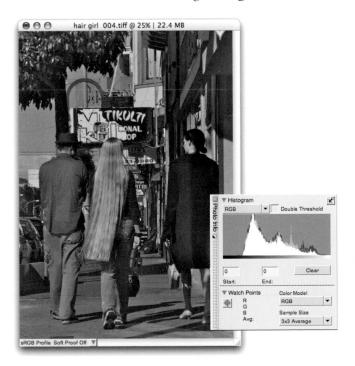

Figure 5.28 As you can see from this low-contrast image and its histogram, there's no black or white in the image. The tones in the image cover a very small range; there's little contrast from the darkest to the lightest tones.

As you can see from the image's histogram, the image contains neither solid black nor white, and all of the image data is clumped near the center. The Auto Levels adjustment can automatically adjust the tones in your image, stretching out the data so that the brightest point is rendered white, the darkest point is rendered black, and all intermediate tones are remapped accordingly.

To add an Auto Levels edit:

- 1. Select Adjust > Light > Auto Levels.
- **2.** An Auto Levels adjustment is added to your Edit List, and your image is adjusted (**Figure 5.29**).

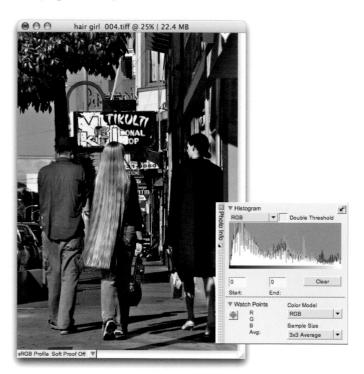

Figure 5.29 After adding an Auto Levels adjustment, the blacks and whites in the image are restored to true black and white. Intermediate tones are adjusted to preserve their original relationships.

3. Click OK in the Auto Levels Settings palette to accept the edit and close the palette.

If you look at the image's histogram now, you can see that Auto Levels successfully stretched the data in the image to better span a full range of black to white. However, some of the midtones in the image went a little dark in the process and could use a little fine-tuning. Fortunately, Auto Levels provides some additional manual controls.

To alter an Auto Levels edit:

- 1. Double-click Auto Levels in the Edit List to open the Auto Levels Settings palette.
- **2.** In the Auto Levels Settings palette, choose Advanced from the Auto pop-up menu. Two new sliders appear (**Figure 5.30**).

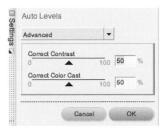

Figure 5.30 The Advanced Auto Levels option has two Auto Levels parameters for fine-tuning your adjustment.

3. Adjust the Correct Contrast slider to attenuate the amount of correction the Auto Levels adjustment applies. By default, Auto Levels applies a contrast adjustment of 100. If the result is too contrasty, you can dial it back by setting the slider to a lower value (**Figure 5.31**).

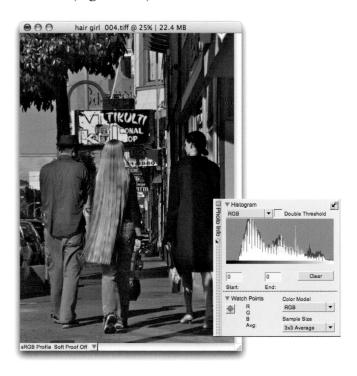

Figure 5.31 Using the Correct Contrast slider in the Auto Levels Settings palette, you can reduce the amount of contrast applied by the Auto Levels adjustment.

Correcting color casts

In addition to adjusting the white point and black point in an image, the Auto Levels adjustment also attempts to correct any color cast problems. A color cast usually stems from one color channel (red, green, or blue) being more or less pronounced than another (**Figure 5.32**).

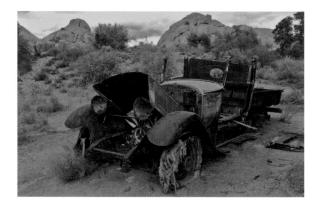

Figure 5.32 In addition to being too dark, this image is too yellow.

By adjusting the white and black points of individual color channels, and therefore shifting the tones within those channels, color casts can be eliminated. On its own, Auto Levels does a good job of correcting color casts. For more control, you can use the Correct Color Cast slider.

To manually correct color casts using Auto Levels:

- 1. Double-click Auto Levels in the Edit List to open the Auto Levels Settings palette.
- **2.** In the Auto Levels Settings palette, choose Advanced from the Auto pop-up menu.
- **3.** Adjust the Correct Color Cast slider to eliminate the color cast in your image (**Figure 5.33**).

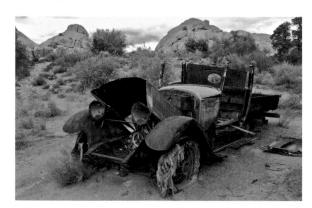

Figure 5.33 Auto Levels brightened up the image nicely, and adjustments made with the Correct Color Cast slider removed the yellow color cast.

Color casts can be somewhat subjective. It's often difficult to tell what "correct" color is in an image. Keep an eye on the histogram while adjusting the slider. As the three color channels fall more into registration with each other, you should approach more correct color. (Obviously, if there's a large part of your image that is red, green, or blue, your histogram will be skewed.) Or, try to find a white object in your image. If you can render the object a true white, you'll have correct color throughout your image.

Getting Help from the Histogram

The Capture NX histogram provides some special utility functions that make it easy to identify exactly where certain tones lie in your image. If you click the Double Threshold check box, two sliders appear beneath the histogram display and your image changes to a *threshold* display. The darkest tones in your image will appear black, and the lightest will appear white. The rest will be represented as gray. If your image doesn't have any black or white, you can drag the two sliders inward until the darkest and lightest pixels are revealed (**Figure 5.34**).

Double Threshold view makes it simple to see what's white and black in your image, which is very handy when you start using the Levels and Curves eyedroppers that you'll learn about in the next section.

You can also highlight a range of tones in the Capture NX histogram by simply clicking and dragging across the histogram. Capture NX highlights the pixels in your image using colored pixels, allowing you to easily see where those particular tones appear (**Figure 5.35**). Click the Clear button to return to a normal view of your image.

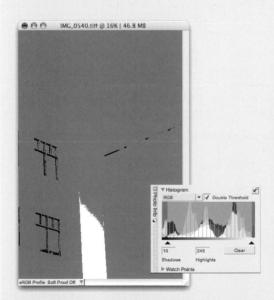

Figure 5.34 The Double Threshold view in the Histogram palette lets you see exactly where the brightest and darkest pixels are in your image.

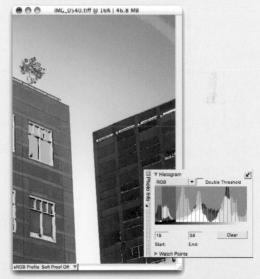

Figure 5.35 If you click and drag across the histogram, Capture NX highlights the pixels in your image that correspond to the selected tonal values.

continues on next page

Getting Help from the Histogram

The Watch Points section of the Histogram palette lets you monitor the RGB values of up to four specific points in your image. Click the Watch Points arrow, choose Add Watch Points, and then click somewhere in your image. Capture NX adds a watch point readout to the Histogram palette (**Figure 5.36**).

Figure 5.36 Watch Points allow you to keep an eye on the color values of specific pixels in your image.

Sometimes, an area in your image might be composed of slightly varying hues of pixels. If you choose another option from the Sample Size pop-up menu, the Watch Points you define will average a small area around the point you click on. This can often make for a more reliable color reading.

Levels and Curves

While Auto Levels does a good job of fixing contrast troubles in an image, there will be times when you'll want more control over which parts of the contrast range are adjusted, and by how much. The Levels and Curves control provides a simple interface for making these sorts of changes.

You add a Levels and Curves adjustment like any other type of adjustment. Choose Adjust > Light > Levels and Curves, or press Command/Control-L. A Levels and Curves adjustment is added to your Edit List, and the Levels and Curves Settings palette appears.

The Levels and Curves Settings palette provides a single interface for what are, traditionally, two different controls (**Figure 5.37**).

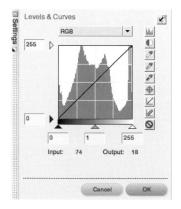

Figure 5.37 Capture NX's Levels and Curves dialog box gives you access to traditional Levels and Curves controls in a single interface.

As you can see, Levels and Curves displays a histogram of the current image with controls arrayed over and around the histogram.

Adjusting Levels

The Levels controls allow you to easily set the black point, white point, and midpoint of your image to correct low contrast or to brighten or darken an image. Note the three sliders located directly beneath the histogram. The leftmost denotes the current black point in your image, the rightmost shows the current white point, and the middle slider shows the current midpoint.

Let's look at how to correct another low-contrast image, this time the one shown in **Figure 5.38**.

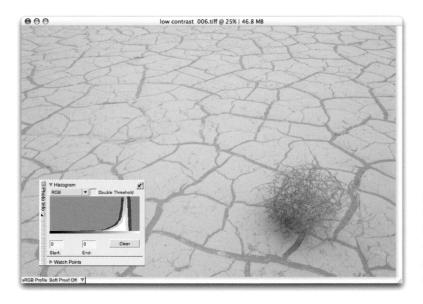

Figure 5.38
We'll correct this
low-contrast image
using the Levels
controls in the Levels
and Curves edit.

Again, you can see that the image lacks any strong blacks, and this is shown in the Levels and Curves dialog box. The black point slider is pointing to a place where there's no data. If you drag the black point slider to the right, to a place where there is data, you indicate that those tones should be black. All the other tones to the right of the black point are remapped, so that the tonal relationships remain the same (**Figure 5.39**).

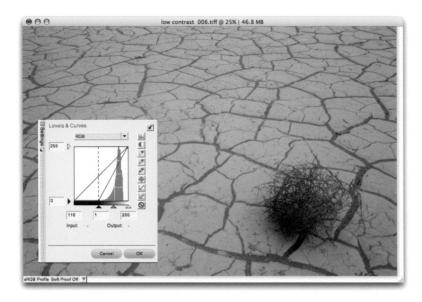

Figure 5.39
By dragging the black point slider to the right, you can redefine which tones in the image should be black.

The blacks in the image are now much better, but the image is dark overall, and the whites are still weak. If you drag the white point slider from its current location (where there's no data) to the brightest data in the image, you remap that data to white, and all intermediate tones are remapped (**Figure 5.40**).

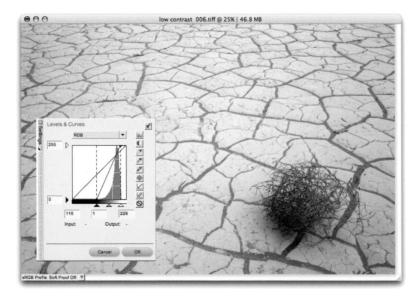

Figure 5.40
You can adjust the white point in the image in the same way you adjusted the black point by dragging the white slider to the tone that you want to be white.

So far, you've done the same thing that Auto Levels does. The advantage of manual control over Levels is that you can independently control the black and white point adjustments, and you can opt for more or less adjustment in either or both parameters (**Figure 5.41**).

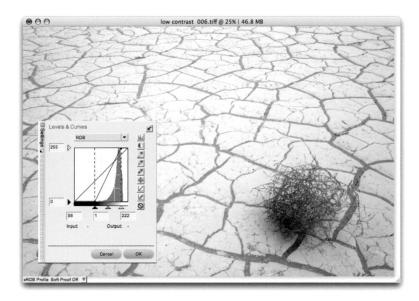

Figure 5.41 Here it was decided to back off a little on the black point adjustment to make the blacks less black and be more aggressive on the white point adjustment to make the whites brighter.

The middle slider, the midpoint, allows you to alter the brightness of the middle tones in the image without changing the value of the white or black points. If you move the midpoint slider to the left, the image gets brighter—to the right it gets darker (**Figure 5.42**). Note, however, that the brightest and darkest parts of the image don't change.

When you move the midpoint slider (sometimes referred to as the *gamma slider*) to the left, Capture NX expands the tones between the midpoint and the white point. Because there are now more bright tones in your image, your image appears, overall, brighter. At the same time, it compresses the tones between the midpoint slider and the black point (**Figure 5.43**). When you move the slider to the right, the opposite happens.

If all of this is confusing, don't worry, you can simply move the slider and immediately see the results. I'm just including the theory for those who want a better understanding of how to read the Levels and Curves display.

TIP Unchecking an edit in the Edit List does not undo the settings for that edit, meaning you can easily turn an edit on and off to view its effects.

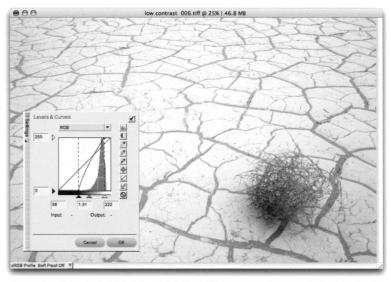

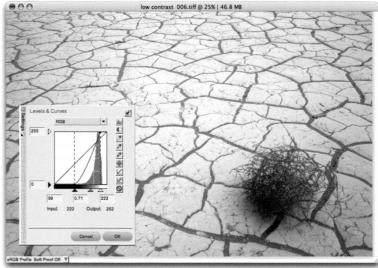

Figure 5.42 As you move the midpoint slider to the left and right, the midtones in the image get brighter and darker.

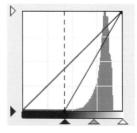

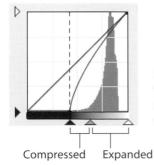

Figure 5.43 When you move the midpoint slider, the tones to one side of the slider are expanded so that there are more of them, whereas the tones to the other side are compressed.

Reading the curve

You've probably already noticed the diagonal black line that Capture NX draws when you move the Levels slider. This line is actually a curve; it just happens to be a straight curve when you first start moving the sliders. The curve is simply a graph of how the tones in your image are being altered. It shows how the original, input colors are remapped into new, output colors (**Figure 5.44**).

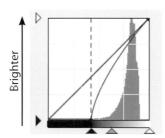

Figure 5.44 Where the curve curves upward, the tones in your image get brighter. A downward curve results in a darkening of that part of the curve.

Like the histogram, the left end of the curve corresponds to black, and the right end represents white. The histogram behind the curve makes it easy to understand which part of the curve corresponds to specific tones in your image.

The important thing to notice about the curve is that it's, well, curvy. Rather than simply brightening or darkening a specific tone, tones across a broad area are adjusted along the curve so that the brightening and darkening in your image is attenuated across the tonal range. This makes for a much more natural, realistic adjustment.

In Figure 5.44 you can see that the darker tones in the image have received more brightening than the lighter tones; the curve is more pronounced at the low end of the graph.

Adjusting individual channels

Most likely you've realized that the image we've been working with has a red cast to it. This cast was made worse when we increased the contrast in the image.

Directly above the histogram in the Levels and Curves Settings, you'll see an RGB pop-up menu. This indicates that the changes are being applied to the full, composite RGB image. But Levels and Curves also lets you operate on individual color channels. If you click the RGB menu, you can select a specific color channel to edit (**Figure 5.45**).

Figure 5.45 The pop-up menu above the histogram in the Levels and Curves dialog box lets you elect to operate on individual color channels.

Because this image has a red cast, let's select the Red channel, and then perform a gamma adjustment on that channel to darken, or reduce, the amount of red in the image (**Figure 5.46**).

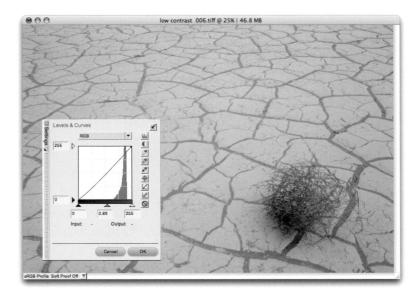

Figure 5.46
Here we made a very slight midpoint adjustment to the red channel to reduce the amount of red in the image. This lessens the reddish cast.

The Red channel adjustment does not eliminate the RGB adjustment you made earlier. You can make separate adjustments for each channel within the same Levels and Curves adjustment.

Channel adjustments are often the easiest way to deal with specific color problems. However, Capture NX provides some additional, easier tools that often solve many color problems.

TIP In the Levels and Curves dialog box, you can automatically switch to the red, green, or blue channel editor by pressing Command/Control-1, 2, or 3. To switch back to RGB view, press Command/Control-~.

Levels and Curves eyedroppers

To the right of the Levels and Curves histogram are a series of buttons that provide very simple mechanisms for defining the white, black, and midpoints in your image (**Figure 5.47**).

Show Before/After Histogram gives you a quick way to see how your histogram has changed. Simply click and hold the button to see what your histogram will look like after the Levels and Curves adjustment is applied. This is a good way to see if your histogram is getting too "combed" (see the sidebar "What Does a Combed Histogram Mean?").

Figure 5.47 From top to bottom, the Levels and Curves buttons are Show Before/After Histogram, Auto Contrast, Set White Point, Set Neutral Point, Set Black Point, Add Anchor Point, Reset Current Channel, and Reset All Channels, Reset this Effect.

Auto Contrast automatically sets the white point and black point of each color channel. Basically, it moves the edges of the data, just like you did manually. Auto Contrast aims for a fairly contrasty look. By default, it discards half a percent of the brightest and darkest pixels in your image, but you can change this behavior using Capture NX's Preferences.

To change the amount of white and black clipping that Auto Contrast performs:

1. Open the Capture NX Preferences and click the Levels and Grid tab (Figure 5.48).

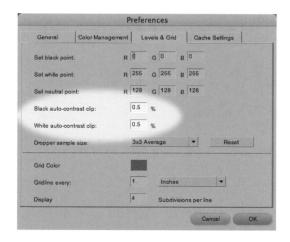

Figure 5.48 Using the Capture NX Preferences, you can change the amount of contrast produced by the Levels and Curves Auto Contrast feature.

2. Change the percentage values in the *Black auto-contrast clip* and *White auto-contrast clip* fields. Higher numbers cause the function to clip more data, resulting in a more contrasty image.

Auto Contrast works well on some images, but can often yield bad color casts and too much contrast.

Reset Current Channel, Reset All Channels undoes any adjustments you have made.

Reset this Effect lets you see a before and after version. Click and hold to see your original, unadjusted image.

Perhaps the most useful of these tools are the Set White Point, Set Neutral Point, and Set Black Point eyedroppers, which allow you to automatically define points by clicking in your image.

With the White Point eyedropper, click on something in your image that is supposed to be white, and Capture NX sets the white point so that tone is represented as white (**Figure 5.49**).

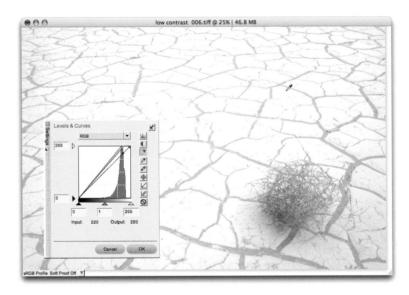

Figure 5.49
We clicked with the
White Point eyedropper
to set the white point
in this image. Notice
that the histogram
now shows separate
red, green, and blue
curves, indicating that it
adjusted each channel
separately.

The Black Point eyedropper works the same way, but sets the black point.

With these eyedroppers, why would you ever set Levels by hand? Because, as you can see in Figure 5.38, there will be times when there is no white or black in your images. In these instances, you'll want to set the white and black points manually.

The Set Neutral Point eyedropper lets you easily neutralize color casts. To use it, click on something in your image that should be gray. Capture NX automatically adjusts the individual color channels to render the tone gray, thus neutralizing the color cast in your image (**Figure 5.50**).

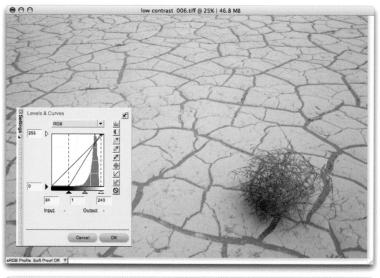

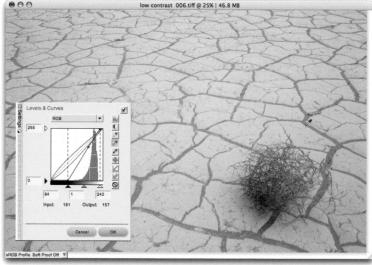

Figure 5.50 If you click with the Set Neutral Point eyedropper on an area in your image that should be gray, Capture NX neutralizes any color casts. Again, you can tell from the histogram that it has made changes to each color channel.

TIP If you're working with an individual channel, you can hold down the Option/Alt key while clicking with either the White Point or Black Point eyedropper to constrain your edit to the current channel.

What Does a Combed Histogram Mean?

As you edit your images, your histogram begins to show *combing*, areas where there are no tones or where there are big single-pixel spikes (**Figure 5.51**). I've already discussed how the Levels control stretches and squashes the tones in your images, expanding some areas to make them brighter and compressing others to make them darker. When an area is expanded, the tonal information that it contains must be stretched out to fill the wider tonal range. Because there is a finite amount of tonal information in your image, Capture NX cannot magically fill a wider tonal range with a limited amount of data, so it must leave some tones empty. These are the blank spots in the histogram.

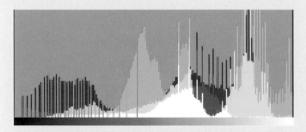

Figure 5.51 Your histogram will show combing and spiking as your edits cause data loss.

When a tonal range is compressed, Capture NX must throw out some tones to fit the data into the smaller space. These discarded tones appear as spikes.

Except for White Balance adjustments to raw images, *all* image adjustments will usually result in some data loss, so don't panic if you start to see combing in your histogram. It's a normal part of image editing. However, too much data loss can appear as visible artifacts in your image. We'll explore this problem in more detail in the next chapter.

Adjusting curves

In the Levels discussion, you saw how the black curve represents your Levels adjustment changes as you move the Levels sliders around. If you prefer, you can also edit this curve directly by clicking on it and dragging to reshape it. The advantage of manipulating the curve directly is that you can add as many control points as you want to create a curve shape that can't be achieved with the Levels sliders. Direct curve manipulation lets you create very isolated tonal adjustments; that is, tonal adjustments that affect a very specific part of the image's tonal range.

Consider the image in Figure 5.52.

Figure 5.52 This image needs a little brightening. However, we'd like the black stripe on the side of the building to remain black.

It's a little dull in the midtones and could use a contrast boost. However, you want to be very careful that you don't brighten the black stripe on the side of the building. Try to keep it very black as you manipulate the other tones in the image.

Instead of using Levels, manipulate the curve directly. To reshape the curve, simply click somewhere on it and drag. The curve is a bit like a rubber band—as you pull one part of it, the rest of it changes. You'll often need to add additional points to "lock down" part of your curve, so that you can isolate the specific tonal range that you want.

With a few simple control points, you can improve the contrast in the image while preserving the darkness of the black stripe (**Figure 5.53**).

Remember, each part of the curve represents a different range of tones. Where the curve goes downward, those tones are darkened. Where it bends upwards, tones are lightened.

Figure 5.53 To correct this image, we defined a curve that darkened some shadow tones, brightened some midtones, and darkened some of the brightest whites in the image.

Highlight and Shadow Clipping Displays

Capture NX can show clipping displays that indicate exactly which highlights and shadow tones in your image are clipped (that is, overexposed or underexposed). If you choose View > Show Lost Highlights (or press Shift-H), any clipped highlights in your image will appear colored (**Figure 5.54**).

Figure 5.54 Show Lost Highlights indicates any clipped pixels by coloring them. Different colors indicate clipping in specific channels, or combinations of channels.

Pixels that are clipped in all three channels appear white. Areas that are clipped in only the red, green, and blue channels appear in those colors. Pixels clipped in only two channels are displayed in the appropriate secondary color. Pixels that aren't clipped at all appear black.

Choose View > Show Lost Shadows (or press Shift-S) to see a similar display that shows clipped shadow tones.

Contrast/Brightness

Capture NX's Contrast/Brightness adjustment offers a different control for manipulating the contrast in your image. Operating like the controls that you might find on a TV set, Contrast/Brightness provides two simple sliders for making adjustments. Contrast/Brightness is somewhat of a blunt tool—it doesn't provide near the finesse and power of Levels and Curves—but keeping a careful eye on your histogram will help you keep the Contrast/Brightness adjustment under control.

You add a Contrast/Brightness adjustment by selecting Adjust > Light > Contrast/Brightness. The adjustment appears in your Edit List, and the Contrast/Brightness Parameters palette reveals your controls, which include two simple sliders, one for Contrast and the other for Brightness.

The Contrast slider is akin to simultaneously adjusting the white and black points in the Levels and Curves adjustment. The Brightness slider shifts the entire tonal range up or down to brighten or darken your image. Capture NX's Contrast/Brightness adjustment is fairly smart about the way that it makes its adjustments, so you shouldn't see color shifts or casts developing as you move the sliders.

To use the feature, you'll probably need to go back and forth between both sliders. For example, **Figure 5.55** shows another low-contrast image to which we'll add a Contrast/Brightness edit by selecting Adjust > Light > Contrast/Brightness.

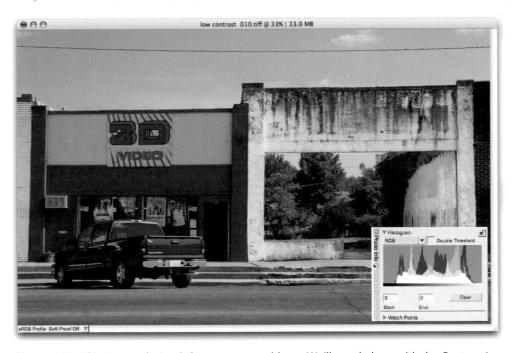

Figure 5.55 This image obviously has contrast problems. We'll attack them with the Contrast/Brightness edit.

Since the problem is lack of contrast, begin by moving the Contrast slider to the right to increase the contrast (**Figure 5.56**).

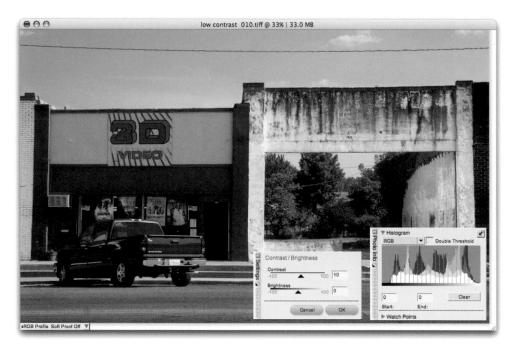

Figure 5.56 Begin by increasing the contrast by sliding the Contrast slider to the right.

However, you can't increase the contrast too far before you begin to clip the whites. Also, note that there still isn't any true black. Use the Brightness slider to shift the entire tonal range down a bit (**Figure 5.57**).

With the extra headroom that was created by darkening the image, you can make another Contrast move to further expand the contrast in the image (**Figure 5.58**).

As you can see, Contrast/Brightness doesn't provide the fine degree of control that Levels and Curves provides, but if you keep an eye on your histogram while you're working, you can make good use of the tool.

Figure 5.57 By next lowering the Brightness, not only do some of the blacks fill in, but a little headroom frees up above the whites.

Figure 5.58 One final Contrast adjustment produces strong tones from black to white.

Managing Your Edits

You can change any edit in the Edit List into a different type of edit by choosing from the pop-up menu that's included in every edit entry (**Figure 5.59**).

Figure 5.59 You can change an edit to a different type of edit by selecting a new edit type from the pop-up menu that's included in every edit's control panel.

So, if you try a Contrast/Brightness adjustment and decide it doesn't provide the control you need, you can simply change the Contrast/Brightness edit to a Levels and Curves edit and configure as you please.

Capture NX's nondestructive editing paradigm means that you can keep several different edits within one document. For example, if you've tried two different Levels adjustments and you're not sure which you like better, you can keep both in the document and simply activate the one you want to use.

Capture NX has other versioning options, which we'll explore in the next chapter.

D-Lighting

When you use the Levels and Curves edit to change the value of a dark tone in your image, all of the tones that have that value are altered. While this might serve to brighten a shadow area, it might also brighten dark pixels that are supposed to be dark.

D-Lighting is a tonal adjustment tool that you can use to brighten shadow areas or darken highlights. When you brighten a shadow using D-Lighting, Capture NX automatically analyzes your image to determine which dark pixels are shadows, and brightens only those. Dark pixels that are simply dark objects are left unaffected.

To use D-Lighting to brighten shadows:

1. Open an image that needs its shadows brightened. In this example, we'll use a portrait that really should have been shot using a fill flash. The shadow on the right half of the man's face is too dark (**Figure 5.60**).

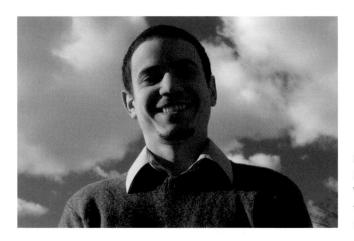

Figure 5.60 This image should have been shot with a fill flash. We'll use the D-Lighting edit to brighten the shadow on the man's face.

- **2.** Add a D-Lighting edit to the image by choosing Adjust > Light > D-Lighting. A D-Lighting edit is added to the Edit List.
- **3.** Drag the Adjustment slider to the right. Your shadows will brighten (**Figure 5.61**).

Figure 5.61 You can brighten the shadows by simply dragging the Adjustment slider to the right.

That's all there is to it. D-Lighting does the rest. It analyzes the image to determine which tones are shadow tones and automatically brightens them. Notice that it rolls off the brightening around the shadow to produce a more realistic effect.

If you choose the Better Quality option, the Adjustment slider will have more sensitivity, allowing for a more subtle, higher-quality effect (**Figure 5.62**). In this mode, the adjustment is more computationally intensive, but on a reasonably fast computer you shouldn't notice a significant difference in performance.

Figure 5.62 Better Quality mode allows for a finer degree of shadow control, allowing you to create more subtle, realistic improvements.

The Color Boost slider that is available in both Better Quality and Faster mode allows you to increase the color saturation in the shadow areas. Sometimes, as you brighten a shadow it becomes slightly washed out. Color Boost allows you to restore some of the color that's lost in the brightening process (**Figure 5.63**).

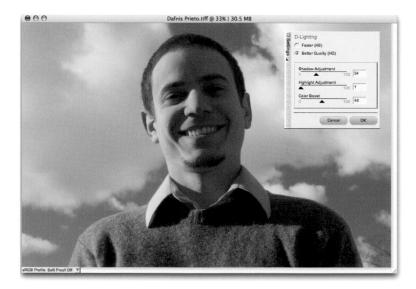

Figure 5.63 The Color Boost slider lets you restore some of the color saturation that gets lost in the shadow brightening.

LCH

As you'll see in the next section, the LCH edit provides some very sophisticated color manipulation controls. However, it can also be used to great effect for your tonal corrections.

LCH stands for Lightness, Chroma, and Hue. With the LCH editor, you can manipulate any of these parameters without affecting the other. The practical upshot for tonal corrections is that you can change the lightness in an image without affecting any of the color.

When you first add an LCH adjustment (Adjust > Color > LCH), you'll see the Master Lightness editor (**Figure 5.64**). The controls in this editor work just like the Levels and Curves controls that you've already learned about.

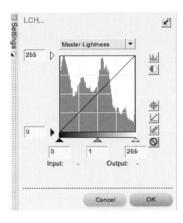

Figure 5.64 The Master Lightness controls in the LCH adjustment provide controls similar to the Levels and Curves adjustment, but with some important under-the-hood differences.

The Levels and Curves edit makes its changes by manipulating the red, green, and blue channels in your document. Because it is directly manipulating individual color channels, there are times when heavy adjustments can produce color shifts in your image.

For example, if you look closely at the building image that was edited earlier, you'll see a pronounced red shift along the boundaries of some of the shadows after using the Levels and Curves edit (**Figure 5.65**).

The Master Lightness control in the LCH edit lets you make the same types of tonal adjustments but without any hue shift (**Figure 5.66**).

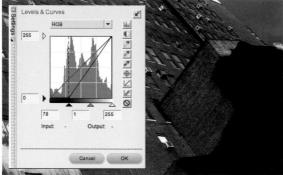

Figure 5.65 In this before and after, you can see how a strong Levels adjustment can introduce color shifts in your image. Note how the bricks picked up a strong red cast, especially in the shadow transition area.

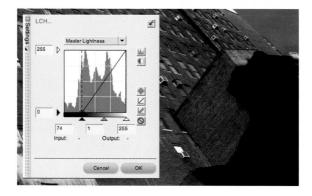

Figure 5.66 Making the same edit with the LCH adjustment lets you improve the tone of the image without picking up any hue shift.

So why wouldn't you use LCH for all of your tonal corrections? Because as you've seen, there are times when you need to neutralize color casts in your image or perform other single-channel edits. Also, you may simply prefer the look of a Levels and Curves adjustment. Sometimes, the hue and saturation boost provided by Levels and Curves is very pleasing.

We'll look at the rest of the LCH controls in the next section.

TIP If you're not sure how to use the controls in the Master Lightness section of the LCH edit, consult the explanation in the "Levels and Curves" section earlier in this chapter.

ADJUSTING COLOR

After completing your tonal adjustments, you'll be ready to consider any color adjustments that your image might need. Very often, your tonal adjustments will correct many of the color problems that your image may have. For those times when you need a little more color control, Capture NX provides several color correction edits.

LCH

You've already seen how you can use the Master Lightness control in the LCH edit to adjust the brightness tones without affecting their hue. LCH provides some additional controls for affecting the color values in your image.

You can add an LCH edit to your image by selecting Adjust > Color > LCH. The LCH Settings palette actually contains several different editing controls. At the top of the palette is a pop-up menu that lets you choose which of the LCH editors you want to work with (**Figure 5.67**).

Figure 5.67 The pop-up menu at the top of the LCH Settings palette lets you select which LCH editor you want to use.

Color Lightness controls

The Color Lightness controls let you alter the brightness of a color without changing its hue. With Color Lightness, you can zero in on specific hues in your image and lighten or darken them.

To use the Color Lightness controls to brighten a hue:

- 1. Add an LCH edit to your image by selecting Adjust > Color > LCH.
- **2.** Choose Color Lightness from the Channel pop-up menu.
- **3.** Without clicking, drag your mouse to the color in your image that you want to change. A small circle appears on the curve in the Color Lightness display (**Figure 5.68**). This circle indicates which part of the curve corresponds to the color you're pointing at.

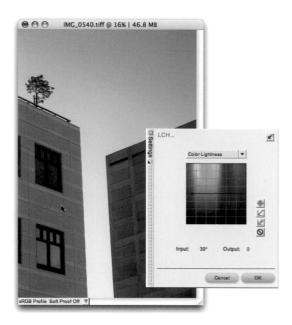

Figure 5.68 The small circle on the Color Lightness curve shows you the location of the color value that your mouse is currently pointing at.

- **4.** Click on the indicated part of the curve and drag upwards. A small spike appears in the curve.
- **5.** Notice the small slider control directly beneath the Color Lightness color ramp. Drag it to the right (**Figure 5.69**).

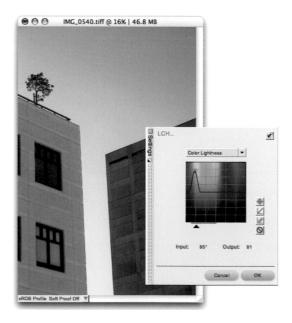

Figure 5.69 We used the Color Lightness controls to lighten the yellow tones of this building.

When you click a point on the curve, you select the color you want to adjust. The farther you drag up or down, the more the color will be altered. Dragging up brightens, whereas dragging down darkens. The hue of the color doesn't change.

The slider control lets you specify how many neighboring tones are adjusted. By moving the slider back and forth, you can create more realistic transitions around your edit.

Chroma

The LCH Chroma editor lets you change the saturation of your image—or just a part of your image—without changing the hue or lightness. The Chroma controls work just like the Color Lightness controls. You can click on the curve to indicate which hues you want to adjust, and then drag up or down to add or remove saturation (**Figure 5.70**).

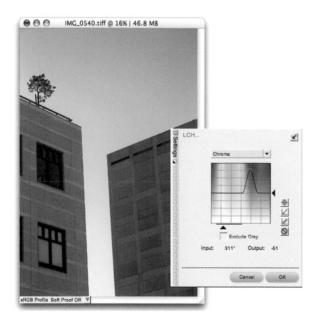

Figure 5.70 Here we increased the saturation of the blues in the image without affecting the yellow building at all.

Note that the Chroma curve has an additional control on the right side: This slider lets you drag the entire curve up or down to change the saturation of the entire image.

The Exclude Gray option lets you protect the grays in your image from any adjustment.

Hue

The Hue adjustment lets you change hues without affecting saturation (chroma) or brightness (**Figure 5.71**).

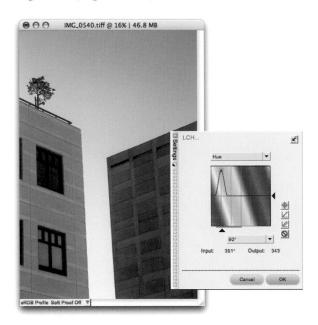

Figure 5.71 We used the LCH Hue adjustment to change the hue of the yellow building to a truly ugly shade of green. Note that none of the other hues in the image were affected, and the overall brightness and saturation of the affected area has remained unchanged.

The controls work the same as Color Lightness: Select the point on the curve that you want to edit, and then drag it up or down. Use the slider to control the width of the edited part of the curve. Choosing options from the pop-up menu beneath the curve display lets you increase the amount of hue change that the edit applies.

Color Balance

The Color Balance edit lets you adjust the amount of red, green, and blue in your image, as well as the contrast and brightness. Unlike the LSH adjustment, Color Balance makes no effort to preserve the hue, saturation, or lightness; it simply allows you to add more or less of each color.

To use Color Balance:

- 1. Select Adjust > Color > Color Balance, or press Command/Control-B to add a Color Balance edit to your document's Edit List. The Color Balance Settings palette appears.
- 2. Move the Red slider to shift the color in your image from cyan to red. Move the Green slider to shift the color from magenta to green, and move the Blue slider to shift from Yellow to Blue. You can use the Contrast and Brightness sliders to perform the same edit you'd make with the Contrast/Brightness edit.

Color Balance is something of a brute force tool, but you can use it to attack color casts or change the overall color tone of an image (Figure 5.72).

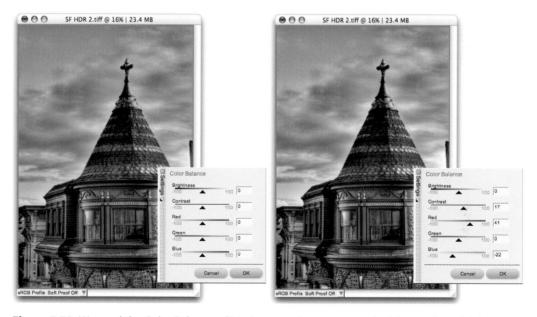

Figure 5.72 We used the Color Balance edit to increase the contrast and add warmth to this image.

Color Booster

The Color Booster edit (Adjust > Color > Color Booster) lets you increase the saturation of an image, but offers the option of protecting skin tones. Usually, increasing the saturation of skin tones turns people weird orange colors. With the Color Booster, you can simply check the Protect Skin Tones check box to protect skin tones from the effect of the edit (**Figure 5.73**).

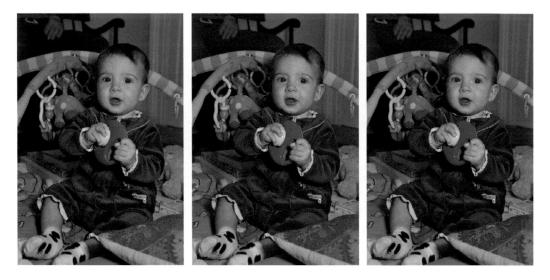

Figure 5.73 We took the original image shown on the left, applied a Color Booster edit to produce the more saturated image shown in the middle, and then activated the Protect Skin Tones option to produce the image on the right. The result is a nicely saturated image with good skin tones.

Note that you'll also find a Color Booster effect in Base Adjustments > Light and Color Adjustments. This effect provides the same controls as the Color Booster, but with an additional Auto button, which analyzes the brightness in the image to determine an appropriate boost amount.

Saturation/Warmth

With the Saturation/Warmth edit (Adjust > Color > Saturation/Warmth) you can increase or decrease the saturation in an image by simply sliding the saturation slider (**Figure 5.74**).

The Saturation adjustment in the Saturation/Warmth edit is a little more aggressive than the adjustment in the Color Boost edit, and it has no provision for protecting skin tones from adjustment.

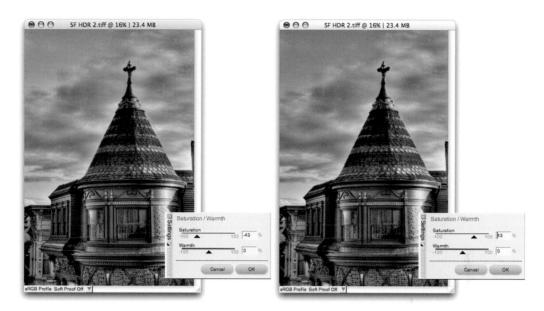

Figure 5.74 Using the Saturation slider in the Saturation/Warmth edit, you can increase or decrease the saturation in an image.

The Warmth slider lets you warm or cool the colors in your image (Figure 5.75). The Warmth slider produces an effect similar to what you can achieve with the White Balance adjustment when working with raw files.

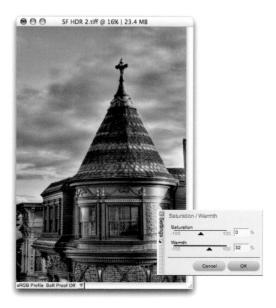

Figure 5.75 With the Warmth slider you can easily warm or cool the colors in an image.

PROCESSING RAW IMAGES

All of the features discussed so far apply to TIFF, JPEG, or raw files. However, if you're working with raw files, the Capture NX Base Adjustments edit provides some additional functions and editing options.

TIP Remember, Capture NX can only process Nikon-format raw files.

Capture NX's raw processing features are divided into two main categories within the Base Adjustments edit: Camera Adjustments and Raw Adjustments.

Raw Theory 101

When you shoot in JPEG mode, your camera performs a lot of internal processing to convert the information that the sensor captures into a finished color image. Your camera includes several internal settings that allow you to specify different qualities of sharpness, saturation, and contrast. These adjustments are made by the camera during the conversion from raw to JPEG.

When you shoot in raw mode, your camera simply writes the data that the sensor captures directly to the camera's storage card. No internal processing is performed. Instead, you use a raw converter application (like Capture NX) to do the raw conversion for you. When you open a raw file in Capture NX, it does the same type of conversion that your camera does internally, resulting in a full-color image.

There are many advantages to shooting in raw:

- Because you're in control of the raw conversion, you can tweak the conversion settings to your particular tastes.
- JPEG files are limited to 8 bits of data per pixel. Your camera probably captures 10–12 bits of data
 per pixel, which means a lot of color information must be thrown out during the conversion to
 JPEG. With raw files, you can preserve the full bit depth of your original image, which provides you
 with images with far greater editing latitude.
- In raw mode you can adjust white balance after you shoot. When you change white balance in a
 raw converter, you alter the raw converter's fundamental understanding of red, green, and blue. So,
 making a white balance change does not "use up" any of the dynamic range in your image, meaning you can perform additional edits without risking tone breaks or posterization.

Camera Adjustments (for Nikon Raw Shooters Only)

If you're working with a raw file, Base Adjustments will show a Camera Adjustments category. The five adjustments in this category (Color Mode, White Balance, Tone Compensation, Saturation, and Sharpening) might look familiar—they're also present in the menu on your Nikon camera. All of these adjustments change the color and tone in your image, but when you configure these options in your camera while shooting raw, no

changes are made to your actual image. Instead, the adjustments you specify are stored in the raw file that your camera produces.

Capture NX uses these parameters during its raw conversion, and you can alter them within Capture NX. The options provided by some of these adjustments—such as Color Mode—varies from camera to camera. Your manual includes details about the settings available on your particular mode.

Color Mode. Nikon cameras come with predefined color modes that specify different hue, saturation, and tone qualities in your image. Consult your manual for the specifics of each mode.

White Balance. White balancing is the process of calibrating the color in your image for the type of light in which you are shooting. You set a White Balance setting when you shoot, and Capture NX uses this information to properly adjust the color in your image. When you shoot raw, you have full control over the white balance of your image.

The White Balance edit lets you select all of the same white balance choices that your camera provides: Incandescent, Daylight, Florescent, and Flash. Other choices include:

- Recorded value, which uses the White Balance setting stored in the file.
- Calculate Automatically, which uses an auto white balance mechanism that generates a White Balance setting based on an analysis of the image.
- *Use Gray Point*, which uses a gray point that you select in your image as the basis for determining white balance.

When you select a predefined White Balance setting such as Daylight, the White Balance Settings palette displays additional controls (**Figure 5.76**).

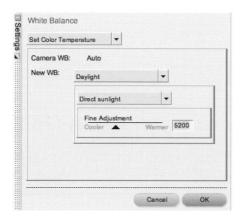

Figure 5.76 Some White Balance settings, such as the Daylight setting, include additional options.

All presets allow you to fine-tune the setting by using the Fine Adjustment slider. Slide it to the left to make your image cooler; move it to the right to add warmth. The Daylight preset also offers a pop-up menu containing additional presets.

Using the Gray Point option is the easiest way to correct the white balance in an image.

To correct white balance with a gray point eyedropper:

- **1.** Select Base Adjustments > Camera Adjustments > White Balance edit. The White Balance Settings palette opens.
- **2.** Choose Set Gray Point from the Set Color Temperature pop-up menu. A new group of controls appears (**Figure 5.77**).

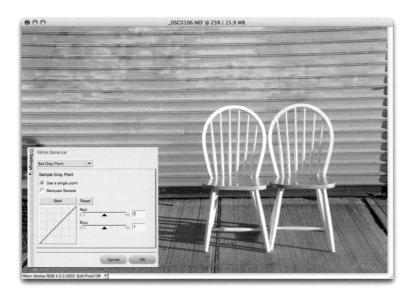

Figure 5.77 Using the Set Gray Point controls, you can set the white balance of your image by clicking within the image.

- **3.** Click the Start button.
- **4.** Click on something in your image that should be neutral gray. Capture NX automatically calculates a new White Balance setting (**Figure 5.78**).
 - If you want to refine your white balance—to warm it up or cool it down—adjust the Red and Blue sliders.
- 5. Click OK to accept the new white balance. Remember, like all other edits, white balance is nondestructive, so you can always go back and change it later if you want to.

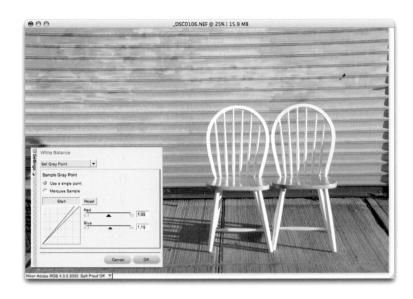

Figure 5.78 With a single click, we were able to correct the white balance in this image.

Sometimes, a gray pattern in your image is actually composed of a number of slightly varying pixels, so it can be difficult to know if you're clicking on the specific pixel that is the gray you want. This is especially true with noisier images. For these instances, click Marquis Selection. When you click Start, you'll be able to drag a selection around a group of pixels. Capture NX then averages the selection to come up with a single, more accurate gray value.

TIP If you want to throw out the current White Balance setting and start over, click the Reset button.

Earlier, you saw how using Levels and Curves, or any of the other tonal correction tools, pushes and pulls the data in your image. This results in data loss that can appear as artifacts in your image. A White Balance adjustment on a raw image does *not* incur any data loss. The raw converter simply changes its basic idea of what red, green, and blue are, so white balance corrections are "free" edits. You should do as much color correction as you can using the White Balance edit.

Tone Compensation. Many Nikon cameras offer a choice of different "tone curves." The tone curve you choose affects how the overall contrast in your image will be rendered. The Tone Compensation edit provides you with the same Tone Compensation options that you'll find in your camera. Consult your camera manual for more information.

Saturation. Your camera also contains a number of preset Saturation settings. Using this adjustment, you can select which saturation setting you'd like to use.

Sharpening. Similarly, you can elect to choose one of the preset Sharpening settings. You'll be best served by keeping this Sharpening setting to a minimum and using an Unsharp Mask edit to perform your sharpening chores. We'll explore Unsharp Mask in the next chapter.

Applying camera adjustments from the browser

As discussed in Chapter 3, when working in the Capture NX file browser, you can open the Camera Settings pane to examine the EXIF information stored in your images. At the bottom of this pane, you'll find a group of Raw controls (**Figure 5.79**).

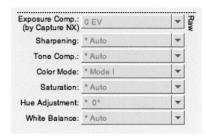

Figure 5.79 The Raw controls in the Camera Settings pane provide the same Camera Adjustment parameters that you'll find in the Base Adjustments edit.

With these simple pop-ups, you can adjust the same Camera Adjustments parameters that are included in the Base Adjustments edit. Tweaking your adjustments in the browser is a quick way of making adjustments without having to open and save your images.

Raw Adjustments

While the Camera Adjustment parameters let you apply broad image quality settings to your image, the Raw Adjustments provide a much finer level of control, and you'll probably perform the bulk of your raw fine-tuning using these settings.

Exposure Compensation lets you brighten or darken your image by up to two stops. Like White Balance, performing an Exposure Compensation adjustment on a raw image is a free edit. The tones in your image—the whole mess of them—are simply shifted up or down. No redistribution happens, so you don't have to worry about data being discarded or stretched. Consequently, if your image needs overall brightening or darkening, it's best to do that with Exposure Compensation. You can refine it later using your tonal adjustment tool of choice.

Exposure Compensation has another important function: It can often restore overexposed highlights. Sometimes, when you overexpose an image, it doesn't get clipped in all three channels. If an image is clipped in only one or two channels, Capture NX can use the remaining channel (in addition to some other tricks) to restore detail to the clipped highlight areas (**Figure 5.80**).

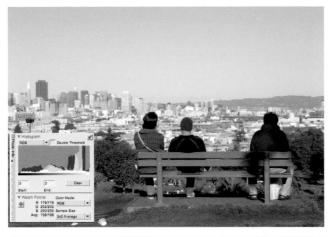

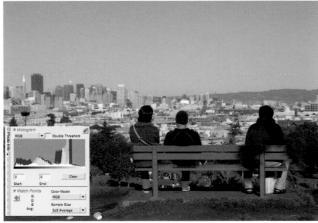

Figure 5.80 Highlight recovery example

Obviously, the resulting image will be much lighter, but you can use other adjustments, such as Levels or D-Lighting, to restore brightness to the image without reclipping your highlights.

Hue Adjustment allows you to alter the hue of your image without changing brightness or contrast. As you move the Hue Adjustment slider to the right, skin tones become more yellow. Move the slider to the left and they redden.

Color Moiré Reduction applies special noise reduction algorithms that can reduce moiré artifacts in the colored parts of your image.

Dust Off removes dust from your image. If you regularly change lenses in the field, there will come a time when you'll have images with visible sensor dust. Sensor dust appears as smudges or blotches in your image. If your Nikon camera supports it, you might be able to use a Dust Reference Image to automatically remove the dust from your image.

To automatically remove dust from an image:

- **1.** Shoot a dust reference photo. Consult your camera's manual for details on how to do this.
- 2. Place the dust reference photo in the same folder as the image you want to edit.
- **3.** Click the Dust Off edit in Base Adjustments > Raw Adjustments. Capture NX automatically removes the dust from your image.

Dust can move and change, so it's best to shoot a dust reference image close to the time when you took the picture or before you change lenses.

Auto Color Aberrations can cause artifacts. By default, Capture NX automatically tries to reduce color fringing artifacts in raw files. If you suspect that this feature is causing additional types of artifacts, turn it off by unchecking it in the Edit List.

An Ounce of Prevention Is Worth a Dust Off Edit

The best way to deal with dust is to make sure it never becomes a problem. Most sensor dust comes from camera and lens components. Keep the camera end of your lenses clean and use a blower brush to blow out the mirror chamber of your camera.

Never spray compressed air into the mirror chamber of your camera!

The liquid propellant used in compressed air canisters can leave residue on your sensor.

If you end up with a sensor problem, consult your camera's manual for details on cleaning. Companies such as visibledust.com offer extremely effective sensor cleaning products.

SAVING FILES

After you've edited an image, you have several options for saving it. Because of its non-destructive nature, saving in Capture NX is a little more complex than in a normal image editing program. You need to decide if you want to save a finished "baked" image that has all of your edits applied, or if you want to save a version of the image that you can return to later to alter and adjust your edits.

Working on a JPEG or TIFF File

If the file you opened was originally a JPEG or TIFF and you choose File > Save, the edits that you've made will be applied to the image, and then be written out in its original format. However, if you later open the image in Capture NX, you won't have access to any of the edits that you made—your Edit List will be empty.

If you want to preserve your edits for later adjustment, choose File > Save As and choose NEF from the File Format pop-up menu.

While many people think that NEF is simply Nikon's raw file format, it's actually much more. NEF files can contain normal bitmap data such as TIFF and JPEG data, along with XML data such as the Edit List that you create in Capture NX. When you open this file later, all of your edits will be preserved.

You'll probably end up saving two versions of your edited image: a NEF version containing all of your edits and a TIFF or JPEG version that you deliver to your client or send to another editing program for additional edits.

TIP To maintain the most quality, save your TIFF files as 16-bit TIFFs. Capture NX provides both 8-bit and 16-bit TIFF options.

Working on a Raw File

If you're working with a raw file, your file is already stored in NEF format. Executing a simple Save command writes your Edit List into the file. When you next open the file, all of your edits appear in the Edit List. However, if you want to give the file to others, they will have to have Capture NX to be able to read and view it. If you'd rather deliver a "normal" file to them, choose Save As to export a TIFF or JPEG file.

NEF Options

When you save a NEF file, Capture NX presents you with a Save Options Dialog that contains two simple check boxes (**Figure 5.81**).

Figure 5.81 When you save a file as a NEF, you are presented with these two simple options.

Use Compression applies a compression algorithm to the NEF file to make it smaller. There's some debate amongst nitpickers as to whether this compression is lossless or not. If there is data loss, it appears to be impossible to see. If you're skeptical of such technology, simply leave this box unchecked. However, if disk space is a premium, you might want to consider making some comparisons of your own to determine if you find compressed NEF files acceptable.

Embed ICC Profile lets you embed a custom color profile in the resulting files.

JPEG Options

When you save a file as JPEG, the Save Options Dialog includes a check box for embedding an ICC profile, as well as a Quality slider that lets you select how much compression you want applied to the file. The Quality menu provides preset compression levels labeled with simple descriptions of quality versus balance (**Figure 5.82**).

Figure 5.82 Saving a file as a JPEG results in these save options.

TIFF Options

When TIFF is selected for saving, the Save Options Dialog provides the standard set of TIFF options, including Bit Depth, Color Mode, Compression settings, and Embed an ICC Profile.

CHAPTER S Advanced Image Editing

In the previous chapter, you learned how to use Capture NX's tone and color correction controls to make adjustments to your entire image. But there will be many times when you'll want to make adjustments to just one part of an image. Sometimes, only the foreground in an image needs to be brightened, or the foreground needs to be brightened and the background needs to be darkened. If you're coming from a wet darkroom background, you can think of localized editing as a supercharged form of dodging and burning. But where dodging and burning let you change localized exposure, Capture NX lets you make localized changes to *any* type of adjustment.

KNOWING HOW FAR TO PUSH AN EDIT

Learning how to use Capture NX's editing tools is pretty simple, and you'll quickly get comfortable using them. Knowing *when* to use them is the part that takes practice. A capable image editor like Capture NX provides a limitless array of editing possibilities. This means a limitless array of choices, which can sometimes lead to a frustrating array of choices. When it's possible to do just about anything to an image, knowing what to do can be difficult. Equally confusing is when you have three or four different versions of an image and aren't sure which one you like best.

Very often, the best way to find your way out of such confusion is to limit your choices, and you can almost always limit your choices by using a technical measure. When you push an edit too far, your image quality starts to degrade, and image artifacts begin to appear. Sometimes, if you simply observe this boundary, your editing options will quickly narrow.

For example, in Chapter 5, "Basic Image Editing," we used the D-Lighting edit to brighten the shadowy side of a face in a portrait (see Figure 5.61). If you look closely at the shadow beneath the man's shirt color, you'll see *tone break* and *posterization* artifacts (**Figure 6.1**).

Figure 6.1 If you push an edit too far, so many tones will be discarded that you'll begin to see tone breaks and posterization in your image. This close-up of Figure 5.61 reveals bad artifacting underneath the shirt collar.

Chapter 5 also discussed how your image editor must throw out data as it redistributes tones when you edit. As it throws out data, the gradients in your image become less smooth. You'll usually notice this in the transitions from shadows to highlights, in skies, and chromed or other reflective surfaces (**Figure 6.2**).

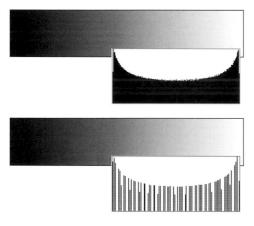

Figure 6.2 If we posterize this gray ramp, banding becomes visible because there are no longer enough tones to make a smooth transition from black to white. This same type of artifacting can appear in the gradients in your image if you push your edits too far.

So keep an eye on these areas in your image while you're editing. If you start to see artifacts appear, you might want to back off of your edits. Of course, there will be times when you don't mind technical perfection; for example, overexposed, noisy images can be very evocative. But for the most part keeping an eye on editing quality will help you make better decisions about which edits to make.

CHANGING COLOR SPACE

In Chapter 4, "Preparing to Edit," I introduced the idea of *color spaces*—mathematical domains into which the colors in your image are mapped. Color spaces are necessary to know which real-world colors correspond to the numeric values that your camera captures.

As explained earlier, your camera lets you specify the color space that you want your images mapped into—usually either sRGB or the larger Adobe RGB. If you're shooting JPEG or TIFF images, your color will be permanently altered to fit into these color spaces.

If you're shooting raw, you can select which color space you want to use in Capture NX. Because NX is nondestructive, you can change the color mode of a raw file at any time; the program simply remaps the colors into the new space.

Capture NX lets you *apply* a profile, which assigns a specific input profile to your image, or *convert* your image to a specific profile. Probably the only time you'll need to apply a profile is if you're doing a studio shoot and you have carefully built a profile for your camera and current lighting situation.

To apply a new color space to an image:

- 1. Choose Adjust > Color Profile. The Color Profile Settings palette opens.
- 2. Click Apply Profile.
- 3. From the pop-up menu, select the profile you want to assign.
- 4. Click OK when finished.

The image on your screen might appear different from the original. But none of the color values in your image have been changed. In other words, if the profile you apply is smaller than the original profile, the colors in your image will not be clipped to the smaller profile.

However, when you convert an image to a different profile, the actual color values in the image are changed to fit the image into the new profile. There are a few occasions when you might choose to convert an image to a different profile:

- If you're going to post an image on a Web page, you might consider first converting it to sRGB.
- If you're sending an image to an online photo printing service, you might consider converting to sRGB since most online services expect sRGB images.
- If you're working with a printer or client who has very particular color space requirements, you might need to obtain a custom profile and convert your images to it.

To convert an image to a new color space:

- **1.** Choose Adjust > Color Profile.
- 2. Click Convert to profile.
- **3.** From the pop-up menu, select the profile you want to convert to.
- **4.** Pick a rendering intent from the Intent menu. In almost all cases, you'll want to use *relative colorimetric*. For more information on the rendering intents provided, consult the Capture NX Help file.
- 5. Click OK.

Note that, like any other edit, a color space change is simply an edit in your Edit List, meaning you can undo it at any time. Because color space changes are nondestructive, you don't have to worry about clipping any of the color out of your file with a color space change. If you convert to a smaller space and later decide you need your image in a larger space, you can simply change the Color Space edit accordingly.

Another way to think about the difference between applying a profile and converting to a profile is that apply changes the look of the image, but not the underlying numbers, whereas convert changes the underlying numbers, but not the look.

SELECTION BRUSHES

In the previous chapter you saw how you could use Capture NX's Tone and Color controls to make global changes to your images. That is, the tone and color adjustments you made affected the entire image. Very often, your entire image will need a contrast adjustment, or a saturation change, or a color cast removal or alteration. At other times, you'll want to limit the effects of an edit to one part of an image. Capture NX provides several ways to make these more localized, selective edits. In this section, we'll look at the program's Selection Brushes.

Brushing on an Effect

When you apply any Edit Step edit (that is, any edit that's not a Base Adjustment edit), the edit is automatically applied to the entire image. However, using Capture NX's Selection Brushes, you can interactively paint a mask that constrains your edit to specific parts of your image. You can brush an effect on or off, or use Lasso, Fill, and Gradient tools to refine your masks.

NOTE The edit must be open in the Edit List before you can begin brushing with the Selection tools. If the edit is closed and you begin brushing, Capture NX assumes that you want to add a Colorize edit and will add it automatically. If this happens, delete the new edit, open the edit you want to add a selection to, and then start your brush work.

The Selection tools are located in the rightmost palette just below the menu bar (Figure 6.3).

Figure 6.3 The Selection tools are located in the rightmost section of the toolbar.

Let's use a Selection Brush to increase the contrast in parts of the image shown in Figure 6.4.

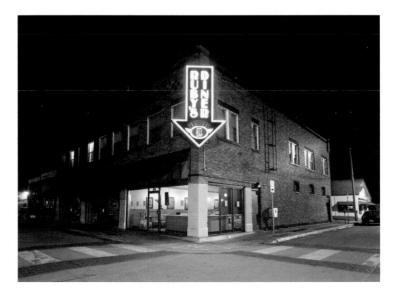

Figure 6.4 We'd like to increase the contrast in the brick textures in this image to bring out more detail.

- 1. Add the effect that you want to apply. In this case, add a Levels and Curves edit.
- **2.** Configure the edit just as you always would; however, the edit will affect the entire image. The goal is to increase the contrast in the bricks, so choose settings that make the bricks look the way you want them to look. Don't worry about how the rest of the image looks (**Figure 6.5**).

Figure 6.5
We configure the Levels and Curves adjustment so that the bricks in the image look the way we want. We're not worried about how the rest of the image is affected.

A selection, or mask, is just like a stencil that controls which parts of the image are affected by the edit you've applied. Right now, the entire image is being affected by the Levels adjustment. Let's change the stencil so that the effect doesn't impact the image at all.

Next to each Selection tool are + and – buttons. These allow you to change the mode of each tool. The + button sets the tool to add the effect to the image; the – button sets the tool to remove the effect from the image.

3. Click the + button next to the Selection Brush tool. The effect disappears, but note that it has not been removed from your Edit List. Also note that in the Edit List the Levels and Curves edit now shows Nothing Selected (**Figure 6.6**). Capture NX has deselected the entire image, meaning that the effect is not being applied to any of it. Because you selected the + Selection Brush, you can add to the selection by simply painting.

Figure 6.6 The Levels and Curves edit now shows that no part of the image is selected, meaning the edit is not affecting any part of the image.

4. Paint anywhere in the image that you want the effect applied. In this case, begin painting over the bricks in the image (**Figure 6.7**).

Figure 6.7 The Levels and Curves effect is applied to any part of the image that you paint into with the + brush.

The bricks on the building and street are now more contrasty. However, the far end of the building on the left side is a little too dark. Let's remove the effect from those bricks.

TIP You can change the size of the brush by using the bracket keys. The right bracket] enlarges your brush, and the left bracket [makes it smaller.

5. Click the – button next to the Selection Brush and brush onto the dark bricks on the left end of the building. The Levels and Curves effect is removed (**Figure 6.8**).

Figure 6.8 If you switch to the – Selection Brush, you can remove the Levels and Curves effect from the places in the image where it doesn't belong.

Note that the Levels and Curves entry in the Edit List now shows Partially Selected, indicating that you have painted selection information into the effect layer.

Now that you've defined the selection, it's a little easier to see if you have the right amount of Levels and Curves adjustment. If you want, you can go back and change the Levels and Curves settings, just as you normally would. Your selection remains the same, so you will see the contrast change appear only on the bricks.

View the Selection. You can choose View > Show Selection to see the selection that you've painted (**Figure 6.9**). White areas in the image are selected—your edit affects these areas; red areas are completely unaffected. Tones in between indicate partial selection.

Figure 6.9 Choose View > Show Selection to see a view of the mask that you've painted.

TIP You can also access the Show Selection option by right-clicking on your image (or Control-clicking if you're using a Mac without a two-button mouse).

Lassoing a selection

For those of you who prefer a Lasso tool to a paint brush, Capture NX provides an assortment of different lassos.

You use the Lasso Selection tools the same way you use the Brush tools:

- 1. Add the edit that you want to apply.
- 2. Use the Lasso tool to select the area you want the edit applied to.
- **3.** Adjust the edit settings, if need be.

If you click and hold on the Lasso tool in the Tool palette, Capture NX presents you with a selection of additional Lasso tools (**Figure 6.10**).

Figure 6.10 You can click and hold on Lasso and Marquee tools to view a menu of additional Lasso tools.

The regular Lasso lets you simply outline the area you want to select. The Polygon Lasso lets you click to define a polygonal selection region, and the Rectangle and Oval Lassos let you define, obviously, rectangular and oval selections.

TIP Double-click the Lasso tool on the toolbar to invoke the Lasso and Marquee options, which allow you to set an edge softness for the lasso.

Fill selections

At any time, you can select the entire image by clicking the + button next to the Fill tool (**Figure 6.11**). Conversely, you can completely remove a selection by clicking the – button next to the Fill tool, and then clicking the Fill button. The – Fill option provides a way for you to remove an entire selection if you make a mistake. If you have a selection currently defined, the Fill tool only fills (or unfills) the selection.

Figure 6.11 The Fill tool lets you fill the entire image or just the current selection with the current effect.

TIP Double-click the Fill tool to open the Fill/Remove options, which let you change the opacity of the fill that will be applied.

Gradient selections

Sometimes you want to apply an effect that varies from one part of your image to another. While you can try to paint in this type of variation using a brush, it's much easier to use Capture NX's Gradient tool.

For example, let's increase the saturation of the sky in Figure 6.12.

Figure 6.12 We'll use the Gradient tool to create a gradual change in the saturation of the sky in this image.

Since skies tend to get lighter closer to the horizon, you don't want to add a uniform saturation increase. Instead, you can use the Selection Gradient tool to add a gradient selection that extends from the top of the screen to the horizon.

To use the Selection Gradient tool:

- 1. Add the effect that you want to your Edit List.
- **2.** Select either + or mode for the Selection Gradient.
- 3. Click to define where you want the gradient to start.
- **4.** Click a second point to define where you want the gradient to end. Your gradient selection is immediately selected, and you should see the effect in your image (**Figure 6.13**).

Note that while the Gradient Selection tool is still active you can drag either end of the gradient line to reposition it.

To better understand what the Gradient Selection tool is doing, **Figure 6.14** shows what the selection for the image in Figure 6.13 looks like.

As you can see, most of the image is red, which indicates unselected (or masked if you prefer to think of it that way) areas. The white area at the top is selected (or unmasked) and

transitions smoothly to unselected at the horizon. This has the effect of gradually applying your Levels and Curves adjustment.

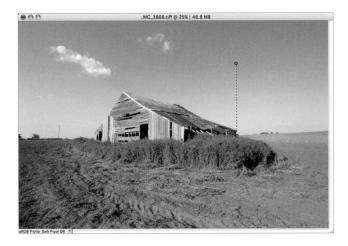

Figure 6.13 This gradient applies a gradual saturation adjustment to the sky in the image.

Figure 6.14 The Gradient tool created a gradual change from completely selected (white) to completely unselected (red).

Custom gradients. If you double-click the Gradient tool on the toolbar, the Gradient Options dialog box appears and allows you to define a custom gradient (**Figure 6.15**).

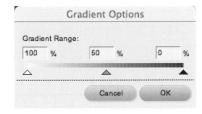

Figure 6.15 Using the Gradient Options dialog box, you can change the gradient to select more or less at either end and to have a different midpoint.

For times when you don't want a gradient selection to be completely selected or unselected, you can change the white and black points (remember, white means completely selected, black means completely unselected, and gray means somewhere in between).

The midpoint lets you shift where the middle of the gradient is. This lets you change the gradient from a straight linear gradient into a gradient that has more selection at one end than the other.

Brush control and combining selections

You can combine any of Capture NX's Selection tools within a single edit. So, you can use whichever tool is appropriate for the area you're trying to select.

For example, the image in Figure 6.14 needs some localized saturation adjustment in the dirt. You already saturated the sky using the Selection Gradient tool. However, the gradient intersects with the top of the barn. You can remove the effect from the barn by using the Selection Brush in – mode (**Figure 6.16**).

Figure 6.16 Using the Selection Brush in – mode, you can remove the saturation adjustment that was applied to the top of the barn.

To add saturation to the dirt in the foreground, use the + Selection Brush. However, the aggressive saturation adjustment that you defined, which is appropriate for the sky, is a little too much for the foreground. If you paint that saturation into the dirt, the dirt will be a little too "hot" (**Figure 6.17**).

Figure 6.17 If you paint the dirt with the full saturation adjustment, the dirt ends up too "hot." You need a partial saturation adjustment on the dirt.

Capture NX provides brush options that let you control the opacity, size, and hardness of the brush edge.

To activate the Brush Options controls, double-click the Selection Brush tool on the toolbar. The Brush Options palette appears (**Figure 6.18**).

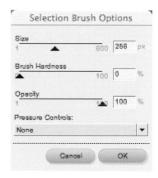

Figure 6.18 The Brush Options palette lets you change the size, opacity, and hardness of your paint brush.

Size simply changes the size of the brush. You can also change the brush size from the keyboard by using the left and right bracket keys.

Brush Hardness controls how hard the edge of the brush is.

Opacity controls how strongly the associated edit is selected. At 100% the full effect of the edit you've defined is applied. At 50%, the effect will be half as strong.

Pressure Controls regulate pen pressure choices. If you have a Wacom-compatible pressure-sensitive tablet, you can use the options from the Pressure Controls pop-up menu to specify whether pen pressure will change brush size, opacity, or both.

With a lower opacity setting, you can paint a more appropriate level of saturation into the foreground of your scene (**Figure 6.19**).

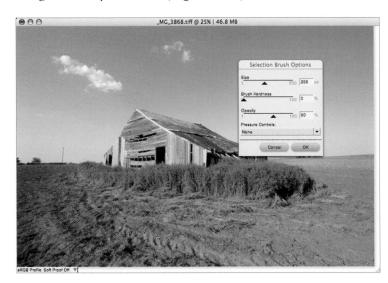

Figure 6.19 After lowering the opacity setting for the Selection Brush, you can paint in a less aggressive amount of saturation on the dirt.

Note that opacity effects are additive. If you paint with 50% strokes, and then paint over those with 30% strokes, the 30% strokes do not replace your 50% strokes. Instead, the semi-opaque strokes build up as you layer on more strokes. So, if you paint with 100% and then paint over those areas with a *lower* opacity, you'll still see 100% of your effect.

TIP The Opacity setting is persistent—it's not specific to just the edit you're working on. For example, if you paint a selection on a Levels and Curves edit, set the opacity to 30%, and then later make another edit, the brush defaults to 30% opacity unless reset to another opacity.

Combining effects

The selections that you make only affect the edit that they're applied to. So, you can create separate edits, each with their own selections. For example, after applying the Saturation edit that you added in the preceding example, you can then add a Levels and Curves edit, and use the Selection Brush to apply the edit to only the barn (**Figure 6.20**).

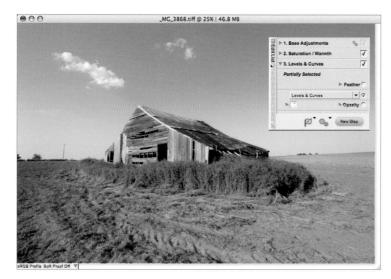

Figure 6.20 The Edit List now contains Saturation and Levels and Curves edits, both of which have their own selections defined.

Feather

If you see "seams" in your final selection—areas where an effect suddenly stops—try using the Feather (Figure 6.21).

Figure 6.21 The Feather option softens the edges of your selection to hide seams and sudden transitions.

The Feather control slider softens the edge of any selection that you've defined, creating smoother transitions and seams.

Seeing your selections

You've seen how you can use the Show Selection command to view your selection. However, Show Selection mode is not interactive—you can't manipulate your selections while the selection is visible. If you're painting a selection for a subtle edit, it can be very difficult to see if you've selected all of the area you want.

In Chapter 5, you saw how you can use the pop-up menu that appears in each edit entry on the Edit List to change that edit to a different type. Using this feature, you can create a more visible mask that's easier to refine.

Creating a selection before you define your edit. In the previous examples, you configured your edit and then started making your selection. But you can also create your selection *first*.

1. With no edits selected, click the + button next to the Selection Brush. A Colorize edit is added to your Edit List and the Colorize palette appears (**Figure 6.22**).

Figure 6.22 The Colorize edit lets you paint visible color onto your area at varying opacities. You can later change this color information into a mask.

- 2. Begin painting on your image. By default, you'll be painting with a kind of gross orange color. You can change the color if you want, but the color you pick isn't relevant to your selection making. What does matter is the Opacity setting in the Colorize palette. Any areas you paint with 100% will be completely selected. Areas painted with 0% will be unselected, and intermediate values will be somewhere in between.
- **3.** After you've painted your mask (**Figure 6.23**), change the pop-up menu in the Colorize entry in the Edit List to the type of edit that you want. In this case, change to a Levels and Curves edit. The color in your image disappears, and the corresponding selection is automatically added to your edit. The edit's Settings palette appears. Configure the edit as you like, but note that the edit only appears in the areas you painted on.

Figure 6.23 If you prefer to be able to see where you're painting when making a selection, you can paint a Colorize edit onto your image, and then change it to the edit type of your choice.

Refining a selection you've already made. Using the same Colorize trick, you can check on a selection that you've already made. For example, returning to the image you worked on earlier in Figure 6.19, you can turn your Saturation edit into a Colorize layer to see exactly what your selection looks like (**Figure 6.24**). You can then refine your selection by painting more strokes in or out, and then turning the edit back into a Saturation/ Warmth edit. The edit is applied through your new selection.

Figure 6.24 You can turn an existing Edit Step with a selection into a Colorize layer to get a better, editable view of your mask.

Your new painting effects are immediately revealed in the selection.

You can, of course, also use the Colorize effect for painting color into your images. While you probably won't usually need to paint 100% color, using a lower opacity and a different blending mode allows you to create hand colorized and tinting effects (**Figure 6.25**).

Figure 6.25 I converted this image to grayscale and then painted in the colors by hand using Colorize layers.

The blending mode simply changes the way that the colored pixels combine with the underlying pixels in your image. Simple experimentation is the best way to determine if a blending mode gives you the effect you're looking for.

CONTROL POINTS

As discussed in the previous section, selective editing allows you to tweak the color and tone of localized portions of your image. You learned how you to use Capture NX's Selection tools to constrain your edits to a specific part of a picture. While selections are a very effective way to make localized edits, having to make selections by hand is time-consuming and often difficult. For example, selecting the sky around the leaves of a tree or around blowing hair can be very difficult.

Capture NX provides another set of tools for making selective edits. The Control Point tools, which are located just to the left of the Selection tools on the toolbar, let you constrain edits to a particular part of your image, and they automatically generate a selection mask for you.

Tonal Control Points

The three tonal control points allow you to perform many of the same type of tonal corrections that you can make with other edit tools, but with some extra flexibility.

Neutral Control Point

In Chapter 5, we looked at several methods for correcting color casts in an image. While they're all very effective, Capture NX's Neutral Control Point provides a much better, single-click solution for correcting casts.

To remove a color cast with the Neutral Control Point tool:

1. Open the image you want to correct (Figure 6.26).

Figure 6.26 Shot in a dark club under pink stage lighting, this image plainly has some color cast issues.

- **2.** Select the Neutral Control Point tool on the toolbar.
- 3. Click on a part of your image that should be a neutral, middle gray color.

4. Capture NX places a Neutral Control Point at the location you clicked and automatically corrects your image (**Figure 6.27**).

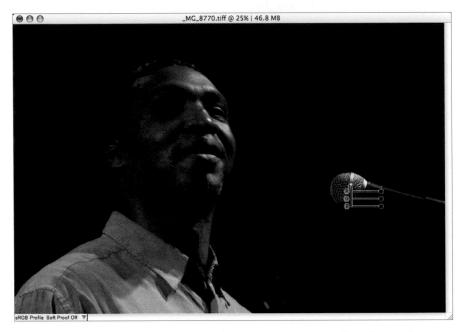

Figure 6.27 With a single Neutral Control Point, you can correct the color cast in this image.

Now try dragging the control point around. If you drag it to a different location, you'll get a very different correction (**Figure 6.28**).

The Neutral Control Point analyzes the color that you clicked on to determine how to equalize the red, green, and blue channels in your image. When they're equal, your color cast is gone. As you move the control point to a new location, Capture NX analyzes the color at that location and adjusts its correction accordingly. So, if your initial click does not yield an image that's neutral enough, you can refine your adjustment by simply dragging the point around.

You can further refine the correction by dragging the red, green, and blue sliders that appear beneath the control point. If you drag any slider away from the control point, you'll add more of that color to your image.

For example, you can warm the image in Figure 6.27 by dragging the red slider to the right a little bit (**Figure 6.29**).

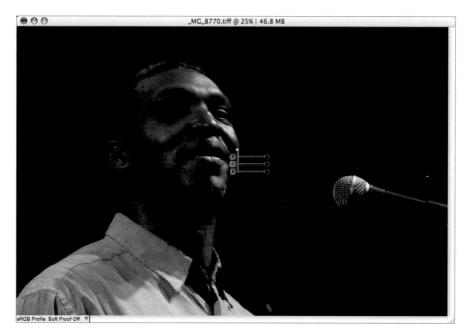

Figure 6.28 If you change the location of the Neutral Control Point, you get a very different adjustment.

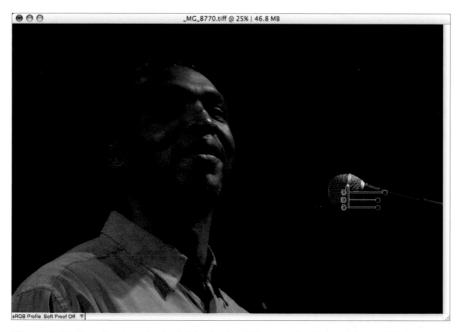

Figure 6.29 By adjusting the individual color sliders on the Neutral Control Point, you can change the color balance of your image. In this case, the image was warmed slightly by increasing the Red slider.

Advanced Controls. The Advanced Controls portion of the Neutral Control Point Settings palette provides a few additional options (**Figure 6.30**).

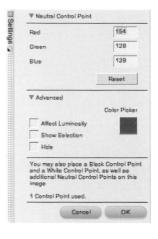

Figure 6.30 You'll find additional options for the Neutral Control Point in the Advanced Controls portion of the Settings palette.

If you check the Affect Luminosity box, an additional Luminosity slider appears beneath your control point. With this, you can brighten or darken the midtones in your image (**Figure 6.31**).

Figure 6.31 The Affect Luminosity adjustment lets you use the Neutral Control Point to change the brightness of the midtones in your image.

Show Selection shows the areas in your image that the control point will affect, just like the Show Selection command you saw earlier. White areas are completely selected, black areas are not selected at all, and gray areas are somewhere in between.

Hide allows you to turn off the effects of the control point to make before and after comparisons.

Using the Color Picker. The Color Picker swatch affords you with yet another level of control for the correction that the Neutral Control Point creates. It also allows you to correct the color in an area that doesn't actually contain any gray, such as sky or flesh tones.

To use the Color Picker swatch to correct a sky:

1. Click with the Neutral Control Point in the sky. The control point is added and the Neutral Control Point Setting palette appears (**Figure 6.32**).

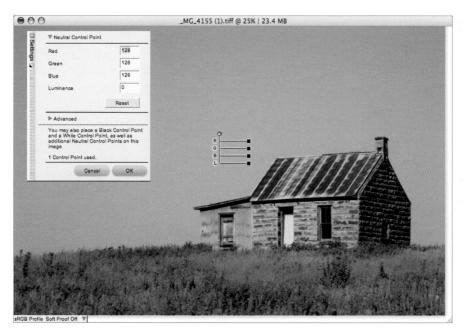

Figure 6.32 We'll correct the color of this sky using the Neutral Control Point and the Capture NX Color Picker.

2. Open the Advanced section of the palette. The Color Picker swatch shows the color that the control point is currently sampling.

3. Click the Color Picker swatch to open the Color Picker palette (**Figure 6.33**). When you select a color in the Color Picker palette, Capture NX calculates the difference between that color and the color that you clicked on in your image, and then subtracts that difference from your image. What makes the Color Picker palette especially useful are the predefined swatches, which give you sample sky, skin, foliage, and neutral tones.

Figure 6.33 The Color Picker lets you pick a color that you would like for the sky. Capture NX calculates the difference between your original color and that destination color.

4. Click on a color in the sky swatch gradient in the Color Picker palette. Your image is immediately adjusted (**Figure 6.34**). By clicking on different colors you can easily try different corrections until you arrive at an overall tone that you like.

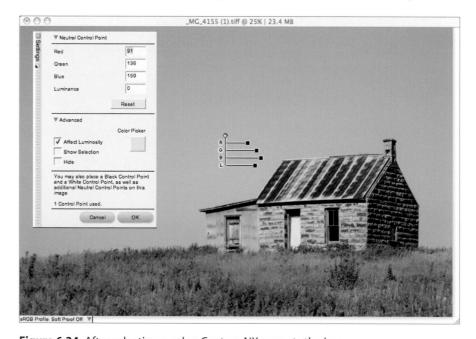

Figure 6.34 After selecting a color, Capture NX corrects the image.

Additionally, you can use multiple Neutral Control Points to correct multiple casts in an image. When you assign multiple Neutral Control Points, Capture NX analyzes data from all of the points to determine a final correction.

White Control Point

Just as the Neutral Control Point lets you specify a neutral tone in your image, the White Control Point lets you define a tone that is supposed to be white. The white point in your image is adjusted accordingly.

To set the white point with a White Control Point:

- **1.** Open the image you want to correct (**Figure 6.35**).
- **2.** Select the White Control Point tool on the toolbar.
- **3.** Click on a part of your image that should be white.
- **4.** Capture NX places a White Control Point at the location you clicked and automatically sets the white point in your image (**Figure 6.36**).

Figure 6.35 The "white" areas in this image are actually more off-white, meaning there's no real white in the image. This image needs a White Point adjustment.

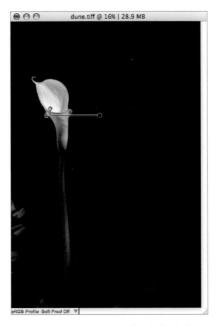

Figure 6.36 With a single click of the White Control Point tool, this image looks much better.

As with the Neutral Control Point, you can drag the control point around to change your white point selection. As you move, Capture NX analyzes the underlying color to determine the correct White Point adjustment.

Beneath the White Control Point is a single Luminance slider. By default it is set to 100%. Drag it closer to the point to darken your image (**Figure 6.37**).

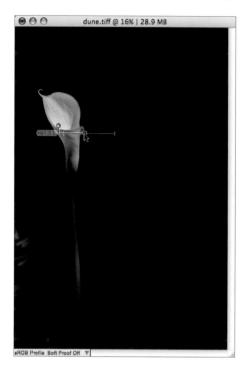

Figure 6.37 The Luminance slider underneath the White Control Point lets you change the brightness of the new white point in your image.

Black Control Point

As you might have guessed by now, the Black Control Point lets you select the black point of your image. Click with the Black Control Point tool on something in your image that should be black. Capture NX adds a control point and automatically sets the black point in your image (**Figure 6.38**). As with the White Control Point, you can alter the Luminance value of the Black Control Point to change the amount of darkening in your image.

Figure 6.38 The contrast in this image was corrected by setting a Black Control Point on a black part of the street lamp and a White Control Point on the white part of the lamp.

Color Control Point

While the Black, White, and Neutral Control Points let you adjust the tonality of your image, the Color Control Point allows you to selectively alter the hue, saturation, and lightness in your image. The Color Control Point uses special U Point technology that is unlike anything that you'll find in any other image editor. With it, you should find that you can make extremely complex adjustments with just a few clicks.

Using a Color Control Point is very simple:

- 1. Click it on the area that you want to adjust.
- **2.** Drag the Size slider to adjust the size of the affected area (**Figure 6.39**).

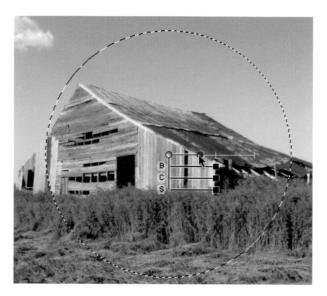

Figure 6.39 Color Control Points have a circular size parameter that controls their area of effect.

3. Alter the color sliders to edit the affected area. In this case, the Contrast slider was used to increase the contrast of the barn (**Figure 6.40**).

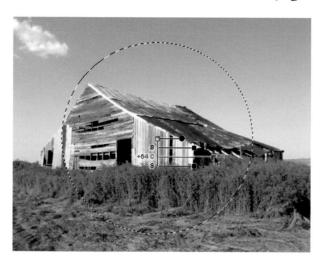

Figure 6.40 The B, C, and S sliders on a Color Control Point let you change the brightness, contrast, and saturation, respectively.

That's all there is to it. Based on where you click and the size of the area you choose to affect, Capture NX automatically calculates a mask for your chosen edit and applies the edit through that mask. For example, **Figure 6.41** shows the mask that Capture NX created for the adjustment that was defined in Figure 6.39.

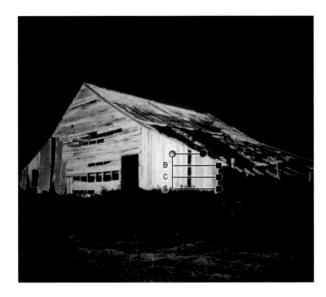

Figure 6.41 The Color Control Point that was defined automatically generates this selection mask.

At first, it may seem strange that Capture NX only lets you define a circular selection area. However, as you can see from the way that it builds a mask, this boundary is all it needs to accurately calculate which pixels should be affected and which shouldn't, and how much effect each pixel should get.

Using multiple Color Control Points

Let's perform a more complex edit. **Figure 6.42** shows an image that needs a saturation adjustment in the sky and a contrast adjustment on the ground. What's more, we don't want either of these effects to alter the dorky-looking guy standing in the foreground, because we'd like to apply separate adjustments to him.

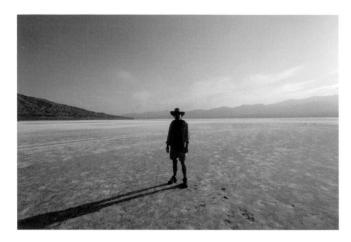

Figure 6.42 We'll perform a lot of correction to this image, improving the brightness and saturation of the sky, increasing the contrast on the ground, and brightening the figure with only a few simple Color Control Points.

Normally, this would require many different selection and masking operations to constrain the edits appropriately. With Color Control Points, you can achieve all of this editing with some simple clicking. Let's begin by working on the sky.

Click with the Color Control Point tool to add a Color Control Point to the left side of the sky. Then drag the Size slider to cover as much of the sky as you can (**Figure 6.43**).

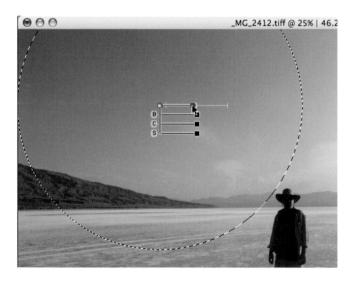

Figure 6.43 Begin by setting a Color Control Point on the sky and setting its size.

Don't worry about the fact that the Size circle extends into the foreground. Capture NX is smart enough to know that that area should be excluded from the mask. Obviously, the entire sky hasn't been covered, but that problem will be taken care of in a moment. You first want to configure the control point's correction.

Make the sky a little brighter and more saturated by using positive adjustments on all three sliders. Capture NX updates the image in real time, so it's easy to fiddle with the sliders to get exactly the effect that you want (**Figure 6.44**).

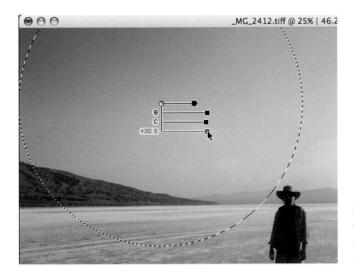

Figure 6.44 By adjusting the Brightness, Contrast, and Saturation sliders, you can add more punch to the sky.

As with any other type of color correction, Color Control Points work their effect by redistributing the tonal information in the red, green, and blue channels. As they do this, some data gets discarded. So, Color Control Points can lead to the same tone break and posterization artifacts that you saw in Figure 5.61. As you adjust the sliders, keep an eye out for those problems.

When you add a Color Control Point to an image, a control point entry is made to your Edit List, and a Color Control Point Settings palette appears. If you're the type of person who likes to work by numbers, note that this palette displays numeric readings for all four of the control point's sliders (**Figure 6.45**).

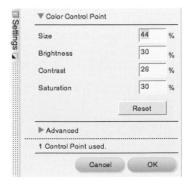

Figure 6.45 The Color Control Point Settings palette provides numeric readouts for the values of the Color Control Point sliders.

The sky is looking better, but only in the left half. You could add another Color Control Point to the right half, but instead duplicate the first control point to be sure that you have the same adjustment across the sky.

If you right-click on a Color Control Point, (or Control-click if you're using a Mac without a two-button mouse) a pop-up menu appears (**Figure 6.46**).

Figure 6.46 Additional options appear if you right-click on a Color Control Point.

Show and Hide let you control the visibility of the control point within your image. Duplicate makes a copy of the control point, and Delete removes it entirely. Reset returns its slider values to their defaults, which basically deactivates the effect of the control point.

Choose Duplicate, and a copy of the control point appears. Immediately, the left half of the sky gets brighter, because the new control point is working on the image, adding an additional round of edits. Click on the point and drag it to the right half of the sky (**Figure 6.47**).

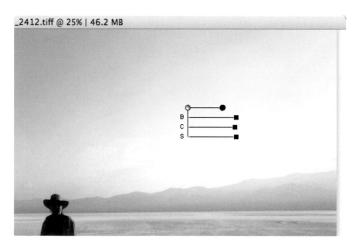

Figure 6.47 After duplicating the original control point, you can drag it to the right side of the screen to alter the other half of the sky.

The right half of the sky is now overexposed. As it turns out, the settings you defined for the control point in the darker, left side of the sky are a little too aggressive for the brighter right side. With a few simple parameter adjustments, you can bring things back in line (**Figure 6.48**).

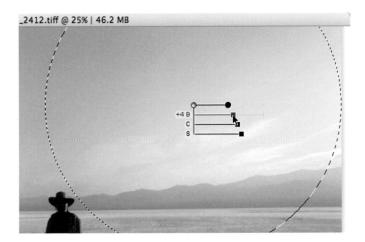

Figure 6.48 A few adjustments to the second control point and the sky is more reasonably exposed.

In the Edit List, you will see an entry for Color Control Point, and then additional entries for each point you've defined (**Figure 6.49**). You can check and uncheck the check box next to Color Control Point to see a before and after view of your image. Unchecking deactivates the effect of all of your control points. If you'd rather see the effect of individual control points, you can deactivate those individually using the check boxes for each entry.

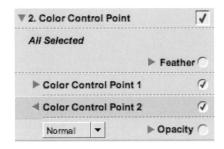

Figure 6.49 Using the controls in the Edit List, you can activate and deactivate some or all of your Color Control Points.

Even though your control point size circles overlap the ground, the ground receives almost no adjustment thanks to the selection mask that Capture NX has automatically calculated. You can see the actual selection by choosing View > Show Selection (**Figure 6.50**).

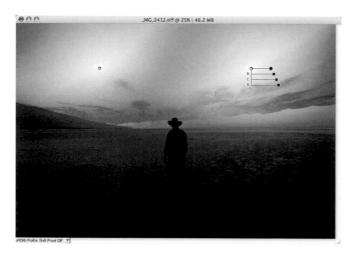

Figure 6.50 Using your two Color Control Points, Capture NX automatically creates a very complex mask that constrains the effects of the control points to only the sky.

The Color Control Points are interactive when in Show Selection Mode. You can adjust their parameters and see the mask change in real time.

Adjusting the foreground. Now you're ready to work on the ground. It doesn't need a lot of adjustment, but a bit more contrast will make it a little more eye-catching. As before, begin with a Color Control Point on the left side of the image and adjust its size and parameters accordingly (**Figure 6.51**).

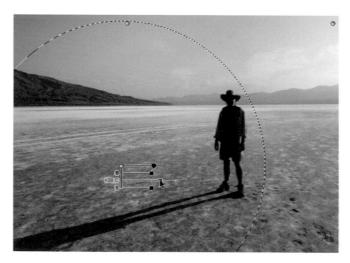

Figure 6.51 With your first foreground control point, you increase the contrast on the ground. Here you can see the difference between the left, affected area, and the right side, which doesn't yet have any adjustment.

Again, duplicate your control point by right-clicking on it and selecting Duplicate. Drag the copy to the other side of the image, but this time you don't need to make any adjustments to its settings. Because the ground is uniformly exposed, the same settings work for both control points.

As you drag the control point around, you should be able to see very small changes in its effect. Like the Neutral Control Points that you saw earlier, Color Control Points work by sampling the color that you place them over. They use this sample color as the basis for their selection calculations. So, when you move the control point around, the original sample color changes, altering the mask and affecting your image in different ways.

One of the most impressive aspects of the U Point technology that drives Capture NX's control points is its ability to properly calculate multiple, overlapping masks. If you view your selection now with all four control points applied, you see a complex arrangement of different masking data with smooth transitions between each effect (**Figure 6.52**).

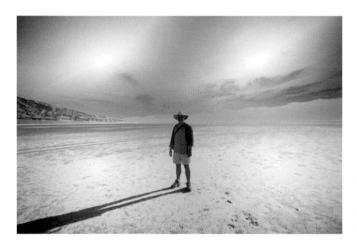

Figure 6.52 With four control points defined, your selection mask is a complex composite of overlapping masking information.

TIP You can toggle the visibility of the control point handles by selecting View > Show/Hide Control Points.

Adjusting the figure. So far, a lot of brightness, contrast, and saturation adjustment has happened, but for the most part, none of it has affected the figure in the middle of the image because of the sophistication of the mask that Capture NX generated. You can use an additional control point to perform a final correction.

A single control point configured with a brightness, contrast, and saturation adjustment brightens up the figure **(Figure 6.53)**.

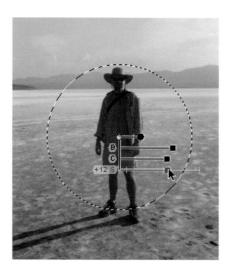

Figure 6.53 With one last control point, you can easily brighten the figure without altering any of your other adjustments.

You've now performed a lot of sophisticated localized editing operations; operations that would have, in another application, required you to hand paint masks or perform complex selections. With Capture NX's Color Control Points, all of that tedious work is performed for you on the fly.

Figure 6.54 shows the final result.

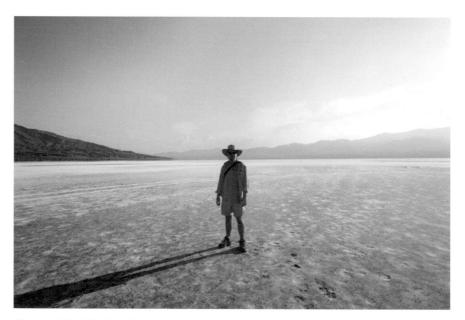

Figure 6.54 With just five control points, you created a complex series of adjustments that would have required lots of meticulous masking in most other image editors.

Advanced Color Control Points

If you open the Advanced section of the Color Control Points Settings palette, you'll find some additional controls (**Figure 6.55**).

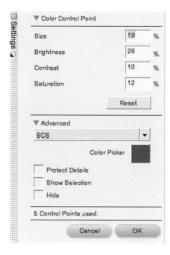

Figure 6.55 The Color Control Point Settings palette provides some additional controls under the Advanced section.

Protect Details allows you to protect one part of an image from the effects of *another* control point. When you click Protect Details, the control point provides only a Size slider. You can drag the control point on top of an area affected by another control point, and then adjust the size of the second point to protect your image from the effects of the first control point.

Show Selection shows you the selection mask created by that specific Color Control Point. The control point's parameter sliders are still active in this mode, allowing you to edit the selection while viewing it.

Hide hides the effect of the control point, allowing you to easily see before and after views of the control point's effect.

The **Color Picker swatch** lets you choose a color using the Color Picker palette. The area affected by the control point will be filled with that color, with the selection defining the opacity and tint of the color. This provides a simple way to add a little bit of tint to an area.

In addition, the pop-up menu lets you select the parameters that you want the control point to have (**Figure 6.56**). As you've seen, control points have Brightness, Contrast, and Saturation sliders by default. From the menu shown in Figure 6.56, you can opt to switch to RGB, which gives you Red, Green, and Blue sliders, or HSB, which provides Hue,

Saturation, and Brightness sliders. Also, you can select All, which displays every slider. All options provide a Size slider.

Figure 6.56 You can specify exactly what type of adjustment sliders you want a control point to have.

There's no right or wrong set of sliders to use; some will be more appropriate for some edits than others. For example, if you're dealing with a color cast or warmth issue, RGB sliders might be easier to work with. Or, perhaps you have more experience with one color model than another and are already used to thinking in a particular way.

Color Control Points and Selection Brushes

You've now seen two major toolsets that Capture NX provides for making localized corrections: Selection Brushes, which let you paint an effect into or out of an area, and Color Control Points, which algorithmically generate masks. These two toolsets can be combined thanks to the fact that you can use Selection Brushes to paint in the effect of a Color Control Point.

For example, say that you want to increase the contrast on the dog shown in Figure 6.57.

Figure 6.57 This dog could use a little contrast adjustment.

A control point makes short work of the contrast adjustment, but in the process his eyes go a little too dark; the catchlight and some of the details around his eye sockets get lost (Figure 6.58).

Figure 6.58 A Color Control Point lets you easily amp up the contrast in the dog's fur, but now his eyes have gone too dark.

However, just as you can paint out the effects of the other types of edits you've applied, you can easily paint out the effects of the Color Control Point using any of the Selection tools. In this case, I used the Selection Brush in - mode to paint out the effect (Figure 6.59).

Color Control Point

Figure 6.59 Using the Selection Brush, you can paint out the effect of the Color Control Point to restore detail to the dog's eyes.

DODGING AND BURNING

The Selection tools that we've been looking at allow you to perform many of the same types of adjustments that were traditionally created using dodging and burning techniques in a wet darkroom. However, Capture NX's tools are far more powerful and flexible thanks to their precision and the fact that they let you adjust color as well as tone.

As you've seen, the tools are very easy to use, but what should you use them for? Sometimes, the areas in your image that need brightening or color/saturation adjustments will be very obvious. At other times, it can be difficult to recognize where selective editing might improve your image.

Remember that light does more than just determine the brightness of your scene. Contour and depth are all indicated by the light and shadow in your image. An image like the one in **Figure 6.60** looks flat because the light is mostly uniform. The shadows are not significantly different from the bright areas.

Figure 6.60 The overcast day made for diffuse lighting in this scene that resulted in the rocks appearing flat and evenly lit. You can add more depth to the scene using some selective lightening and darkening.

You can increase the overall contrast of the scene to make the image look much better (**Figure 6.61**), but there's still more depth that you can add to the scene with a little localized brightening and darkening.

Figure 6.61 I darkened the dark side of the rock by creating a Levels and Curves adjustment that darkens, and then painted the effect into only the dark side of the rock. Here you can see the result along with the final Selection mask.

The scene in Figure 6.60 looks flat because it was an overcast day. The sun was not bright enough to cast strong shadows, so there is little relief visible in the image. However,

you can still tell that one side of the rock pile is being lit slightly more than the other. Accentuating this difference will give the rock more of a sense of shape and depth.

By using a Levels and Curves adjustment, you can darken the image, and then use the Selection Brush to paint that darkening into the dark side of the rock (**Figure 6.62**).

Figure 6.62 Next, I added an additional Levels and Curves effect, but this time configured it to brighten. With the Selection brush you can paint this lightening into the bright parts of the image. The result is that the rock has more depth.

Next, you can add another Levels and Curves adjustment, but set this one to lighten the image and then paint that lightening into the bright parts of the image to lighten those areas (**Figure 6.63**).

Figure 6.63 The final image has a more profound sense of depth on the rock, thanks to the extra shading that was introduced.

By the time you're done with the image, it will have three Levels and Curves edits: one for the overall, global brightening, a second one for darkening the dark parts of the rock, and a third one that lightens the light parts (**Figure 6.64**).

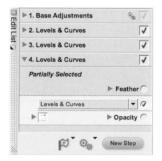

Figure 6.64 The final Edit List contains the three Levels and Curves adjustments that were created.

Facial Retouching

The selective lightening tactic discussed in the previous section can also be used to reduce lines in wrinkles in peoples face. If you look closely at a wrinkle in a photo, you'll see that it consists of a dark line bordered by a light line (sometimes it's only a light line) (**Figure 6.65**).

Figure 6.65 A wrinkle usually consists of a dark line with a light border.

You can use a Levels and Curves edit to create a lightening effect, and then use the Selection Brush to paint that effect over the wrinkle (**Figure 6.66**).

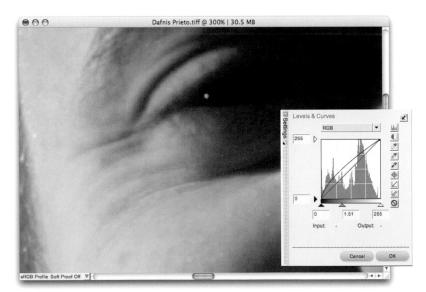

Figure 6.66 By brushing in a Levels and Curves adjustment configured to lighten your image, you can reduce the appearance of the wrinkle.

In most cases you'll want to use a midpoint, or gamma, shift in the Levels and Curves edit to perform the lightening. A white point adjustment will create too strong of an effect, and one that might result in ugly tonal changes.

If your wrinkle also has a light edge to it, create an additional Levels and Curves edit that darkens the image, and then paint that effect into the light part of the wrinkle.

THE OPACITY MIXER

You can control the opacity of any edit that appears in the Edit List using the Opacity control that appears in the controls for that edit. When you click the reveal arrow next to Opacity, the Opacity Mixer opens (**Figure 6.67**).

Figure 6.67 The Opacity Mixer lets you control how an effect mixes with the underlying pixels of your image.

Changing the opacity of an effect alters the way that the effect is applied to your image. For example, lowering the opacity of an effect reduces it. Changing the Blending Mode options alters the way that the edited pixels are applied to your image. For example, if you choose the Multiply blending mode, the filtered pixel values will be multiplied with the original pixel values to produce a much darker pixel.

The All menu lets you select alternate methods for applying opacity. Selecting RGB lets you adjust the opacity of individual color channels, and selecting Luminance and Chrominance lets you change the opacity of either the luminance or chrominance channels. The practical upshot is that you can intensify or weaken the brightness or color information in your image.

It can be difficult to predict the effect that blending modes will have on your image. The best way to learn to use them is simply to try them out and experiment.

FILTERS

The Capture NX Filter menus provide a final set of edits that you can apply to your image. Like all other edits, the filters are nondestructive, can be deactivated or altered at any time, and can be applied selectively using any of the Capture NX Selection tools.

Photo Effects

The Photo Effects filter lets you apply simple tonal and color corrections to your image (**Figure 6.68**). The Photo Effects filter operates in several different modes, which you can switch between using the pop-up menu.

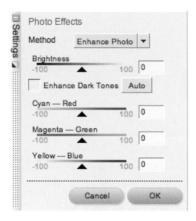

Figure 6.68 The Photo Effects edit lets you alter the luminosity and color balance of your image.

The default, **Enhance** mode, offers a Brightness slider, which lets you lighten or darken your image, and the color sliders let you tone your image.

In **Black and White** mode, you can adjust the Brightness slider, and then adjust the mix of red, green, and blue color channels using the color sliders. Different channel mixes can yield very different results, as you can see in **Figure 6.69**. We'll discuss black and white conversion more in a later section.

Sepia mode lets you tone your image with a sepia tint. The Brightness slider controls the overall brightness of your image, and the color sliders are disabled.

Tinted performs a grayscale conversion to your image and then lets you tint the image with a color of your own mixing. Adjust the color sliders to choose your desired tint.

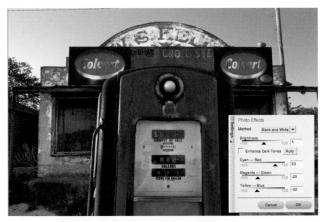

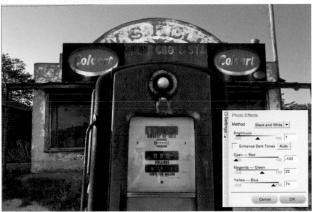

Figure 6.69 By mixing your color channels in different ways, you can create many different grayscale images from the same color source image.

Add Grain/Noise

While digital photographers often spend time worrying about noise in their image, the fact is that sometimes grain and noise can add a nice texture to an image. Capture NX's Grain/Noise filter lets you add grain of varying amounts and sizes. In addition, you can choose color or monochrome grain (**Figure 6.70**).

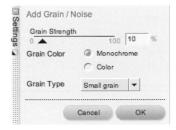

Figure 6.70 The Add Grain dialog box lets you add texture and grain to your images.

TIP Sometimes, the best way to hide noise in your image is to add more. Adding noise to low-light, grainy images can often make them look better. This works particularly well with cell phone images. The texture created by the noise often adds unsightly compression artifacts.

Contrast: Color Range

The Contrast: Color Range filter lets you adjust the brightness and contrast of specific colors in your image (**Figure 6.71**).

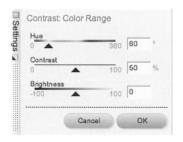

Figure 6.71 With Color: Contrast Range you can adjust the brightness and contrast of specific colors in your image.

The color that you select with the Hue slider will be lightened in your image, and its complementary color will be darkened. For example, in **Figure 6.72** I selected a red color in the Hue slider, which brightens the flower. At the same time, the blue in the background is darkened.

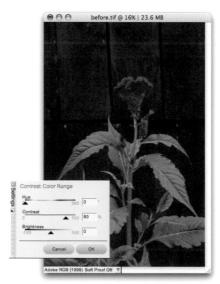

Figure 6.72 Here you can see the before and after effect of a Contrast: Color Range adjustment. I targeted red, which increased the brightness of the red while simultaneously darkening the blue in the image.

The Contrast slider controls the amount of change that the filter produces, and the Brightness slider lets you adjust the overall luminosity of the image.

Note that unlike Color Balance controls, which affect the entire image, the Contrast: Color Range has a very constrained effect.

Black and White Conversion

The Black and White Conversion filter provides another way to convert your images to grayscale. Unlike the Photo Effects filter, which lets you craft a custom channel mix, the Black and White Conversion filter lets you select a color filter, just like you might use when shooting black and white film (**Figure 6.73**).

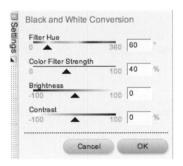

Figure 6.73 The Black and White Conversion filter provides a more traditional film-like approach to black and white conversion.

The Filter Hue slider lets you select the color of the filter you'd like to use for your black and white conversion. So, for example, you might choose a reddish filter for increased contrast in sky tones.

Color Filter Strength controls how strongly the filter color is applied during your conversion, and Contrast and Brightness let you control the contrast and overall luminosity of your image.

ADDITIONAL ADJUSTMENTS

There are a few additional items under the Focus menu (Adjust > Focus) that we didn't cover in Chapter 5.

Gaussian Blur

The Gaussian Blur adjustment lets you apply a blur to your image (**Figure 6.74**). The Radius slider controls the amount of blurriness, and the Opacity slider controls the intensity.

Figure 6.74 You can add a blur to your images using the Gaussian Blur filter.

High Pass

The High Pass filter is basically an edge detection filter. It converts the solid areas of your image to gray while leaving the areas of sudden contrast change alone. The practical upshot is a map of the edges in your image (**Figure 6.75**).

The most common, practical application for the High Pass filter is to combine it with some opacity adjustments to improve the apparent sharpness of your image.

To sharpen using the High Pass filter:

- 1. Add a High Pass filter to your image and set the radius fairly high—20 to 30 pixels, for example.
- 2. In the Edit List, open the High Pass edit's Opacity controls.
- 3. Set the Opacity mixer to Luminance and Chrominance mode.
- **4.** Set the Chrominance opacity to 0%.
- 5. Set the Blending Mode to Overlay.
- **6.** Adjust the High Pass Radius setting to taste.

Using the High Pass filter in this way (**Figure 6.76**) can result in images with better detail without risking the sharpening artifacts that can occur with the Unsharp Mask effect.

Figure 6.75 The High Pass filter identifies edges in your images.

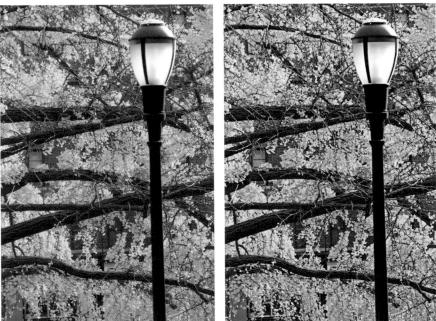

Figure 6.76 Using the High Pass filter and an opacity mix, you can dramatically increase the sharpness and detail in your image.

Noise Reduction

Located under the Adjust menu is a Noise Reduction edit that provides you with tools for reducing any noise troubles you may have. There are two types of noise in a digital photo: luminance noise, which manifests as brightly colored specs, and chrominance, or color noise, which appears as colored pixels and splotches.

The Noise Reduction adjustment provides simple controls for applying noise reduction (**Figure 6.77**).

Figure 6.77 The Noise Reduction edit lets you lessen the amount of luminance and chrominance noise that appears in your images.

Intensity specifies how much noise reduction is applied. Increase the slider value to reduce the noise in your image.

Sharpness is a light sharpening effect that tries to counter the overall softening of your image that takes place when you apply noise reduction.

Method controls how noise reduction operates. Noise Reduction can be applied in a Faster mode or a Better-Quality (but slower processing) mode.

Edge Noise Reduction reduces noise along edges in your image, resulting in stronger edges and therefore better sharpness.

As with sharpening, it's best to apply Noise Reduction while viewing your image at 100%.

Unsharp Mask

It's not actually possible to increase the sharpness in an image—edge detail is either there or it isn't. However, it's possible to increase the *apparent* sharpness of an image by making the edges in the image appear more acute.

An edge is really nothing more than a sudden change of contrast in an image. Edges are almost always made up of dark or light lines. The Unsharp Mask filter changes the acutance of an edge by identifying the line of sudden contrast change, and then darkening the pixels along its dark side and lightening the pixels along the light side. This serves to make the edge more contrasty. However, too much of this additional contrast and your image can be plagued by *halos* (**Figure 6.78**).

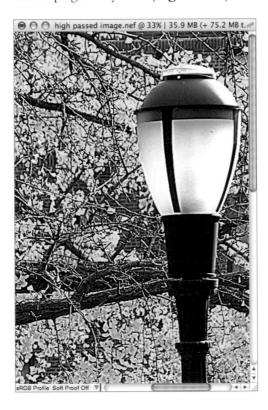

Figure 6.78 If you apply too much sharpening using the Unsharp Mask edit, your image will be plagued with ugly halos and an extreme level of contrast.

Unsharp Mask provides three simple controls (**Figure 6.79**):

Intensity specifies how much lightening and darkening should be applied.

Radius specifies how many pixels of halo should be created.

Threshold controls how much contrast change is required before the filter registers an edge as an edge.

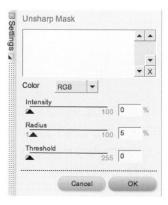

Figure 6.79 The Unsharp Mask Settings palette provides simple sliders for adjusting the Unsharp Mask parameters.

The Color pop-up menu lets you apply sharpening to individual channels. With one Unsharp Mask edit, you can apply separate sharpening settings to each color channel as well as the RGB channel. Each sharpening that you make is added to the scrolling list at the top of the Unsharp Mask palette.

Here are some important guidelines to consider when sharpening:

- Resize your image to its final output size before sharpening. If you apply sharpening and then resize, your sharpening effect may get lost in the resizing. However, note that Capture NX does adjust sharpening amounts when you resize your image in an attempt to scale your desired sharpening amount to fit the new size of your image. Consequently, in Capture NX, it's not quite as critical to sharpen at the very end of your workflow. But you'll still get more accurate sharpening if you adjust the settings yourself to conform to your final image size.
- Sometimes, only parts of your image need to be sharpened. For example, flesh tones
 don't hold up very well to sharpening, because pores, wrinkles, and veins get accentuated. For most faces, it's the eyes that matter. Use the Selection Brush to apply the
 sharpening effect to only the areas that need it.
- It's best to view your image at 100% when configuring your sharpness settings.

Sharpening operations often go hand in hand with Noise Reduction.

CHAPTER SELECTION CONTROL and Batch Processing

In the previous two chapters you saw how Capture NX's nondestructive editing architecture lets you easily add and change edits at any time. Unlike destructive editing systems, you aren't limited to just a few "undos," and you can change or remove edits in any order. You may find that once you're used to working nondestructively, going back to a normal destructive editor is very difficult.

But nondestructive editing has some additional benefits that we haven't explored yet. As you learned earlier, when you make an edit in Capture NX, the specifics of that edit are stored in a list. When Capture NX needs to display an image onscreen or output it to a printer or file, the list of edits is applied to your original image data file. Since it does all of this on the fly, you can alter the list at any time. The new edits are applied to your original image, and the updated, edited version is displayed.

Because edits are kept separate from image data, Capture NX allows you to perform some handy version control and batch processing features. We'll explore all of these in this chapter.

VERSION CONTROL

No matter what kind of image editing software you've used in the past, you're probably accustomed to occasionally (or maybe frequently) making multiple versions of the same file. You'll make multiple versions for many different reasons. Sometimes, it's simply because you want to try out several different approaches to an image, but you want to keep each one. You might create multiple versions if you're trying to decide whether an image works better as color or grayscale. Or, you might create multiple versions when printing—for example, creating a version for each type of paper you want to print on, since different paper types often require slightly different tone and color adjustments.

In a destructive editor, you usually create a new version of an image by duplicating your original file or using a Save As command to save a copy of your current image with a different name. You can then perform a different set of edits on each document that you create.

This scheme has a few drawbacks. First, it quickly uses up lots of disk space. Unless you're creating smaller versions, each new version that you save is the size of your original image. If you're working on a large file, (25 MB or bigger), saving five or six versions can quickly consume a respectable amount of disk space. Second, these save operations can take time. Even a speedy computer can take awhile to write out a very large file.

Additionally, saving multiple versions like this can create housekeeping problems. You have to come up with a naming scheme that makes sense to you, and you have to keep all of the files that you've created organized.

Nondestructive Versions

In a nondestructive image editor like Capture NX, creating multiple versions is much simpler. Since an edit in NX is simply stored in a text file and then applied to a master image file later, there's no need to ever duplicate that master image file. Instead, you can simply create multiple text files full of edits with each one linked to a single image file.

The Edit List files that Capture NX creates are very small, usually just a few dozen kilobytes. So, you can easily create dozens of versions with very little impact on your storage space. What's more, writing out these tiny little files is a very speedy process, so creating a new version doesn't take much time.

These last two features lead to something of a "meta" feature of Capture NX's versioning capabilities. Because creating a new version is so speedy and comes with so little storage penalty, you'll probably be more willing to create multiple versions, which you might find makes your work much easier.

Creating a New Version

To create a new version, choose New Version from the Version menu in the Edit List (**Figure 7.1**).

Capture NX prompts you to enter a version name. Enter it and click OK to save the version. You won't see anything different on your document, but if you open the Version menu, you'll see both your new version and a new entry called (*Current*).

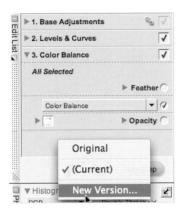

Figure 7.1 Choose New Version from the Version menu at the bottom of the Edit List to create a new version of any image.

You can then make changes to your image and save another version. You can select either version from the Version menu to switch back and forth to either configuration.

When you make new changes, they are applied to the (*Current*) version, not to the version that you just saved. You can't make changes to a saved version. You can only load it, alter it, and save it again as a new version.

Note too that you can't save over a version with another version of the same name. You need to save altered versions under a new name, and then delete the old copy using the Edit Versions command on the Version menu. Edit Versions displays a dialog box that allows you to easily delete any existing versions.

At any time you can switch back to your original image by selecting Original from the Version menu.

If you want to save an image containing multiple versions, you must save it in NEF format. The NEF format keeps all alternate versions within the file, meaning you don't have to worry about keeping track of extra documents or sidecar files.

COPYING AND MOVING SETTINGS

Because an edit on a document is nothing more than an entry in a text file, it's possible to move edits around in your document or copy them from one document to another.

For example, there might be times when you want to rearrange the edits in your Edit List. Maybe you've accidentally inserted an edit in the wrong place, for example, or decided that your Levels adjustments should occur *after* your Saturation adjustment.

While Capture NX won't let you drag edits around to change their order, you can use the Copy and Paste settings commands to effectively move an edit.

To move an edit in the Edit List to a new location in the same document:

- 1. In the Edit List, click the edit that you want to move.
- 2. Choose Copy Settings from the Batch menu (Figure 7.2).

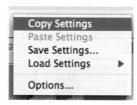

Figure 7.2 At the bottom of the Edit List is a pop-up Version menu containing simple commands for Copy and Paste settings.

- **3.** Choose Paste Settings from the Batch menu. The setting you copied is added to the end of the Edit List.
- **4.** Delete the original copy of the edit.

Pasting a setting always adds it to the end of the list. It's not actually possible to use paste to insert an entry into the middle of a list. However, you can move multiple steps at one time using the preceding technique. Simply select each edit by Command/Control-clicking on it in the Edit List, and then use the Copy and Paste commands in the Batch menu. All of the edits are moved, in order, to the end of the list.

TIP You can also copy and paste edits between documents. So, if you have a bunch of similar images—such as a burst set—you can create an edit or series of edits that correct that image, and then copy and paste those edits into the other images in your burst set.

BATCH PROCESSING

In the previous section, you learned how you can easily move edits around in a document or between documents, simply by copying and pasting them. This is because an edit is nothing more than a note in a text file that is associated with your image. In addition to making it easy to move edits around, this architecture also makes it possible to batch process your images. With batch processing, a series of edits can automatically be applied to a selected group of images.

Any type of edit can be applied in a batch process, including control points and selections. But before you can apply a batch process, you need to save the edits that you want to apply to other images.

Saving Settings

The Batch menu at the bottom of the Edit List provides a Save Settings command that saves all of the settings that are currently defined in the Edit List. When you choose the command, the dialog box shown in **Figure 7.3** appears.

TIP You can also access the Copy, Paste, Save, and Load commands by right-clicking anywhere in the Edit List palette.

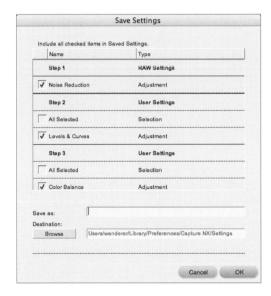

Figure 7.3 With the Save Settings dialog box, you can specify exactly which edits you want to save in a settings file.

With this dialog box, you can specify exactly which settings you want to save in the set. In most cases, you'll probably leave all of the options set.

Note that each Edit Step also has an associated Selection step, which specifies whether the edit is applied to the entire image or just a selection. If you've defined an edit selection specific to the particular image you're working on, you may want to uncheck the selection before saving the set. This allows you to define a new selection for each image the edit set is applied to.

In the Save as field, enter a name for the settings.

Using the Browse button, you can specify a location to save your settings to. By default, settings are saved in the Capture NX Preferences folder, and unless you have a specific reason to save them somewhere else, it's best to save them to the default location, simply because it is easier for NX to find them.

However, if you work with multiple machines or with other photographers, you might want to save your settings to a common location, on a network volume or external drive, for example.

After you've configured the dialog box, click OK to save the settings.

TIP Due to a bug in Capture NX 1.1, if you choose a destination before you enter a filename, the program will think you haven't entered a name. So, be sure to enter the name first, and then select a destination.

Loading Settings

After you've saved some settings, you can easily apply them to any other document by simply opening a document and choosing the Load Settings command from the Batch menu (**Figure 7.4**).

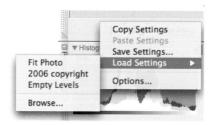

Figure 7.4 The Load Settings command in the Batch menu automatically shows previous settings files that you've saved.

Any settings that you've saved automatically appear in the Load Settings pop-up menu. If the settings file you're looking for doesn't appear, choose the Browse option and then navigate to the desired file.

After you select the settings file you want, those settings are automatically applied to your image, just as if you had applied each edit by hand. Your Edit List should show an entry for each adjustment in the settings file. You can alter any of these edits just as you normally would.

Managing Settings

Over time, as you save more settings, the Load Settings menu will become longer and longer. You can hide or delete settings from the Load Settings menu by clicking the Batch menu and choosing Options.

The Settings Options dialog box (**Figure 7.5**) provides three tabs: Manage Settings, Batch Process, and Watched Folder. Using the Manage Settings tab, you can easily hide a settings

file by unchecking its check box, or delete it altogether by clicking the setting to select it, and then pressing the Delete button.

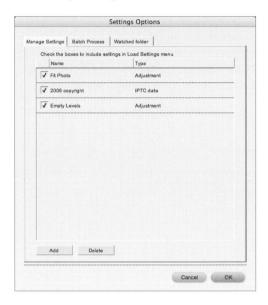

Figure 7.5 From the Settings Options dialog box you can manage saved settings files or initiate different types of batch processes.

If you've saved a settings file but it's not showing up on the Load Settings menu, click the Add button to add it. A standard open dialog box appears. Navigate to the settings file and click OK to add it to the Load Settings menu.

TIP All of the options provided on the Batch menu at the bottom of the Edit List are also available on the Batch menu on the main menu bar.

Changing File Formats

The Capture NX File Browser provides a simple way to convert batches of images to a different file format without having to manually open and save each one. In the File Browser, select the images you want to convert, and then choose File > Save As. Capture NX presents you with the Processing Queue dialog box (which you'll learn more about later). Using the controls in the lower half, you can select a destination and file naming convention, as well as format and save parameters.

If you've been editing lots of images and saving them as NEF files, there will probably come a time when you want to convert all of those images to TIFF or JPEG files for use in another program. Using Save As from the File Browser makes it simple to output your final files.

Batch Processing

By using Save Settings and Load Settings you can easily apply the same edits to multiple images. However, these commands require you to manually issue each Load and Save step. So, these commands aren't really practical if you have a huge number of images to process.

For times when you want to apply the same settings to entire folders full of images, you can use Capture NX's Batch Processing feature. Batch Processing does nothing that you haven't already done using the Load Settings and Save Settings commands; it just issues these commands automatically, so that you don't have to continually open and save images.

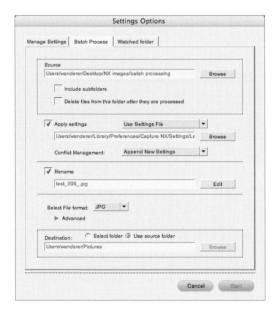

Figure 7.6 You'll use the Batch Process tab in the Settings Options dialog box to configure and run batch operations.

You can access Capture NX's Batch Processing controls (**Figure 7.6**) through the Settings Options dialog box shown in Figure 7.5. However, there are several ways to access this dialog box:

- As mentioned in the previous section, you can access the Settings Options dialog box by choosing Options from the Batch Menu at the bottom of the Edit List. Then click the Batch Process tab.
- Choose Batch > Run Batch Process from the main menu bar.
- Choose Options from the Batch menu in the File Browser (**Figure 7.7**).

Figure 7.7 You can access the Settings Options dialog box (and from there, the Batch Process palette) from the Batch menu at the top of the Browser palette.

No matter how you invoke the Batch Options dialog box, the Batch Process controls will be the same.

Choosing a source

Begin by selecting a source folder. In the Source section of the Batch Process dialog box, click the Browse button and navigate to the folder that contains the images you want to process (**Figure 7.8**).

Figure 7.8 Select a folder of source images using the Source controls at the top of the Batch Process palette.

If the folder contains subfolders full of images that you also want to process, check the "Include subfolders" box.

If you want to automatically delete the source files after they have been processed, check the "Delete files from this folder after they are processed" box. Obviously, you'll want to be very careful with this option, lest you accidentally delete your original images.

Selecting settings to apply

Next, you need to choose the settings that you want to apply to the batch (**Figure 7.9**). Check the "Apply settings" check box. If you want to use a previously saved settings file, leave the Use Settings File pop-up menu as it is. If you want to use the settings from the currently opened image, change Use Settings File to Use Original Settings.

Figure 7.9 Use these controls to select and configure the settings that you want applied to each image in the batch.

If you will be using a saved settings file, click the Browse button to navigate to the settings file.

The Conflict Management pop-up menu lets you specify how to handle images that already have settings applied to them. Append New Settings adds the settings in the settings file to the image's existing settings, and Replace Current Settings completely overwrites any existing settings with the settings stored in the file.

If you select Show Differences, Capture NX displays a dialog box when the batch process is run. The dialog box lets you specify whether to use the image's settings or the settings from the settings file (**Figure 7.10**).

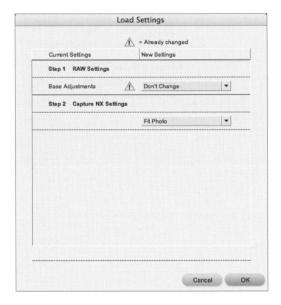

Figure 7.10 If you select Show Differences in your batch configuration, Capture NX lets you choose which edits to apply to an image if it encounters a conflict while the batch is running.

Renaming

If you leave the Rename check box unchecked, Capture NX saves the new file with the same name as the original file, possibly overwriting the original. In many cases, you'll want to rename the files as the batch process is performed.

To have the Batch Processor rename edited images, check the Rename box, and then click the Edit button to bring up Capture NX's File Naming dialog box (**Figure 7.11**).

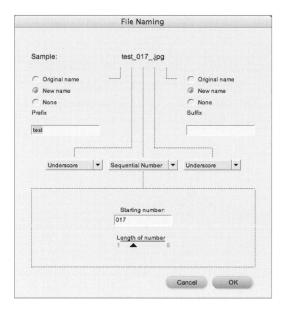

Figure 7.11 Using the File Naming dialog box, you can specify exactly how you want your images named during batch processing.

In the File Naming dialog box, you can specify a filename that has the following components:

- A name, which can be the file's original name, a new name that you specify, or no name
- A separator, which can be an underscore, hyphen, or space
- A sequential number (which you can format using the Starting Number and Length of Number controls), date, or date/time stamp
- Another separator
- A suffix, which can be the original name, a new name, or none
- A file extension, which is determined automatically by the file format that you specify in the Batch Process dialog box

The File Naming dialog box should provide you with all the controls you need to create any type of filename.

Format and destination

In addition, you'll want to select the file format and destination that you want to save your edited images to. From the Select File format menu, you can choose NEF, TIFF, or JPG (the same formats that Capture NX's Save As command offers). Which one you select

depends on what you want to do with the resulting images. If you think you'll need to adjust any of the edits that are applied by the batch process, select NEF. If you are batch processing images to create final deliverables for Web or print design, or for editing by users who don't have Capture NX, select TIFF or JPG.

In the Destination field, you can elect to save the resulting images back into the folder that contains the source images, or you can click the Select folder option to choose a new folder for saving.

Run the batch process

With the Batch Process dialog box configured, click the Start button to begin processing your files. Every Capture NX-compatible image in the folder that you selected as your source folder will be processed by the operation. If you checked "Include subfolders," any compatible images in enclosed subfolders will also be processed.

Capture NX won't display any of the processed images. Instead, a simple progress bar indicates the number of images that have been edited. When the batch process is complete, your new, saved images appear in their destination folder.

You can expand the Processing Queue dialog box to show a more detailed view of your batch progress (**Figure 7.12**).

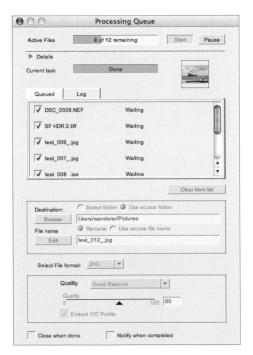

Figure 7.12 The Processing Queue dialog appears when your batch process is running. If you open the Details palette, you can manage the image queue, review the destination, and save settings that have been defined for the batch.

Watched Folder

A Watched folder provides another way of starting a batch processing operation. If you specify a folder as a Watched folder, any images that you place in that folder will automatically be processed; you won't have to issue a specific batch process command.

You configure a Watched folder from the Settings Option dialog box, just like you do a batch process. All of the same settings, renaming, and file format commands are provided. The only difference is that instead of selecting a source folder, you select a folder to watch (**Figure 7.13**).

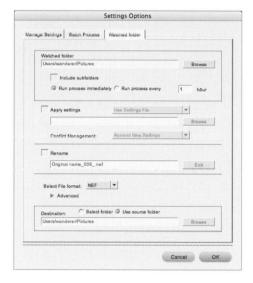

Figure 7.13 You can use the Watched folder palette to configure a folder that automatically batch processes any image that you place into it.

Click the Browse button to specify the folder that you want to watch, and check "Include subfolders" if you want to watch any nested subfolders.

If you click the "Run process immediately" option, the batch operation will be applied to an image as soon as it's placed in the folder. If you click the "Run process every x hour" option, batch processing will only occur at the specified interval. If you don't need your images processed right away, processing at an interval might make more sense for your workflow.

The advantage of a Watched folder is that it allows for further automation of your image production pipeline. For example, you can share the Watched folder with other users on your production team. As they copy images into the Watched folder, your settings can automatically be applied and saved to a final folder that is used by your print or Web designer.

APPLIED BATCH PROCESSING

Obviously, batch processing is an ideal utility for complex postproduction pipelines. But there are plenty of more pedestrian chores that can also be tackled with a simple batch process.

Preparing Images for the Web or Email

If you've just returned from a shoot, made your selects, and performed an initial round of edits, you might want to quickly dump those images onto a Web site or a photo sharing site, or send them in an email. You can use Batch Processing to automatically resize and save them.

- 1. Open one of the images you want to prep for the Web or email.
- **2.** Add a Fit Photo edit to the end of the Edit List.
- **3.** Change the Fit Photo units to Pixels and enter the maximum width and height that you want your images to be. Choosing 640 x 480 or 800 x 600 ensures a good display on smaller monitors.
- **4.** Save the settings file as "Resize for Email." In the Save Settings dialog box, make sure that *all* edits except Fit Photo are *un*checked. You want to create a settings file that only contains the Fit Photo command.
- **5.** Close your image and choose Batch > Run Batch Process.
- **6.** In the Batch Process dialog box, select your source folder, and then select your Resize for Email settings.
- **7.** Set Conflict Management to Append New Settings. This adds the Fit Photo command to the end of any edits that you've already applied.
- **8.** Configure your save and destination options accordingly, and run the batch.

When the batch is run, all of the edits that you made to the images are applied, along with the Fit Photo edit, which resizes the image. The results are saved in the format you specified into the destination you chose.

TIP I use Fit Photo rather than Size Resolution, because with Fit Photo I don't have to worry about whether the image has a portrait or landscape orientation.

Quick Web Preview

Sometimes, when you come back from a shoot, you want to quickly get your selects posted to the Web without having to engage in a lot of editing. If you're working for a client, being able to quickly produce a Web gallery of your selects can be essential: You'll want client approval before you begin a time-consuming editing process.

Create a settings file that applies an Auto Contrast edit and a Fit Photo edit, and then execute this settings file on your shoot using the Batch Processor. You'll quickly get a set of resized images that have had a reasonable initial contrast adjustment. This should be good enough for refining the selection for further editing.

Preparing for Print

Just as you can batch process images for Web and email delivery, you can build settings files that can prepare your images for printing. Printing workflows vary, but it's safe to assume that all print jobs will require resizing, and possibly sharpening. As you did for the Web and email prep, create a settings file that resizes to your desired size.

For print, you'll want to set both the image size and the resolution. You can do both with a Size/Resolution edit, but that edit will only work with images of a specific orientation. Instead, use both a Size/Resolution edit and a Fit Photo edit.

- 1. Open an image that you want to process.
- 2. Add a Size/Resolution edit.
- **3.** Select Change the Output Size (DPI). Enter **240** into the dpi field (or whatever resolution you want to use for printing) (**Figure 7.14**).

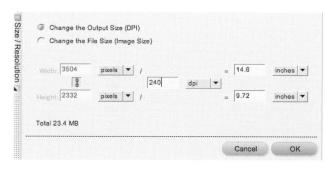

Figure 7.14 Use the Size / Resolution edit to specify the printing resolution that you want for your images. You'll perform the resizing using Fit Photo.

4. Add a Fit Photo edit and configure it to the width and height, in inches, that you want for your images.

The resulting images are sized to fit in the specified width and height, and have the resolution that you specified in the Size/Resolution Edit.

- 5. Add an Unsharp Mask edit and configure it appropriately.
- **6.** Save the settings file.

Now save and process the images as you learned earlier. For best results, save the images as TIFFs rather than JPEGs to avoid JPEG artifacting.

CHAPTER EIGHT

No matter what your organizational and editing workflows are, it's a safe bet that one of the last steps of your workflow will be output. Whether you need electronic output, printed output, or some combination, Capture NX provides fully color managed, easy-to-use output options.

OUTPUTTING ELECTRONIC FILES

If you need to deliver electronic files to a client, create images for use on a Web page, send pictures via email, or pass a file you've been editing in Capture NX to an additional editing program, you'll need to output files.

By default, when you save a file in Capture NX, it is saved as a NEF file, a proprietary Nikon format that includes both the original image data for your image and the list of edits that you've created in the program. Capture NX knows how to interpret and process the data to render a final image, but the edited files will not be readable by any other program. So, if you need a file that can be read by another application or by a user who doesn't have Capture NX, you'll need to use the Save As command to save the image in a different format.

TIP You can change the default file format from NEF to JPEG or TIFF in the General section of the Preferences dialog box. The Save as preference also lets you opt to automatically save in the file's original format or in the last file format that you saved.

As shown earlier, if you choose File > Save As, you can elect to save in either JPEG or TIFF format (in addition to NEF) by choosing your desired format from the File Format pop-up menu.

Saving for the Web or Email

If you want to output an image for use on the Web or for sending via email, you'll most likely need to resize it before saving. The use of Fit Photo and Size/Resolution was discussed in Chapter 5, "Basic Image Editing." You'll use these commands to resize your image and will then want to save as a JPEG for posting on the Web or sending via email.

In the previous chapter, I detailed some automation procedures that you can use for outputting to the Web or email.

Saving for a Print Workflow

Most printing workflows should use TIFF files rather than JPEG files for maximum image quality and to avoid potential compression artifacts. Most likely, you'll need to resize your images to particular specifications and save your TIFFs with specific settings. You might also need to attach a specific color profile. Consult your printer or art director to find out exactly what is expected for TIFF file delivery. Chapter 5 covers resizing, and Chapter 7, "Version Control and Batch Processing," offers some solutions for batch image conversion.

Saving for Use in Another Image Editor

While Capture NX provides a full assortment of editing and retouching features, there will be times when you need to tweak or alter an image in another program. For these instances, you'll want to output your images as TIFF files, which you will then open in your other editor. While you could use JPEG format to transfer files, every time you resave a JPEG file, you introduce more quality loss.

TIFF files also give you the option of saving in 16-bit format to preserve more of the colors that your camera originally captured. JPEG files are automatically converted to 8-bit upon export. For maximum editing latitude, choose 16-bit in the TIFF Save Options dialog box. Even if your final files will be 8-bit JPEGs, making the transfer in 16-bit mode allows you to push your edits further before encountering posterization and tone breaks.

PRINTING

Capture NX provides powerful printing features that let you create single prints or contact sheets, with or without metadata captions. Capture NX's printing architecture is fully color managed and provides complete soft proofing capabilities to help you get a better screen to printer match. You can invoke the Print Layout dialog box from within a specific document or from the File Browser.

Printing an Individual Image

Printing an image is fairly simple. Select File > Print to invoke the Print Layout dialog box, and then configure as needed. Capture NX uses its own custom print dialog box that looks a little different from the Print dialog box provided by your operating system (**Figure 8.1**).

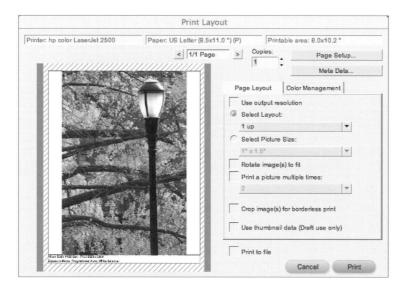

Figure 8.1 Capture NX has its own Print dialog box that provides a full assortment of layout and color management features.

The printing controls are fairly straightforward. On the left side of the dialog box is a preview display that shows how your image will fit on the currently selected paper size. The three text fields across the top of the display indicate which printer is currently selected, what size paper you'll print on, and what the printable area of that paper size is.

Using the controls on the right side, you can configure and customize the printing process. The controls are grouped into two tabs, Page Layout and Color Management. I'll cover color managed printing separately.

Page Setup. Click the Page Setup dialog box to invoke your operating system's standard Page Setup controls. From here you can select the printer and paper size that you want to print on.

Copies. Use this field to indicate how many copies of the page you want to print.

Meta Data. Click this button to bring up the Meta Data dialog box (**Figure 8.2**). From here you can turn on metadata sets that will be printed beneath your image. Using the Font controls, you can select the formatting of the printed metadata. You can also elect to print the date and time that the image was shot on top of the image.

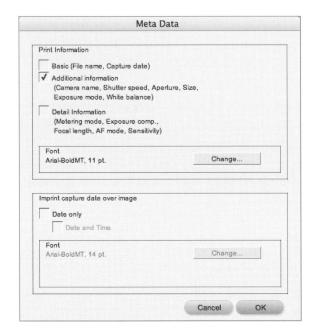

Figure 8.2 The Meta Data dialog box lets you select metadata for display beneath your image in your final print.

Use output resolution. By default, Capture NX fits your image to the current page size. If you've meticulously resized your image by hand using a Resize or Fit Image command, you can check the "Use output resolution" option to force the program to use those settings instead.

Select Layout. When printing individual images, this pop-up menu has no effect.

Select Picture Size. The Select Picture Size menu contains some predefined images sizes (**Figure 8.3**). If you select one of these presets, Capture NX automatically resizes your image and outputs it at the optimal resolution for that size.

Figure 8.3 Use the Select Picture Size menu to select a predefined print size.

Rotate image(s) to fit. This option automatically rotates your image to maximize the use of the page. Capture NX automatically determines which rotation will yield the largest image.

Print a picture multiple times. If your chosen print size is small enough to fit multiple copies of the image on the current paper size, this menu lets you select how many copies of the image to include on the page (**Figure 8.4**).

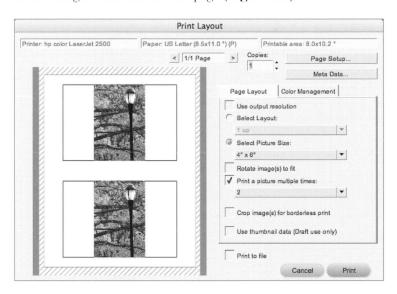

Figure 8.4 If your image size is small enough, you can choose to print multiple copies of an image on the same page.

Crop image(s) for borderless print. If you want to print an image without a border and the image has a different aspect ratio than your current paper size, this option automatically crops it to fit.

Use thumbnail data. This option prints using lower resolution data for times when you're running your printer in draft mode. For the speediest printing, check this option.

Print to file. This option allows you to output the indicated page to a JPEG file. If you select this option, when you click Save, Capture NX asks you to select a location and then prompts you to pick a compression setting. Print to file allows you to easily export JPEGs formatted to a particular size along with metadata captions.

Note that the preview display updates to reflect changes you make to any of these settings, making it easy to understand exactly what type of layout you've specified. When you've configured the Print Layout dialog box to taste, click the Print button. The standard Print dialog box for your printer appears. You can then specify paper type, printing modes, and any other options necessary to get the type of print you want.

Printing a Batch of Images

You can use the Browser to batch print a group of images. Just select the images that you want to print, and then choose File > Print. Configure the Print Layout dialog box accordingly, and then click Print. Capture NX prints each image according to the specifications that you define in the Print Layout dialog box. Obviously, when selecting images, you'll need to select pictures that will print okay with the same print settings. For instance, you don't want to pick some images that need to be printed with the "Use output resolution" option and others that don't.

Capture NX's "Rotate image(s) to fit" option and other layout controls make it easy to define parameters that yield the optimal layout for each image in a batch.

When you have launched the Print Layout dialog box with multiple images selected, you can use the Forward and Back buttons next to the print display field (**Figure 8.5**) to view each image. This allows you to ensure that your chosen settings are appropriate for all of the images in your batch.

Figure 8.5 The page navigation tools let you thumb through multiple images if you've chosen to print multiple images from the Browser.

Printing a Contact Sheet

Using the Browser, you can easily create contact sheets that display multiple, separate images on one page. Note that this is different than the Select Layout option you saw earlier, which lets you print multiple copies of the *same* image on one page.

To create a contact sheet:

- 1. In the Browser select the images you want to print.
- **2.** Choose File > Print.
- **3.** In the Print Layout dialog box, click Select Layout, and then select the number of rows and columns that you want on your contact sheet (Figure 8.6).

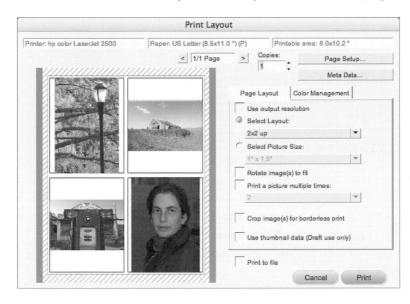

Figure 8.6 When you have opened multiple images, use the Select Layout menu to choose a contact sheet layout.

- **4.** Configure any other options as needed. Note that the Meta Data controls automatically place metadata beneath each image on your contact sheet.
- 5. Click Print to move on to the standard Print dialog box—the one you use when printing a single image.

Note that the "Print to file" option works with contact sheets as well as individual images. So, you can easily create JPEG images of your contact sheets for posting to the Web or emailing.

Color Managed Printing

Color management is simply the process of trying to ensure consistent color across different devices—usually monitors and printers—and from one program to another. For color management to work, your monitor and printers must be profiled. Running a coloraccurate system is expensive. To get accurate onscreen proofs, you'll need a high-quality (read *pricey*) monitor as well as special profiling hardware.

Whether you choose to use onscreen proofing or not, over time you'll probably learn to better predict how the image on your screen will appear on paper. As you become more experienced with the traits of your particular printer, it will become easier for you to look at an image onscreen and say, "Oh, that will shift to red," or "Those shadows will turn out too dark."

Both the Mac and Windows operating systems provide tools for creating monitor profiles by eye, but if you're going to bother with color management, you really should invest in a monitor profile. Both ColorVision and Pantone now offer monitor profiling and calibration hardware for under \$100. For \$150 to \$300 you can get higher-end products from ColorVision and Gretag Macbeth. You'll quickly earn back your investment in saved paper and ink, so it's well worth investing in some monitor profiling hardware.

Any device that you choose will include software and instructions on profiling, and you should find the process fairly easy and painless.

Note, however, that no matter how good your monitor is and how often you profile it, your printed output will *never* look exactly like what's on your screen. Your monitor is a self-illuminated transmissive display with a very large gamut, whereas a print is a reflected medium with a much smaller gamut. That said, color management *can* help you reduce the number of test prints that you need to make to get good results. If you can decrease the number of test prints from five or six to two or three, you'll be doing a good job.

Installing printer profiles

For onscreen proofing to work, you must have ICC profiles installed for your printer. Most high-quality photo printers ship with ICC profiles that are installed along with the printer driver. Some vendors provide profiles as a separate installation, and others provide improved profiles as a separate download. Check your printer vendor's Web site for more information.

Color management workflow

The process of color managed printing is fairly simple: You'll start by activating and configuring Capture NX's Soft Proof feature (see the next section). When you create a soft proof, Capture NX uses the information stored in your monitor and printer profiles to generate an onscreen simulation of what your image will look like when printed.

When you print, you have a number of options for specifying how Capture NX should process your color. You can simulate each of these options when soft proofing. So, one of your goals when soft proofing is to determine exactly which color settings you want to use when printing.

With the Soft Proof feature active, you may decide that you want to make some additional adjustments to your image to compensate for the effects of printing on certain types of paper. For instance, some glossy papers might introduce a green or blue cast into your image, so you may decide to perform a green or blue hue shift to your image to compensate.

Once you have your soft proof looking the way you want it to, you can execute your print operation.

Activating onscreen proofing

In the lower-left corner of the document window, you'll find the toggle button for activating and deactivating soft proofing (**Figure 8.7**). Click the button to activate soft proofing, and the Soft Proof Dialog appears (**Figure 8.8**).

Figure 8.7 The soft proofing switch at the bottom of the document window lets you toggle soft proofing on and off.

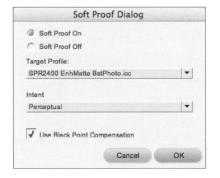

Figure 8.8 In the Soft Proof Dialog, you can select which paper profile you want to use and specify how you want Capture NX to process the colors in your document to fit within the gamut of your chosen paper.

Configuring the Soft Proof Dialog is fairly simple:

- 1. Select Soft Proof On to activate soft proofing. You'll most likely notice an immediate change in the appearance of your image. Don't worry, Capture NX has not done anything to the actual color values in your image. If you click Soft Proof Off, your image returns to normal.
- **2.** From the Target Profile pop-up menu, select the printer profile you want to use when printing. You'll usually have separate profiles for each type of paper that you can print on, perhaps separate profiles for different settings that you'll use with each paper type, and possibly even different viewing conditions.

3. Select an intent. These days, any printer you use will have a smaller color gamut than your document. Consequently, Capture NX has to map the broad range of colors in your document into the much smaller color space of your printer. The intent you choose controls how that remapping will occur.

Perceptual intent attempts to maintain the relationships between colors to produce an image that looks natural to the eye.

Saturation is only useful for very saturated images such as illustrations and business graphics; you'll never use it for photos unless you want a very stylized look.

Relative Colorimetric maps the white point of your image to the white point specified in your printer profile, and then lines up all the other colors accordingly. Colors in your image that lie outside the gamut of your printer profile are mapped to the closest possible color. You'll probably use this intent most often because it preserves the greatest number of colors in your image.

Absolute Colorimetric doesn't map the white in your image to the white of your printer profile. Instead, it tries to reproduce the exact white that appears in your image. So, if the white in your image is actually a little bluish, Absolute Colorimetric reproduces it that way. All other colors are then mapped to their closest counterpart, as in Relative Colorimetric.

While the Soft Proof Dialog is open, try different rendering intents until you find the one that you like best.

- **4.** Specify Black Point Compensation. The Black Point Compensation check box is available for all intents save Absolute Colorimetric. Black Point Compensation maps the black point in your image to the black point of your printer profile. You'll almost always want this option turned on unless your images lack a true black.
- 5. When you've determined the settings that yield the best soft proof, click OK.

If need be, you can now perform additional edits. Your image is still being proofed in real time, so you can see the soft proof update as you work on your file. If you decide you want to change your proof settings, click the soft proof toggle again to invoke the Soft Proof Dialog. You can also deactivate soft proofing altogether by opening the Soft Proof Dialog and choosing Soft Proof Off.

Printing

With your proof adjusted, you're ready to print.

- 1. Choose File > Print and configure any page layout settings to taste.
- **2.** Click the Color Management tab to view the Color Management controls (**Figure 8.9**).

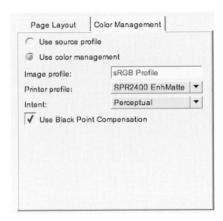

Figure 8.9 You'll use the controls on the Color Management tab to configure the Print dialog box to match the settings you determined during your soft proof.

- **3.** If you used the Soft Proof controls, the Color Management tab will automatically be configured with the same settings—printer profile, rendering intent, and black point compensation.
- **4.** Click Print to move on to the standard Print dialog box.
- **5.** Using the controls in the Print dialog box, *deactivate* any color correction that is built in to the printer. This is an essential step. Capture NX is already handling color correction, so you don't want the printer adding another layer of color correction. Consult your printer manual for details on how to deactivate built-in color management.
- **6.** Configure the rest of your print options and print.

Compare the results to your screen to see how well they match.

Improving soft proofing accuracy

As mentioned earlier, your prints will never exactly match your monitor. However, there are some measures you can take to try to improve the match.

- Adjust your viewing environment. When looking at your monitor, other colors in your field of view can influence your perception of the colors in your image. Try to remove any bright colors from behind your monitor. Also, make sure your computer desktop contains a neutral background.
- Adjust the lighting in your room. When you profiled your monitor, your profiling software probably asked you what the ambient lighting conditions were in your room. If these have changed, either put them back the way they were or make a new profile for the new conditions.
- **Get better printer profiles.** Often, the profiles that ship with a printer are not very good, either because they were poorly made in the first place or because not every printer that rolls off of the assembly line is identical. Printer profiling hardware is not cheap (such devices start at \$1000), but there are several online services that will make a profile for you. Most of these are reasonably priced (\$25–\$50), and the profiles they generate can make a great improvement in your printing accuracy.

Finally, remember that your monitor changes over time, so you should regularly reprofile it to keep it as accurate as possible. Most profiling devices include software that automatically reminds you to reprofile.

Printer-Controlled Color

Depending on the printer you have, you may find that you get as good, or better, results by letting the printer handle the color rather than Capture NX. To use printer-controlled color, click the "Use source profile" option on the Color Management tab of the Print Layout dialog box. Then leave color management on in your printer driver dialog box.

When using driver-controlled color, Capture NX's soft proofing features are irrelevant. The preview shown by soft proofing won't necessarily be representative of what you get from the printer. The only way to determine if you prefer Capture NX or driver-controlled color is to try them both. A few years ago it was safe to say that driver-controlled color was inferior to application managed color, but over the last year or two that's changed. HP, Epson, and Canon have all managed to greatly improve their printer drivers, and you can now get excellent results directly from the printer driver.

BACKUP AND ARCHIVING

No workflow is complete without an archiving step, and while you're working, you might want to consider regularly backing up your work files. The difference between backup and archiving is as follows:

- Backup is the process of creating duplicates of the files you're working on, so if you
 have a hardware malfunction or accidentally screw up an image, you can restore to
 your last backup.
- Archiving is the process of storing completed images when you're done working with them.

You typically create backups by copying your files to a second hard drive. Because you usually want to update your backup files as you continue to edit your images, hard drives make for quick, efficient backups and easy restoration.

When you're ready to archive your images for long-term storage, you can use hard drives or optical media such as recordable CDs and DVDs. Optical disks are cheaper per megabyte than hard drives, so you can easily create multiple copies, but hard drives allow for easy rewriting if you later decide to edit or alter an archived copy.

However you choose to back up and archive your images, remember that you should save *both* your NEF files and a rendered TIFF. The NEF files will allow you to return to a fully editable version of your image at a later date, and the TIFF files will give you an image that you can use in other applications. A TIFF file is especially handy in the event that you one day lack access to a copy of Capture NX.

WHERE TO GO FROM HERE

Many resources are available on the Web for Capture NX information and general image editing tips, including my own Web site at www.completedigitalphotography.com. But if you really want to improve your Capture NX chops, your best choice is to practice. Get out, shoot some images, and then put them through your Capture NX workflow. I hope by this point you have a good idea of how to find your way around the application.

If you have any questions or comments, I'd love to hear them. You can email me directly using the Feedback link on my Web site.

INDEX

8-bit conversion, in raw image processing, 21 8-bit images, use of 8-bit numbers with, 10 16-bit images, use of 16-bit numbers in, 10 16-bit TIFFs, saving, 139 Symbol [] (bracket) keys, resizing brushes with, 147	Black and White Conversion filter, using, 187 Black and White mode, using with Photo Effects filter, 184 black clipping, controlling with Auto Contrast, 111 Black Control Point tool, using, 166–167 black point, controlling with Levels and Curves eyedroppers, 110–113
A additive color combination, explanation of, 63 adjustment sliders, specifying for control points, 178 Adobe Gamma control panel, using in Windows, 66 Adobe RGB versus sRGB, 71 Aperture, importing images with, 42 archiving, 57, 221 Auto Color Aberrations setting, using for Raw Adjustment, 138 Auto Contrast, controlling white and black points with, 111 Auto Levels adjustments correcting color casts, 102–104 making, 99–104 Auto Levels edits adding, 100 altering, 101 Auto White Balance mode, shooting in, 13	blacks in images, adjusting levels of, 106 blue channel editor, switching to, 110 blue component, specification of, 10 borders, eliminating from printed images, 213 bracket keys ([]), resizing brushes with, 147 brightness, controlling with levels curve, 109. See also Contrass Brightness adjustments Brightness slider using, 117 using with Contrast: Color Range filter, 187 Browser applying camera adjustments from, 136 moving files within, 48 organizing, 45–46 Browser palette features of, 35–36 opening, 46
Base Adjustments	opening images with, 73 Browser views, using, 46–47 Brush Options controls, activating, 153 brushes, resizing, 147 burning and dodging, 180–183
applying as edit Steps, 81 Camera Adjustments and Raw Adjustments, 82 editing, 82 explanation of, 79–80 Batch menu Load Settings command in, 198 Save Settings command in, 197	Calibration of monitors, significance of, 63 Camera Adjustments for Nikon raw applying, 82, 136 making, 132–136
Batch menu commands, using with IPTC metadata, 56 batch processing, 204 choosing source for, 201 renaming edited images in, 202–203 selecting format and destination for, 203–204 selecting settings to apply for, 201–202 starting with Watched folder, 205 using to prepare images for print, 207–208 using with images for Web or email, 206 batch renaming files, 49 batches of images, converting to different file formats, 199 Bird's Eye palette location of, 36	Capture NX adding to Photoshop workflow, 59 color management in, 72 interlocking palettes in, 34 using with iPhoto and Aperture, 42 using with non-Nikon raw files, 58 card readers configuring Macs for, 39 configuring Windows for, 43 cards, transferring images from large batches of, 45 CFA (color filter array), Bayer pattern as, 9 channel editors, switching to, 110 channels adjusting, 109–110
relationship to Light Table view, 47	constraining edits to, 113

chips, photosites on, 7	Color Management controls, viewing, 219
Chroma editor in LCH, using, 127	color management software, profiles examined by, 63–64
clipping, example of, 27	Color Moiré Reduction setting, using for Raw Adjustment
clipping displays, indicating highlights and shadow tones in,	138
116	Color Picker
CMY (cyan, magenta, yellow), subtractive combination of, 63	activating, 36
Color Aberration Control, using, 97–98	using with Neutral Control Points, 163–165
color adjustments	color spaces
Color Balance edits, 128–129	applying, 143–144
Color Booster edits, 130	
in JPEG image processing, 14	converting images to, 144
	in JPEG image processing, 12–13 overview of, 71–72
with LCH (Lightness, Chroma, Hue), 125–128	
in raw image processing, 20	in raw image processing, 19
Saturation/Warmth edits, 130–131	setting preferences for, 72
color balance, changing for Neutral Control Points, 161	color systems, overview of, 63
Color Balance edits, making, 128–129	color values, monitoring with Watch Points, 104
color batches, mixing, 8–10	colored filters, relationship to photosites, 8
Color Boost slider, using with D-Lighting, 122	colorimetric interpolation
Color Booster edits, making, 130	in JPEG image processing, 12
color casts	in raw image processing, 19
correcting, 102–104	Colorize palette, using with selections, 156
removing, 77	colors
subjectivity of, 103	averaging between pixels, 9
color channel editors, switching to, 110	calculating for pixels, 8–9
color channels	CompactFlash Reader, using, 45
importance of, 11	Compare mode, using, 50–51
presence in final images, 10	compressed air, advisory about using, 138
Color Control Point Settings palette, Advanced section of,	Conflict Management pop-up menu, using in batch proces
177–178	ing, 202
Color Control Points. See also control points	contrast
adding to sky, 170	adjusting based on histograms, 28
adjusting foreground for, 174–175	increasing, 180
configuring for brightness, contrast, and saturation,	increasing with Color Control Points, 179
175–176	increasing with Selection Brush, 145-148
deactivating effect of, 173	in JPEG image processing, 14
displaying pop-up menu for, 172	in raw image processing, 20
duplicating, 172	using Auto Contrast feature, 111
increasing contrast with, 179	contrast and tone, adjusting, 77, 99. See tone and contrast
using, 168–179	contrast and tone adjustments. See tone and contrast adjust
using with Selection Brushes, 178–179	ments
color correction, performing, 78	Contrast slider, using, 117
Color Filter Strength slider, using with Black and White	contrasty histograms, 28–29
Conversion filter, 187	Contrast/Brightness adjustments, making, 116–119. See also
color fringing, removing, 98	brightness
color information theory, 24	control point handlers, toggling visibility of, 175
Color Lightness controls, using with LCH, 125–127	control point sliders, numeric readings for, 171
color managed printing	Control Point tools. See also tonal control points
activating onscreen proofing, 217–218	Black Control Point, 166–167
implementing, 219	identifying, 35
installing printer profiles for, 216	location of, 158
overview of, 215–216	Neutral Control Point, 159–165
process of, 216	White Control Point, 165–166
color management	control points. See also Color Control Points; tonal control
in Capture NX, 72 workflow of, 216–217	points
WOLKHOW OI, 210–217	deactivating effect of, 173

hiding effects of, 163, 177	Edit Steps
selecting parameters for, 177	adding, 83
specifying adjustment sliders for, 178	altering, 84
copies of pages, printing, 212	deleting, 83
Copy and Paste settings, using with edits, 195–196	edits. See also settings
Copy command, accessing, 197	applying as Edit Steps, 80–81
Correct Contrast slider, using, 101	constraining to current channel, 113
Crop tool	copying and moving, 195–196
displaying, 84	managing, 120
making geometric adjustments with, 87-88	pushing limits of, 141–143
cropping, controlling when straightening images, 86	saving prior to batch processing, 197–198
Crop/Straighten/Rotate tools, identifying, 35	storing with Edit List palette, 31
curves	effects
adjusting, 114–115	changing opacity of, 183
reading relative to Levels slider, 109	combining, 155
cyan, magenta, yellow (CMY), subtractive combination of, 63	electronic files, outputting, 209–210
	email
D	preparing images for, 95
darkness, controlling with levels curve, 109	resizing images for, 93
date view, changing to, 53	saving image files for, 210
demosaicing	email images, using batch processing with, 206. See also image
in JPEG image processing, 12	Enhance mode, using with Photo Effects filter, 184
process of, 9	EXIF (exchangeable image file) information, storage of, 17
in raw image processing, 19	Exposure Compensation setting, using for Raw Adjustment,
destination and format, selecting for batch processing, 203-204	136–137
destructive versus nondestructive editing, 29	Eyedropper tools, identifying, 35
detail in images, factors related to, 24	cycdroppers
Details view, using with folders, 47	gray point eyedropper for correcting white balance, 134
digital cameras	Levels and Curves, 110–113
final images from, 10	-
image sensor in, 7	F
digital images, composition of, 10–11	facial retouching, applying, 182–183
digital photography	Feather option, using, 155
advantage of, 22	fields, saving settings as, 197
downside of, 7	File Directory palette, features of, 35–36
diodes, presence on photosites, 7	file formats, changing, 199
dirt, adding saturation to, 152–153	File Naming dialog box, using in batch processing, 202–203
Distortion Control, using, 96	file storage
D-Lighting adjustments, making, 120–122	in JPEG image processing, 17
dodging and burning, 180–183	in raw image processing, 21
lots per inch, changing to dots per centimeter, 90	filenames, displaying images by, 46
dust, dealing with, 138	files. See image files
Dust Off setting, using for Raw Adjustment, 138	Fill selections, using, 149 Fill/Remove options, opening, 149
E	fills, changing opacity of, 149
5	Filter Hue slider, using with Black and White Conversion
edge detection filter, High Pass filter as, 188–189	filter, 187
Edit List, Base Adjustment entry in, 79	filters
Edit List context menu, options on, 84	Black and White Conversion, 187
Edit List palette	Contrast: Color Range, 186–187
location of, 36	Gaussian Blur, 188
storing edits with, 31 edit lists, saving, 31	Grain/Noise, 185
ant note, saving, J1	High Pass, 188–189
	Photo Effects, 184–185
	Unsharp Mask, 191–192

Fit Photo edit, using with batch processing, 206	overview of, 25–27
Fit Photo, making geometric adjustments with, 95–98	showing before and after adjustments, 110
Flip commands, making geometric adjustments with, 88	using with tones, 103
folders	Hue adjustments, making, 125–128, 138
browsing, 35	
Display Calibrator Assistant on Mac, 65	1
displaying details of, 47 displaying number of images in, 46	Image Capture, using with Macs, 41–42
lock icon between Width and Height fields, 91	image editing
opening, 45–46	palettes available for, 36–37
reorganizing, 45–46	theory of, 24–27
software monitor calibration on Mac OS X, 65	image editing workflow
viewing images in, 46–47	adjusting tone and contrast, 77
watching for batch processing, 205	making final tweaks, 78
foreground, adjusting for Color Control Points, 174–175	making geometric corrections, 76–77
format and destination, selecting for batch processing, 203–204	performing color correction, 78
full-color image, image processing control, 15	removing color casts, 77
tun-color image, image processing control, 15	sharpening and outputting images, 78
C	image editors saving image files for, 210
G	image files
gamma	moving within Browser, 48
in JPEG image processing, 14	organizing, 43–48
in raw image processing, 20	renaming, 49
gamma adjustment, performing on red cast, 110	saving, 139–140, 210
gamma slider, using with Levels controls, 107	image glut, managing, 22
Gaussian Blur filter, using, 188	image masters, backing up, 43
geometric adjustments, 76–77	image ratings, changing, 54
Crop tool, 87–88	image resolution, changing, 90
Fit Photo, 95–98	image sensors, explanation of, 7
Flip commands, 88	images. See also email images; select images; Web images
making with grid, 89	adding keywords to, 54
resizing, 89–94	changing number of pixels in, 91–92
Rotate tool, 85	converting to different profiles, 143–144
Straighten tool, 86	correcting distortion in, 96
Gradient selections, using, 150–152	cropping, 87–88
Grain/Noise filter, using, 185	cropping for borderless print, 213
gray point eyedropper, correcting white balance with, 134	darkening with Levels and Curves adjustment, 181
grays, protecting from adjustments, 127	displaying by filenames, 46
green channel editor, switching to, 110	importing in Macs, 39–42
green component, specification of, 10	importing in Windows, 43
green photosites, numbers of, 8	importing with iPhoto and Aperture, 42
grid, making geometric corrections with, 89	level of detail in, 24
gridlines, using with Crop tool, 88	moving into subfolders, 48
11	navigating with Bird's Eye palette, 36
Н	opening, 73–74 preparing for email, 95
hardware profiling, 67–68	
High Pass filter, using, 188–189	preparing for printing, 207–208 printing, 211–214
highlights and shadow tones, indicating in clipping displays,	printing, 211–214 printing batches of, 214
116	resizing, 89
Histogram palette, using Watch Points feature on, 104	resizing for print, 92–93
histograms	resizing for printing, 212
combining, 114	resizing for Web or email, 93
contrasty histograms, 28–29	rotating, 85
identifying overexposure with, 27	rotating for printing, 213
identifying underexposure with, 27	0 [

saving, 31	LCH adjustments, making, 123–124
saving as JPEG files, 31	LCH (Lightness, Chroma, Hue)
saving as TIFF files, 31	Chroma editor, 127
saving in NEF format, 31	Color Lightness controls, 125–127
sharpening and outputting, 78	Hue adjustment, 128
sharpening with High Pass filter, 188	LCH editors, choosing, 125
sorting in ascending and descending order, 46	Levels & Grid preferences, setting, 89
straightening, 86	Levels and Curves adjustments
transferring from multiple cards simultaneously, 45	adding, 104
viewing in folders, 46–47	configuring to increase contrast, 146
viewing in other applications, 31	creating lightening effect with, 182
images in folders, displaying number of, 46	darkening images with, 181
importing images	Levels and Curves eyedroppers, using, 110–113
in Macs, 39–42	Levels controls
in Windows, 43	manual control over, 107
ink, primary colors of, 63	using, 105–108
inkjet printing, suggested resolution for, 90	using midpoint slider with, 107
intent, choosing for color managed printing, 218	Levels slider, reading curve related to, 109
iPhoto, importing images with, 42	library structure, maintaining with Lightroom, 44
IPTC metadata. See also metadata sets	light
advantage of, 57	intensities of, 13
applying settings for, 56	primary colors of, 63
copying, 56	Light table view, using, 46–47
creating settings for, 55	lightening effect, creating with Levels and Curves edit, 182
editing, 54	Lightroom, using for Mac and Windows, 44
ISO setting, increasing, 11	lines, straightening, 86
8,	lock icon between Width and Height fields, effect of, 91
J	lossy compressor, JPEG as, 16
	luminosity, controlling for Contrast: Color Range filter, 187
JPEG compression, explanation of, 16	Luminosity sliders
JPEG files	using with Neutral Control Points, 162
changing NEF files to, 209	using with White Control Point tool, 166
managing image glut with, 22	
printing pages to, 214	M
saving, 139–140	
saving images as, 31	Macs
JPEG image processing	importing images in, 39–42
8-bit conversion, 16	installing printer profiles on, 70
color space, 12–13	monitor software profiling on, 65–66
colorimetric interpolation, 12	using Image Capture with, 41–42
demosaicing, 12	using Lightroom for, 44
file storage, 17	viewing thumbnails on, 41
gamma, contrast, and color adjustments, 14	Masking tools, identifying, 35
noise reduction and sharpening, 15	masks
white balance, 13	viewing with Show Selection option, 148
JPEG images, shooting, 11	viewing with Show Selection option, creating for Color
	Control Points, 174–175
K	Master Lightness control in LCH, using, 123–124
K (Kelvin) scale, using with light intensity, 13	masters, backing up, 43
keyboard shortcuts, creating for Compare features, 51	metadata sets, printing, 212. See also IPTC metadata
keywords, adding to images, 54-55	metric measurements, using, 90
	midpoint slider, using with Levels controls, 107
L	midpoints, controlling with Levels and Curves eyedroppers,
labels, applying to select images, 52	110–113
,,	monitor profiles. See also profiles

Lasso Selection tools, using, 149

hiding and showing, 34

information in, 63–64	opening, 34
investing in, 216	Photo Info palette, 36
monitor profiling	tool palettes, 35
frequency of, 68	Watched folder palette, 205
hardware profiling, 67–68	Paste command, accessing, 197
profiles and viewing conditions, 68–69	pen pressure controls, adjusting, 154
software profiling on Macs, 65–66	Photo Effects filter, using, 184–185
software profiling on Windows, 66	Photo Info palette, location of, 36
multishot card readers, using, 45	photodiodes, relationship to photosites, 7
	Photoshop Lightroom, using for Mac and Windows, 44
N	Photoshop workflow, adding Capture NX to, 59
Navigation tools, identifying, 35	photosites
NEF format	diodes on, 7
changing to JPEG or TIFF format, 209	relationship to colored filters, 8
saving image files in, 140	pictures, printing multiple times, 213
saving images in, 31	pixel colors, specifying with three numbers, 10
Neutral Control Point tool, using, 159–165	pixels
Nikon raw shooters, Camera Adjustments available to,	allocation of, 89
132–136	averaging colors between, 9
noise reduction and sharpening	calculating colors for, 8–9
in JPEG image processing, 15	pixels in images, changing number of, 91–92
raw image processing, 20	posterization artifact, example of, 142
Noise Reduction edits, using, 190	pressure controls, setting for pens, 154
nondestructive resizing, using, 94	primary colors, translating, 63 print
nondestructive versus destructive editing, 29–31	print preparing images for, 207–208
non-Nikon raw files, using Capture NX with, 58	resizing images for, 92–93
NX. See Capture NX	print workflow, saving image files for, 210
	printer profiles. See also profiles
0	installing, 216
onscreen proofing, activating for color managed printing,	installing on Macs, 70
217–218	installing on Windows, 70
Opacity Mixer, using, 183	printer-controlled color, using, 220
Opacity setting	printing
applying to brush edges, 153–154	batches of images, 214
changing for fills, 149	color managed printing, 215-220
Open Image command, using, 73	contact sheets, 214–215
Open Recent command, using, 73	copies of pages, 212
OS, opening images from, 74	images without borders, 213
overcast day image, applying dodging and burning to, 180–183	implementing color managed printing, 219
overexposure, identifying with histograms, 27	individual images, 211–214
	metadata sets, 212
P	pictures multiple times, 213
page navigation tools, using, 214	resized images, 212
Page Setup controls, invoking, 212	Professional CompactFlash Reader, using, 45
palettes	profiles. See also monitor profiles; printer
Bird's Eye palette, 36	applying, 143
Browser palette, 35–36	converting images to, 143-144
Brush Options palette, 153	examination by color management software, 63-64
Camera Settings palette, 36	and viewing conditions, 68-69
Color Control Point Settings palette, 171	
Color Picker palette, 36	R
Edit List palette, 36	ratings
File Directory palette, 35–36	assigning to images, 52

assigning to images, 52

changing for images, 54

Raw Adjustment settings, 82	evaluating, 50
Auto Color Aberrations, 138	rating, 52
Color Moiré Reduction, 138	Selection Brushes
Dust Off, 138	increasing contrast with, 145-148
Exposure Compensation, 136–137	switching to, 148
Hue Adjustment, 138	using with Color Control Points, 178-179
raw concerns	Selection Gradient tool, using, 150
shooting performance, 22–23	Selection tools
storage, 22	combining, 152–154
workflow, 22–23	location of, 145
raw files	selections
opening, 74	combining effects of, 155
saving, 139	creating before defining edits, 156
using Capture NX with non-Nikon raw files, 58	Fill selections, 149
raw image processing	fixing seams in, 155
8-bit conversion, 21	Gradient selections, 150–152
color space, 19–20	lassoing, 149
colorimetric interpolation, 19	refining, 157
demosaicing, 19	seeing, 156–158
file storage, 21	viewing, 148
gamma, contrast, and color adjustments, 20	sensor problems, avoiding, 138
noise reduction and sharpening, 20	Sepia mode, using with Photo Effects filter, 184
white balance, 20	Set Neutral Point eyedropper, using, 112
raw mode, advantage of, 13, 21	settings. See also edits
raw processing features, Camera Adjustments for Nikon raw,	copying and pasting, 196
132–136	loading, 198
red cast, performing gamma adjustment on, 110	managing, 198–199
red channel editor, switching to, 110	saving to specific locations, 197
red component, specification of, 10	selecting for batch processing, 201–202
Rename option, using with batch processing, 202–203	Settings Options dialog box
resampling, using bicubic interpolation for, 91	accessing Batch Processing controls in, 200–201
resizing images, 89, 92	tabs in, 198–199
considering as edits, 94	shadow tones and highlights, indicating in clipping displays
nondestructive resizing, 94	116
for Web or email, 92	shadows, brightening with D-Lighting, 120-121
resolution of images, changing, 90	sharpening, 78
RGB pop-up menu, options on, 109	guidelines for, 192
RGB values, monitoring with Watch Points, 104	with High Pass filter, 188
rotate tags, using with selected images, 49	sharpening and noise reduction
Rotate tool	in JPEG image processing, 15
displaying, 84	in raw image processing, 20–21
making geometric adjustments with, 85	shooting performance, considering for raw mode, 22–23
rotating images for printing, 213	Show Before/After Histogram feature, using, 110
0 0 1 0	Show Differences option, using with batch processing, 202
S	Show Lost Highlights feature, using, 116
sampling, relationship to image sensors, 7	Show Selection option, using, 148
saturation, adding with + Selection Brush, 152	Size/Resolution dialog box, displaying, 90
Saturation, Warmth edits, making, 130–131	Size/Resolution edit, using for batch processing, 207
	sky
Save command, accessing, 197 Save Settings dialog box, displaying, 197	adding Color Control Points to, 170-171
screen space, maximizing, 36	correcting with Color Picker, 163-164
select images. See also images	sliders, specifying for control points, 178
applying labels to, 52	Soft Proof feature, using with color managed printing,
comparing, 50–51	217–218

soft proofing accuracy, improving, 220	V
software profiling	versions, creating, 194–195
on Macs, 65–66	views, changing, 53–54
on Windows, 66	
sRGB	W
versus Adobe RGB, 71	Wacom-tablet, pressure controls for, 154
using, 12	
storage, considering for raw mode, 22	Warmth slider, using, 131 Warsh Points feature, monitoring color values with 104
Straighten tool	Watch Points feature, monitoring color values with, 104
displaying, 84	Watched folder, starting batch processing with, 205 Web
making geometric adjustments with, 86	resizing images for, 93
subfolders, moving images into, 48	saving image files for, 210
subtractive color combination, explanation of, 63	
_	Web images, using batch processing with, 206. See also images
T	Web preview, creating, 207
threshold display, using with tones and histograms, 103	welcome screen, deactivating, 74
thumbnails	white, yielding, 9 White Balance edits, making for Nikon row 123, 136
resizing display of, 48	White Balance edits, making for Nikon raw, 133–136 white balance
using Zoom tool with, 47	in raw image processing, 20
viewing folders as grids of, 46	white balance, relationship to JPEG processing, 13
viewing on Macs, 41	white clipping, controlling with Auto Contrast, 111
TIFF files	White Control Point tool, using, 165–166
changing NEF format to, 209	white points
saving images as, 31, 139–140	adjusting levels of, 106
TIFF mode, advisory about shooting in, 21	controlling with Levels and Curves eyedroppers, 110–113
Tinted mode, using with Photo Effects filter, 184	Windows
tonal control points. See also Control Point tools; control	importing images in, 43
points	installing printer profiles on, 70
Black Control Point tool, 166–167	monitor software profiling on, 66
Neutral Control Point tool, 159–165	using Lightroom for, 44
White Control Point tool, 165–166	workflows
tone and contrast adjustments, 77, 99	adding IPTC metadata, 54–57
Auto Levels, 99–104	advanced example of, 38–39
Contrast/Brightness, 116–119	archiving, 57
D-Lighting, 120–122	backing up and archiving, 221
LCH (Lightness, Chroma, Hue), 123–124	backing up image masters, 43
Levels and Curves, 104–115	choosing select images, 49–54
tone break artifact, example of, 142	of color management, 216–217
tone curves, effect of, 135	considering for raw mode, 22–23
tones	editing and output, 57
adjusting contrast of, 119	image editing, 76–79
using histograms with, 103	importing images in Macs, 39-42
tool palettes	importing images in Windows, 43
features of, 35	organizing image files, 43-48
undocking, 35	renaming image files, 49
toolbar, tools in, 35	six steps for, 37
tweaks, finalizing, 78	using Capture NX with non-Nikon raw files, 58
U	wrinkles, retouching, 182
<u> </u>	_
underexposure, identifying with histograms, 27	Z
Unsharp Mask filter, using, 191–192	Zoom tool using 47

Zoom tool, using, 47